TABLE OF CONTENTS

WINTER 2023
VOLUME 3, NUMBER 2

EDITOR
LEON WIESELTIER

MANAGING EDITOR
CELESTE MARCUS

PUBLISHER
BILL REICHBLUM

JOURNAL DESIGN
WILLIAM VAN RODEN

WEB DESIGN
BRICK FACTORY

EDITORIAL ASSISTANT
DARIUS RUBIN

Liberties is a publication of the Liberties Journal Foundation, a nonpartisan 501(c)(3) organization based in Washington, D.C. devoted to educating the general public about the history, current trends, and possibilities of culture and politics. The Foundation seeks to inform today's cultural and political leaders, deepen the understanding of citizens, and inspire the next generation to participate in the democratic process and public service.

Engage
To learn more please go to libertiesjournal.com

Subscribe
To subscribe or with any questions about your subscription, please go to libertiesjournal.com

ISBN 978-1-7357187-9-8
ISSN 2692-3904

EDITORIAL OFFICES
1101 30th Street NW, Suite 310
Washington, DC 20007

FOUNDATION BOARD
ALFRED H. MOSES, *Chair*
PETER BASS
BILL REICHBLUM

DIGITAL
@READLIBERTIES
LIBERTIESJOURNAL.COM

Liberties

MICHAEL IGNATIEFF

Epistemological Panic, or Thinking for Yourself

I have been a college teacher for some of the happiest years of my life. When I tell people what I do for a living, *what I really do*, I say I teach people to think for themselves. It's still a wonderful way to make a living, but over time I have begun wondering whether I have been fooling myself. I could just be teaching them to think like me, or how to package the conventional wisdoms that they have scraped off the Internet. I find myself wondering, therefore, what it really means to think for yourself, what it means for teachers, for students, and for a society that tells itself it is free.

Thinking for yourself has never been easy, but the

question of whether it is still possible at all is of some moment. The key ideals of liberal democracy — moral independence and intellectual autonomy — depend on it, and my students will not have much experience of either if they end up living in a culture where all of their political and cultural opinions must express tribal allegiance to one of two partisan alternatives; where they live in communities so segregated by education, class, and race that they never encounter a challenge to their tribe's received ideas, or in a society where the wells of information are so polluted that pretty well everything they read is "fake news."

Thinking for yourself need not require every thought to be yours and yours alone. Originality is not the goal, but the autonomous and authentic choice of your deepest convictions certainly is, and you are unlikely to make authentic choices of belief unless you can learn to wrestle free from the call of the tribe and the peddlers of disinformation and reach that moment of stillness when you actually can ascertain what you think.

The contradiction that teachers face in their classrooms — are we teaching them how to think or how to think like us? — plays out across our whole society. From grade school through graduate school, in our corporate training centers, in our government departments, our enormous educational apparatus is engaged in training us in the ways of thinking appropriate to academic disciplines, corporate cultures, and administrative systems, but with the ultimate objective, so they proclaim, of independent thought. This contradiction – the simultaneous pursuit of conformity and independence — is also at the core of our anxiety about innovation. Our societies say that they prize "thinking outside the box," whatever the box may be. Our political authorities tell us

that the solution to every problem we face — secular stagnation, climate change, geostrategic chaos — depends on "innovation," which in turn depends, finally, on somebody somewhere thinking beyond the cliches and the conventions that inundate us daily and keeps us locked in a state of busy mental stagnation.

Our culture tells us we either innovate or we die, but economists such as Robert Gordon point out that the capitalist economy of the twenty-first century has nothing on the horizon to rival the stochastic lurch of innovation in the Edison and Ford eras at the beginning of the twentieth century. The energy transition, when it finally comes, may yet unlock a new stochastic lurch, but so far progress is slow. Despite these warning signs of stagnation — even decadence, as some conservatives argue — our culture clings to the signs of innovation that we can identify, even to minor upgrades to the software on our phones, because such hope as we have for our future depends on faith that the onward and upward path of new ideas continues. But this hope soon collides directly with the unprecedentedly large pressures for conformity that are generated by those same institutions of innovation. The Pharaonic size of the corporations that control the digital economy raises not just a problem of monopoly or distributive justice, but also an epistemological quandary: are Google, Microsoft, and Facebook, these all-devouring machines, actually places where people can think for themselves? I refer not only to their customers but also to their employees. Is it likely that their well-compensated and disciplined workers can think against the grain of the corporate logic that they serve every day? If not, we may all be on the long way down to secular decline. An institution of innovation may be a contradiction in terms.

The same question haunts the universities in which I have spent some of my life teaching. Every one of these institutions is devoted to what it calls "academic freedom," but how much freedom do these institutions, their disciplines, their promotion and recruitment processes, their incentives, their intellectual fashions, actually make possible for the individuals inside them? Are they hives of orthodoxy or heterodoxy? Does the competitive search to publish, to earn grants, to make an impression on the public, create a genuine climate of intellectual liberty or just enclose everyone, willingly or not, in an organized, pious, censorious, progressive conformity? That is not a trick question.

The academic fields in which I work — history and international relations — demand new thinking because the world that they study, and for which they train aspiring practitioners of diplomacy and finance and politics, is changing fast, yet it is unclear that any of us have the measure of the moment. To use the metaphor that everybody is using, we are observing a shift in the tectonic plates, a fracturing of what used to be called "the liberal world order." Not a day passes without someone offering a new grand narrative to replace the stories that we told ourselves to make sense of the end of the Cold War. But each new claimant fades away, defeated by the complexity of the task; and in some cases, it may be the affirmation of the old wisdom that is a sign of intellectual independence. We are living in a dark cloud of crises — climate change, war, global inequality, economic turbulence, social intolerance — and nothing matters more than that we think freshly and clearly.

Recently, as the gloom has deepened further, our rounding up of the usual suspects — the incompetence of our leaders, the savage swamp that is the internet, the frantic polarization of politics — has given way to a kind of chronic episte-

mological unease, as if we have begun to realize that we have trapped ourselves inside frames of thought that point us away from reality and not towards it. The trouble is that too many people find comfort and safety in those frames and resist the instability — another term for open-mindedness — that results from questioning them.

But sometimes there are exceptions to the retreat into platitudes. Let me give an example. I sit in on regular team calls by a company that advises major business clients on geostrategic risk. Everyone on the call is impressively well-educated and articulate and plugged into impressive information networks. Someone on the call has just returned from a highly regarded conference of experts. Others have just had confidential discussions with a government minister or a well-placed adviser. The calls review the world's unending torrent of bad news — Ukraine, China-Taiwan, the climate change inferno in the Mediterranean and California, the repeal of *Roe v. Wade* — and all this calamitous news is parsed by knowledgeable principals and then packaged for the clients and "monetized" for the company.

The calls are wonderfully informative, as well as scary. What is scary is the fear that this superbly informed group might be unable to see what may be staring us all in the face. On one such call, the CEO of the firm, after listening to an hour's review of the US-China standoff on Taiwan in the wake of Nancy Pelosi's visit, asked his team the right question: with all this privileged information, weren't they just recycling what all the other shapers of elite opinion — *The New York Times, Project Syndicate, The Economist, Le Monde*, the *Frankfurter Allgemeine Zeitung*, the CIA, the State Department, the West Wing, and competing risk assessment firms — were also thinking? What are we missing? he asked. What are we not seeing?

10

These are the right questions, and not just for his firm. Advanced opinion tends to run in herds, exactly like unadvanced opinion. It is increasingly useless. Epistemological panic — the queasy feeling that our time has jumped the tracks — has created a hectic search to create a new master narrative, a new single explanation, a new key to all mythologies. (How else explain the success of Yuval Noah Harari?) This frantic search to give our time a shape and a meaning makes me wonder whether the new technologies that so accelerate the exchange of information are in fact having a spectacularly ironic effect: instead of incubating new ideas, they are coagulating conformity. As a result, might our information elites just be sleepwalking their way towards the abyss, like our ancestors in 1914? But even this analogy to the sleepwalkers of 1914 is a little shopworn, another sign that I am no less trapped in my paradigms than anyone else.

From the classroom to the engineering lab to the national security conclave to the geostrategic risk business, our future depends on our capacity to think anew. While thinking in a group can help, groupthink is the enemy of integrity and innovation. A truly new thought begins in a single insurgent mind.

Do we live in societies where such people are allowed to flourish? Do any of us actually still know what it means to think for ourselves? Or are we all just recycling opinion on our hectoring devices? It would not be right or good, at this late stage in the life of liberal democracies, to conclude that we live, despite our vaunted freedoms, in a state of unfreedom. The situation is more paradoxical than that. The paradox —

Tocqueville and Mill warned us of it — is that free institutions do not create free minds. It is always possible that our institutional freedoms might still leave us chained in a state of epistemological unfreedom. So how, beyond re-reading Tocqueville on the tyranny of the majority and Mill on liberty, do we think about the obstacles to free thinking in our own day?

For a start, we are confused about what thinking is. To think is not to process information. We have impoverished our understanding of thinking by analogizing it to what our machines do. What we do is not processing. It is not computation. It is not data analysis. It is a distinctively, incorrigibly human activity that is a complex combination of conscious and unconscious, rational and intuitive, logical and emotional reflection. It is so complex that neither neurologists nor philosophers have found a way to model it, and the engineers of artificial intelligence are still struggling to replicate some of the simplest forms of pattern recognition that human cognition does so effortlessly. We must beware that in our attempt to make computers think like us we do not end up thinking like them.

Nor is thinking a matter of expressing yourself or having opinions. It is not about turning on the fountain of your personality. It is an exercise in finding reasons to persuade yourself and others that something is true, or at least plausibly true. Thinking has truth as its goal and its organizing discipline. Bullshitters, as Harry Frankfurt told us, are precisely those who do not think: they simply express what comes into their minds, without concerning themselves with whether what they are saying has any relation to reality. Every university is, or should be, properly worried that their classrooms are training generation after generation of accredited bullshitters.

Nor is thinking about expressing your identity. It is not an intellectual achievement to parrot the truisms of our tribes. Indeed, thinking is about emancipating yourself from identity, insofar as it throws into question prior and unexamined ideas. Identity is a warm bath, but thinking is a discipline. Many important lines of thought are austerely impersonal, purged of the origins of those who thought them up. Think of mathematics, physics, and logic. These are great systems of thought made possible by thinkers who in the laboratory and the library neutralized or discarded their identities and lived, in their working lives, in the impersonal realm of signs and symbols. It doesn't matter that perfect objectivity is impossible; imperfect objectivity, the progressive correction of biases, is certainly possible, and all that we need. Even in the social sciences, it is basic to our methods that we try to leave our personal "priors," experiences, and histories behind, or in some way to bracket them, so as to see what the data tells us. In this work, thinking means leaving ourselves behind.

In deep ways race, ethnicity, class, and gender do structure our thoughts, but they do not have to imprison them, and we certainly should not celebrate the intellectual limitations that they impose upon us. Thinking is communicative action, and the fact that we can communicate to each other across the limits imposed by our particularities is proof that we are capable not only of thinking for ourselves, but thinking about how other people, very different from us, might see the world. Thinking is therefore reflective about thought: we need to grasp how these factors of biology and sociology condition our understanding, so that we may, for the purpose of analyzing a subject and understanding it truthfully, neutralize those conditions. Lots of other animals engage in conceptual operations, but we are the only animals who have thoughts

Epistemological Panic, or Thinking for Yourself

about our thoughts. Thinking, properly speaking, turns back upon itself. It is the attempt to understand how we end up thinking the way we do, and what we can do to transcend the boundaries set up by our identities.

One of the most important modern ideas about thinking is the recognition of the intellectual advantage conferred upon us all by social and cultural diversity. The best way to think through and beyond your own identity is to be in communication with other identities, different from your own, and to realize, as you interact, how their identities shape what they think. In realizing this, you realize something about yourself. Yet thinking is emphatically not about reproducing yourself, over and over, and confirming your starting point, as a male, female, white, black, rich, or poor person. That is not thinking. It is what Freud called repetition compulsion.

Thinking can take us to a lonely place, where skill, technique, experience, even will power, sometimes are of no avail, where, to make progress at all, we have to step away and wait until a new path suggests itself. We can get better at thinking, to be sure, but there is always going to be someone who thinks better than we do. This is another reason why we are not like machines. They all compute the same way, while each of us is differently endowed. It is when we see others thinking, and so often more clearly, that we discover, once again, just how difficult it is, and also just how much it defines us, to think for ourselves.

Not all cultures and periods of history have made this goal the basis of their society. Chinese mandarin education, under the emperors, was formidably egalitarian and proved to be a crucial avenue of mobility and elite renewal for a traditional society, but thinking for yourself was not its goal. Its purpose was to train bureaucrats in the routines and the skills required

to administer an empire. The Greek city-states of the ancient world, the Roman imperial regimes, the medieval Christian states, and the Islamic empires, though they were all the settings of intellectual breakthroughs, all feared what would happen if women, or slaves, or the poor were allowed to think for themselves. They understood, quite rightly, that adopting such a principle — recognizing the essentially egalitarian and meritocratic nature of genuine thought — would be playing with fire, likely to blow apart systems of rank order and privilege. Perhaps only Western culture, and only since the Protestant Reformation, has embarked on the dangerous experiment of believing that everyone, literally everyone, is entitled to think for themselves, and entitled, furthermore, to that once exclusive privilege of male elites, the right to an examined life.

To manage this revolutionary adventure, Western author-ities took education away from the church in the eighteenth century and made a massive bet on secular learning, first by private charity, then by the state. As an English government minister said in the 1870's, introducing an education bill, that "we must educate our masters." The hope was that education would canalize the combustible thoughts of the newly enfran-chised (male) masses into sober conformity. Education ever since has sought to manage the contradiction between what a free society preaches about the right to think for yourself and the lessons it needs to instill to maintain bourgeois stability.

All of us have lived through that contradiction, first as pupils in primary school. Schools do teach you how to think and they do it (or they used to do it within living memory) by dint of repetition, boring exercises, lines written in a notebook, raps on your knuckles when your penmanship wobbles. Later, in college, you begin learning a discipline, and

15

the experience shapes your thoughts ever after. No originality then, no thoughts you can call your own, before first learning how to think from someone else. Your thoughts do remain in that magnetic field of your primary and secondary education for your entire life. Looking back, once education is over, we can see just how halting and foolish our first steps into knowledge truly were. I still have a battered paperback of *The Birth of Tragedy* on my shelf, the same edition I first read fifty years ago in college, and I squirm when I re-read my marginal notations. Thinking for yourself is a humbling encounter with your own foolishness.

One thing you learn, as you grow, is that you don't have to think everything through to first principles; you don't have to master everything. We cannot rely on ourselves for our understanding of astrophysics and medieval art and macroeconomics; we must rely on authorities. But we can arrive at strict standards for what counts as authority and choose to trust people who are in a position to know. A lot of what teachers do, when we try to get people to think for themselves, is to mark out, as best we can, the terrain of knowledge where relatively secure answers have been found and can be trusted.

Learning to trust a discipline and the knowledge it has certified as true is the starting point for any venture into thinking for yourself. Most of what you know you take off the peg, like a suit or a shirt you buy in a store, or the furniture you get from IKEA. College is like an IKEA store. It does not include assembly. In the lecture hall, the concepts are delivered boxed and flat-packed. You take them back to your room, and with the Allen wrenches that the professors have given you, you put together the furniture to fill the rooms of your mind. No surprise, then, if your mind starts looking like everyone else's.

This creates what Harold Bloom famously called the anxiety of influence, the sense of being derivative, the worry that you are not speaking your own truth but being spoken by the various discourses that you have assembled for yourself. There is even the anxiety that there is nothing left for you to say. "Born originals," the eighteenth-century poet Edward Young wrote, "how comes it to pass that we die Copies?" You want to think for yourself because you want to be somebody. Thinking is how you create, over time, the feeling that you exist as a distinct individual.

But originality, again, is not the objective of thinking. Bloom was writing about poets, and more generally about artists, for whom originality matters deeply, but the point of thinking is to say something true, not something new. Originality is not the only marker of individuality. Novelty cannot vouch for the truth of a proposition. And the obsession with originality eventually leads us to admire contrarianism — or as it is more accurately known, sheer contrarianism — which is a contentless and purely theatrical position, determined by no higher ambition than to say what is not being said, and thereby to draw attention to oneself. Sometimes a consensus is right and sometimes it is wrong; if you have thought the subject through and arrived at your own reasons to concur with others about it, then you have not surrendered your intellectual integrity; but a contrarian is just a reverse weathervane. The point is not to think originally but to think critically.

You free yourself from the anxiety of influence first by learning a discipline and then by casting a skeptical eye on the discourses that it seeks to make canonical. In my undergraduate and graduate education, spanning the 1960s and 1970s, discourses blew regularly through the campus, sweeping

all right-thinking people into their clouds of abstraction. First it was Marxism, then structuralism, then post-structuralism, then discourse analysis. I forget the rest of them. They created fashions in thought and fashionable thinkers, lots of them French or German. Cliques arose in which the confident deployment of a certain jargon was the test of entry. Fifty years later many of these discourses seem comic or irrelevant, but at the time they were exciting and predominant, a mighty source of academic power and legitimation, and their successors today are no different, with the same unhappy consequences for freedom of thought.

In evaluating the currently fashionable strictures on what can and cannot be said on campus, I find myself reaching back to my graduate education and remembering how the ascendant discourses liberated me only to suffocate me later. As a trainee historian, I was enthralled by the young "humanist" Marx of 1843–1844, and the Marxist historians of the British school, Eric Hobsbawm and E. P. Thompson. For a time, these brilliant Communists and ex-Communists were my *maîtres à penser*, even though I never ceased being a stone-age Cold War liberal. All apprentices need masters. Then there comes a moment, essential to any free and mature intellectual life, when apprentices need to break free.

Intellectual independence always begins with a small act of rebellion. In the middle of reading a book, or during an experiment, or pondering the numbers spewing out onto your computer screen, you suddenly have a suspicion that something isn't right, though you are not sure what. This is the decisive moment, when you have a choice to ignore this flick-

18

ering unease or to begin to wonder why. Once this epistemo-
logical disquiet takes possession, the question becomes what
you are prepared to put at risk to resolve it. There is always an
element of oedipal struggle in any commitment to think for
yourself — a moment when you break with a supervisor, an
intellectual idol, a close friend. If the revolt succeeds in giving
you your freedom, it leaves behind a lifelong watchfulness, a
skepticism about authoritative academic (and non-academic)
rhetoric and the prestige of *maîtres à penser*. At the end of this
journey, you may end up feeling, like those radical Protestant
sectarians of the sixteenth century, that you have earned the
right to *sola Scriptura*, to read and interpret the holy scriptures
for yourself, without the mediation of dogmatic authority.

Here is where the individualism of modern liberal culture,
derided equally on the right and the left, is so critical for
the creation of free thought. For there must be a moment
when a thought fails to convince you even when it appears
to convince everyone else, or when you are alone with a
thought that doesn't seem to be occurring to anyone else. The
communitarians would have you question this experience
of independent reflection and wonder nervously whether
heresy or apostasy is on the horizon. For some communitar-
ians, other minds are more real than their own. But this is a
fiction: like the specificity of your body, the specificity of your
mind is evidence of your individuation.

Yet it is always a struggle. Someone else is always quicker,
cleverer, has read the book that you did not, seems to grasp
things that you fumble for. So thinking for yourself quickly
becomes a competition to think as quickly and as smartly as
the others. Competing with others, you discover, is how you
become like them, not how you distinguish yourself from
them. Catching up is not an intellectual activity. So you begin

to separate from the pack, from the people you eat with and go to the movies with. You choose solitude and study. You set yourself the task of mastering a book, a theory, a disciplinary approach, anything that will give you the sense that you have mastered what is necessary for serious thought about a subject, and so can rely, not completely but sufficiently, upon your own resources. When you have gained mastery, at least to your satisfaction, this gives you the confidence to go on, and you need confidence because everyone around you seems to be ahead of you. You discover that you have your own pace, your mind's own tempo. As for those canonical books on the shelves, their authors remain in another league: austere, elegant, relentless, eternal; and thinking for yourself means respect for the canon, for the very few eternal works that set the standard for thought itself. But if the canon teaches anything, it is that you must not become enslaved to it, or anything else, only because it is venerable.

What you think about hoovers up the entirety of your waking and sleeping life, the eternal and canonical as well as the transitory and foolish. You work on the promiscuous stream of your own consciousness — memories, jokes, phrases, shameful incidents that will not go away, epiphanies that had better not go away, the babble of social media, the unending tide of information that sluices in and out of your machines, the data you collect and that collects you, the books you read and annotate. None of this stream counts as thought itself, and none of the processing of information counts as thinking. Actual thinking comes later, when the moment arrives to put order in the house.

As I have aged, my own mind, originally furnished by Ikea, has gradually become more like those photographs of Picasso's studio: palettes, brushes, sketchbooks, dusty photos,

abandoned sculptures, paint tubes, knives, African heads, all lying around in an order that only he could understand. So thinking for me became an exercise in trying to remember where I put something in the studio of my mind, where I heard something, read something, since suddenly I seemed to understand what use to put to it. There must be orderly minds whose upstairs rooms are like an office, with filing cabinets, and books and manuals arranged in alphabetical order, affording instantaneous ease of access. Good luck to them. But thinking emerges from chaotic minds as well as orderly ones. What both have in common is tenacity, going on and on, when everyone else has turned out the light and turned in.

When you have found an idea that is properly your own, you come back to yourself with a feeling of surprised discovery. You have revealed yourself, for the pleasure and satisfaction of it, surely, but also because you think it might make a difference, change somebody else's mind, "contribute to the literature," and so on. Many of the motives that draw you to an act of thought are extrinsic — like trying to impress, to get tenure, to make your mark; and extrinsic motives will lead your thought into certain grooves to meet certain expectations. Thinking guided only by extrinsic motives runs the risk of being captured by the institutions, the authorities, and the celebrities you want to impress.

Yet there is also a kind of thinking for yourself where you feel compelled to do it, intrinsically, for its own sake. The experience is of being taken possession by a thought. This is certainly the most perplexing, frightening, and pleasurable kind. For it feels like the idea is thinking you, thinking itself into being, inside your head. You go to sleep thinking about it; you dream about it; when you wake, you see some new element you want to explore; everything is murky, struggling

Epistemological Panic, or Thinking for Yourself

to rise into consciousness, to get itself fixed in language, so that you can begin to understand what the idea is trying to say. The unconscious aspect of thinking is uncanny and suggests that part of what makes thinking for yourself so difficult is that it is never an entirely rational or conscious process, even when it prides itself on being so, but instead a thick and murky and subliminal experience, in which reason is never all there is, highly emotional, highly unstable, impossible to predict, difficult to control, and finally very hard to put down on the page.

Thinking a new thought can feel like a moment of self-expression, but it is actually a moment of self-distanciation in which, having searched your mind and memories for materials, you suddenly see that you can create something new from the materials that you had taken for granted. Thinking can feel like a surprise, in which you awake to what was in you, until then unsuspected and unrevealed.

Thinking for yourself is not solipsism, a perfectly isolated and self-confirming activity that occurs only inside your head. It is social: you work within force fields of thoughts and ideas created by others, and good thinkers are often, though not always, generous ones, quick to acknowledge others and their dependence upon them. Since dependence creates anxiety, a worry about being derivative, the only way out of this worry is to gratefully acknowledge your dependence and then make sure to take the thought further than where you found it. From dependence on the thoughts and insights of others, you gain confidence in your own way of thinking.

With that confidence comes a responsibility to the field in which you work, a responsibility to your own reputation as a serious person who doesn't play around with the facts. Thinking for yourself means taking responsibility for your

thoughts when they enter public discourse. Fools are people who say the first thing that pops into their heads. (That is the deep problem with the spontaneity of social media; a person's first thoughts are never his best thoughts.) Even bigger fools claim an originality that they do not deserve. The biggest fools of all think that everything they think is their own invention. Self-congratulation is never the hallmark of a real thinker. Instead, thinking people have a morality of knowledge: they accept the obligation to back up what they say with evidence, facts, footnotes, citations, and acknowledgment of where they got their ideas from; with a rigor of argument and an analytical care about concepts. They lose sleep about error and misinterpretation.

In our thinking about thinking, we rarely pay enough attention to its ethical frames of responsibility to self, to method and discipline, to truth itself. Nor do we pay enough attention to its psychic requirements, to the kind of character that is needed to be a good thinker. The qualities that make a good thinker are not the same as make a good citizen. Civility and politeness are all very well in society at large. Good manners are a lovely attribute, but in intellectual life the instinct to be nice and to be liked can be fatal. Rigorous thinking must be followed wherever it leads. The unpleasantness of controversy is inevitable. Everybody cannot be right. This is yet another instance where the ethos that liberal democracy encourages — civility, deliberation, compromise — is in radical contradiction with the intransigence proper to scientific and humanistic discovery. In politics, in ordinary life, compromise is good, even necessary. In reasoning and research, by contrast, you must

23

be a fighter, tenacious, persistent, stubborn in your insistence that someone's argument is wrong and yours is closer to the truth that you are both pursuing.

Thinking for yourself also means honesty in defeat. It is hard for competitors in intellectual fields to admit when they are wrong, when the data fails to prove their point, when they cannot find a way to rebut someone's devastating rebuttal. Thinking for yourself demands a difficult kind of honesty, a willingness to concede defeat when the evidence is against you, and enough resilience to resume the search for the answer that still eludes you. And these conditions for honest and public disputation are not only traits of thought but also traits of character. Liars, even brilliant ones, are useless to thinking.

Liberal societies need this kind of character and this way of being, but it works against many liberal values: compromise, perfect reasonableness, the search for social accord, the desire to be liked and thought well of. There is something intransigently solitary about thinking for yourself, and a liberal society should want to encourage a temperament that is strong enough to endure solitude, contradiction, unpopularity, standing up for yourself against the tide of opinion. As Tocqueville and Mill, our greatest psychologists of liberal society, saw long ago, a society like ours that lives by and for progress and innovation cannot survive without protecting and fostering this type of intransigently individualistic character.

If thinking for yourself is the goal of your life, then it pays to maintain a certain distance from the institutions in which you work and live. Distance implies wariness about received opinion, about fashions, about the recurring tides of certainty and urgency that course through the places where we work and soon have us all facing the same way, thinking the same

thing. The larger point is about liberal society: if thinking for yourself is your goal, do not go looking for the comfort of belonging or the certitude of faith. Do not expect a free society to provide these for you. Belonging is not the fondest dream of a serious intellectual. She dreams of other satisfactions first.

Liberal society works best — it is most productive as well as most free—when its members all feel a certain alienation, a certain dividedness about the objectives and the values of the institutions inside which they work. Alienation is another term for distance and detachment; it need not be melodramatic or wounding. It is simply one of the epistemological conditions for a working mind, and for the pleasures of its work. Objectivity is a variety of alienation. Who would trust the views of a thinker who is not to some degree alienated – that is, detached – from her subject? One of the very first scientific societies in the world, the Royal Society, founded in 1661 by the likes of Isaac Newton and Christopher Wren, took as its motto: *Nullius in Verba*. Take Nobody's Word for it. Imagine: the greatest scientists of their time set up an organization to promote scientific thinking, and their working rule was not even to take each other's word for the truth. That is an ideal of truth that is also an ideal about institutions: to give us a place not to belong and imbibe the pieties of a tribe, but where we take nobody's word for it.

In case you were wondering, I doubt that I have myself measured up to these standards. I have lived in an orthogonal relation to the liberal institutions that have made my life possible: in academic life but not of it, in the commentariat but not of it, and so on, but whether this has enabled a genuine independence of mind, I cannot say, and in my own reckoning I come up short. So my strictures here are not an exercise in coyly concealed self-congratulation, so much as an effort to

describe an ideal and to recommit myself to it in the classes that I teach.

The larger question, beyond the type of intransigent individual that we want a liberal society to nurture and to protect, is how to manage the contradiction, at the heart of our institutions, between teaching people how to think and teaching them to think for themselves. This is an old contradiction, of course, but we need to understand how new conditions in the twenty-first century have sharpened it. Briefly, the answer is this: no society before ours has ever been so dependent for its economic progress and cultural self-understanding on knowledge. An entire literature — "post-industrial," "knowledge is power," "the information society," "symbolic analysts" — has established this epochal difference. In such an order, the creators of knowledge possess enormous power; and we can measure it not least by the extraordinary financial returns that patented inventions, best-selling books, movies and TV shows, apps and other knowledge products earn for those who devise them.

Having monetized the products of thinking in hugely valuable forms of intellectual property, corporations, governments, universities, and some especially successful individuals face the dilemma of how to institutionalize their creativity. The owners of ideas, whether they are individuals or corporations, have powerful new algorithms at their disposal, enabling them to canalize innovative ideas into opportunities for profit, market share, influence, and power. The new technologies have accelerated the concentration of economic and intellectual power in a handful of monstrously large corporations that run the Internet and thereby set the standards for university culture and learning world-wide. The issue hanging over all of this is whether new technologies

for discovering and aggregating preferences in ideas helps or hinders the impulse — thinking for yourself — that drives the entirety of our society's capacity to innovate.

If you put these two factors together — new technologies to aggregate and identify preferences in ideas and an oligopoly of institutions that certify what profitable and useful knowledge is, together with their licensed authority to teach people how to think — what do we have? A society that teaches us how and what to think, or a society that teaches us to think for ourselves? Those who think that "surveillance capitalism" is the root of the problem, or who prefer to blame social media, or who wish to force-march us back to their old verities — all these people have their answers ready. But the question is more than a sociological or political one. It is, rather, a personal and moral one. It may be more useful to conclude that this is a question — whether thinking for yourself is possible — that cannot have a general answer. It must be asked by everyone who cares about an examined life and an examined society. A society will be only as thoughtful as the people who are its members; or as thoughtless, with all the terrible consequences that always issue from unfree thinking. Those who do think for themselves will have to answer the question for themselves. It is a condition of the proper use of freedom to ask yourself continually whether you are truly as free as you think you are.

MARY GAITSKILL

The Trials of the Young: A Semester

In 2014 I was hired, for two consecutive spring semesters, to teach writing and literature at one of the *officially* happiest colleges in America. The place was located in a beatific, temperate environment, with mountain views and imposing, elegant architecture; extraordinary foliage and trees burst from the very pavement, flowers were everywhere. There were outdoor swimming pools, conveniently placed grills and fountains, the latter to be drunkenly danced in on graduation or really whenever somebody felt like it. Upbeat music emitted from invisible speakers, wafting constantly across enormous athletic fields; artistic performances and lectures were available

almost every day or night. The faculty were erudite, dedicated, and inspiringly strange. Students were receptive, hard-working, and very well-prepared; they were the best undergrads I had ever encountered. They were also, with few exceptions, remarkably easy-going.

There was something intimidating about the opulence of the place, and also a little eerie; to me, that kind of apparent perfection invariably holds the secret of its inevitable ruin. I knew it was perverse to feel that way in the midst of a wonderful opportunity for which I was grateful — but I did feel that way, almost on arrival. The stark rectilinearity of the architecture, the Triumph of the Will plazas, the huge terraced terracotta buildings — if you aren't used to that scale of things it is disorienting, especially if you are the only human walking the huge expanse between the huge structures. So, at the end of what turned out to be a lovely semester, when one of my favorite students, a kid from India named Chetan (not his real name; all names in this essay have been changed) caustically informed me that this was "the happiest college in America" and that it got on his nerves, I sincerely replied, "Yeah, I know what you mean. What's wrong with them?"

But whatever was wrong wasn't wrong with all of them; some people apparently were not so happy at all. By the fall of 2015, the Dean of Students had been essentially forced to resign after a humongous campus-wide protest about her alleged racial insensitivity, which somehow got combined (in the media) with a Facebook photo of two grinning blonde students in Halloween costumes that featured ponchos, sombreros, and glued-on mustaches. A quivering apparatus sprang up to attack the unhappiness: more multicultural clubs, more diverse hiring, a mentoring program, and an administrator to oversee diversity came into being.

But when I returned for another engagement in 2019 I noticed that students were no longer so easy-going: they were positively touchy. A higher percentage per class needed mental-health disability dispensations and a couple of students had to take time off due to breakdowns. During the semester a student published an essay in the school paper titled "On Being Unhappy at One of the Happiest Colleges in America." The writer identified his experience of racism as the source of his discontent, but towards the end of his piece he broadened his focus to note that the happiness itself could create mental health stress across the student body. He mentioned the deaths of two white male students that had occurred within the same week that year, one a suicide, the other a drug overdose.

An anecdote about those deaths that is minor but which seems relevant: in conjunction with mass counseling services and a candlelit remembrance, a community gathering was also held featuring a free food truck, board games, and coloring supplies.

Fast forward to 2021. The unhappiness was continuing its upward creep, for obvious reasons: the pandemic, the exponentially growing climate crisis, political madness culminating in the attack on the Capitol, the ever louder voice of white nationalism, the murder of George Floyd, the vicious street attacks on Asian people which seemed to loom larger and more horrible in contrast with the extra anti-racist vigilance on campus.

Anyone who isn't living in off-grid isolation is aware of the tireless efforts by hyper-conscious campus administrations to create classrooms where everyone feels safe and as few people as possible will be made "uncomfortable," let alone unhappy. Some institutions require "trigger warnings" to be announced before "problematic" material is read, and some classic texts

might not be taught at all — for example, professors of literature might hesitate to include a story by Flannery O'Connor (featuring the n-word) on their syllabus. Title IX protects everyone from rape or harassment, and mandatory training "modules" educate faculty about proper codes of conduct and speech. In response to the stressors listed above, the response at the now less-happy campus was to double down on such efforts: fewer white male authors on the syllabus, please, more instructional modules on how to engage students over Zoom, more anti-racist teacher trainings, more refinements of language (the n-word should not be uttered aloud for any reason by any not-black person, not even if the person is reading it from a hundred-year-old text), more polls on how more diversity might be achieved.

Such strenuous gesticulation has been so widely mocked (even by academics who do it) that it is easy to forget why it started. Campus assaults and sometimes horrific drunken rapes were a part of campus life for decades and I don't doubt that they still occur. (For a recent example, see the Hobart and William Smith frat rape, 2014.) In the almost thirty years in which I have taught as a visitor at various universities, I have witnessed or heard about disgusting and demoralizing racial insults (in 2005, for example, a program on the student TV station at Syracuse University featured images of an actual lynching on a comedy show) as well as the more subtly painful experience of isolation faced by minority groups — experience that professors could unintentionally exacerbate or not notice or not know how to address if they did notice.

But still, even people outraged by such cruelties might fairly mock the corrective apparatus, not only because it is ridiculous (which it often is) or dictatorial (which it often is, even if people on the ground are usually reasonable in its

application). The deeper trouble is that it is ineffectual and confusing. It is confusing to conflate the reading of a hate word in a book from one hundred years ago with its actual use in the present time; it is confusing to treat the fictional expression of misogyny as if it is the real thing. It is desensitizing to hear a routine "land acknowledgment statement" read before every gathering. Anyone who thinks it's funny to broadcast the image of a lynching victim or who would take part in a gang rape might grit their teeth and undergo the retraining, but I can't imagine that their racism or misogyny would be moved by it.

On a less drastic level, such statements and modules are too easily parroted and thus absorbed into the status quo that they are trying to challenge. In 2019, one of my male students repeatedly used the phrase "toxic masculinity" in an essay on Richard Yates' *Revolutionary Road*, and while the words were not completely inappropriate, they struck me as empty. I asked him in a private conversation what he meant by the phrase, and he basically said that he learned it at a talk held during his freshman orientation; it meant entitled men treating women badly. I said I didn't think that those descriptors applied to the character in the book exactly, that there are more interesting ways to talk about him. At some point in the conversation I asked him how he felt about the neutral trait "masculine" being linked with poison. He shrugged affably and said it was okay with him, he didn't mind.

Of course he didn't mind. He was a handsome young guy with a perfectly good mind and a winning combination of confidence and politeness. I wonder, would anyone tell this guy that he had "toxic masculinity?" Maybe a girl angry because he failed to text her back, or a girl flirting with him— and now, courtesy of the mandatory talk, he can win points by

saying it first, plus he can use it in papers and get points that way, too. Easy peasy!

But less confident, less sophisticated young men — those with the most vulnerable self-esteem — might find it disconcerting to be told, no matter how sensitively it was put, that the trait that they have grown up considering desirable, their most basic default identity is now toxic. This does not seem to me a minor side effect.

So. My recent fiction writing class in this complicated environment was quite small, partly because a few of the people that I accepted had read an interview I did with *The New Statesman* in Britain which made them think that my "stance" regarding "SA" (sexual assault) would make them feel "unsafe" in class. But I was pretty happy with my group of eight, including one very animated and bright guy named Luke who on the first day told me that he couldn't sit still, he needed to pace. He assured me that his pacing would not indicate disrespect of any kind; it was just part of his personal energy and he had to do it. But when I explained that pacing was okay during a Zoom class but in person he had to sit still, it turned out that he was able to do so.

He could not refrain from pacing, however, when he came back to my office with me to discuss his first project. During that conversation he paced and paced, taking books off the shelves and commenting on them before focusing on his main question, which was: could he write his first story about someone who rapes, murders, and jerks off on the body of a little girl — in the first person?

I replied: "No. Not in this climate. It would cause a big fuss and frankly I don't want to deal with it. People would go

33

The Trials of the Young: A Semester

nuts, the dean's office would get involved, it would be a crisis. I mean, maybe later on you could ask the class how they would feel about it? Maybe if they got to know you? But — "

In case you are wondering why the equivocation instead of a loud clear no, it was because I used to believe — it is almost instinctive for me to believe — that anything is fair game in a writing class, that even the most offensive subjects are open for exploration in the free country of art. But years of teaching experience (most specifically the year 1997, about which more in a moment) have persuaded me otherwise, at least when it comes to undergrads. Still, it was hard to be immediately clear-cut with this extremely enthusiastic, friendly, and intelligent kid. It was actually hard not to get up and start pacing with him.

"The other issue with writing on that subject," I continued, "is that it's really hard to write anything good, especially in the first person. Because no one really understands why people do those kinds of crimes. The people who do them *especially* don't understand why they — "

"You're completely wrong," Luke replied. "They do understand why they do it."

I asked why he thought so; he cited an interview that he had read in which a high-IQ serial killer explained the causes of his murderousness (basically, Mom Rage). I said, "Okay, I get that. But I don't know if those explanations really explain anything and anyway I think you should come up with something else to write."

Eventually he did. He wrote about a double suicide featuring hallucinatory and extremely violent images of self-harm, the most violent thing about it being the total unreality of anyone in the story but the narrator. As writing it was good, even powerful in its efforts to render the self-hate

it described, in layers of dreamish, hellish pictures that were truly painful to read. But the other students who expressed strong feelings about it disliked it for its solipsism; they disliked in particular that the female character in particular was a voiceless prop. That feature got some critical attention from me as well. But I think mostly the class, including myself to a degree, were unnerved by the sheer, unrelenting, unvaried rage-pain of it. Luke took it all pretty gracefully, even if the sexism part plainly irritated him.

Minutes after the class ended, I got an email from Luke in which he described hitting himself in the face; he said he thought I would enjoy it. I wrote back, I'm sorry to say a little flippantly, that I hoped this didn't mean he was upset by the reception of his story. He indignantly replied that it meant no such thing. Then he emailed again, attaching what he said he would really like to submit to the class though he knew it was too edgy for them. It was, basically, a description of a guy preparing to torture a younger guy who idolized him, including a detailed description of what he meant to do plus a vivid description of what some serial killer had done to his mom. I replied that he was right, this would not go over well.

Then I emailed an administrator to tell her that I was concerned about a student. I met with her in person in an outdoor setting — Covid was surging — which was as usual spectacularly beautiful. She asked me if I thought the student was presenting a "safety issue" for the class; I said I was not a hundred percent sure — you can't be these days! — but he probably wasn't going to come to class with an assault rifle and start shooting. I believed that he was more likely a danger to himself. She said she would put out feelers to see if he had "set off any alarm bells" for anyone else, or had in any way "gotten on the radar" of the mental health apparatus.

The Trials of the Young: A Semester

We talked a little about the student body in general. She said mental health issues were "through the roof," that a number of students had already been sent home in that calendar year to receive care; in some cases, their parents had to be persuaded to accept them back. She expressed the opinion that even before the pandemic, student mental health had been declining for... I don't recall the number of years she gave. We talked about why this might be; our ideas were not original. She thought upper-class parents were so over-protecting their children that the kids could not deal with even a managed environment on their own. I thought they were disconnected from their own bodies because so much social life had migrated away into the digital ether. I thought they could not sit still and be with themselves or comfort themselves. We agreed that the world was going to shit.

My mind was not put to rest by the conversation. Luke had disturbed me and I didn't know what I felt: anger or compassion or real interest in his mind. And he was not my only concern. Another student had turned in a story about suicide, specifically an attempted suicide, which I foolishly assumed to be completely fictional because the protagonist was female while the writer was male, and because the details of the hospital in which the character recovered were completely unconvincing, as was the dialogue assigned to therapists and staff. Several other people in the class also felt that part of the story was unconvincing and, apparently, they spoke from personal knowledge. Almost half the class had spent time in a mental institution, enough to know what the experience was like. And the author, upon being critiqued, revealed, seemingly out of sheer exasperation, that he too had experienced this. The story was in part autobiographical, he said.

It was a startling moment. It was also a softening

moment. There was a beat of silence during which I felt the room become gentler, more empathic, a feeling so palpable it was akin to touch. It was natural for me to take advantage of the soft moment to say that I appreciated the writer's will to tackle such a difficult subject; not only difficult personally, but, owing to the depth and the perversity of it, objectively hard to illuminate. Which made Luke protest loudly, insisting once again that I was completely wrong about the difficulty of the subject, and that writers should not hesitate to go there. I responded crabbily that of course writers could go there but they should understand that it was not easy, and they should not be surprised if they failed the first or second or third time.

We then moved on to the next startling moment, which arose from a discussion about technique. The discussion concerned a moment of dialogue during a scene when the protagonist's parents arrive at the hospital, right after she has come to consciousness; it was trite and emotionally flat. I allowed that sometimes in terrible situations people do say things that are trite, because they are overwhelmed. I suggested that the writer could add depth by describing the parent's facial expressions, their voices and movements. "When the mother hugs her daughter, what does the hug feel like?" The student asked me what I meant. I tried to explain: her body could feel hard and tense, it could feel soft and warm. It could feel weak or strong. There are a lot of different gradations of touch, I said; a person's body can say a lot of things that they don't say in words. And the student replied, "I have no idea what you're talking about. I've never felt anything like that in a hug."

The thought popped into my head: "That is why you felt suicidal." Later, more sensibly, I thought that the student was

possibly just being defensive. But I wondered. I meant what I had said to the admin person. I think people are becoming crazy because they have become too estranged from their own bodies to feel them. Or to feel other people.

I am not alone in thinking that the pandemic made such estrangement worse. But I remember becoming aware of it many years before, during a discussion of internet porn with a nearly all-female class. The discussion was triggered by a story about the inhibiting effects of porn on girls who, because boys have become so habituated to it, feel obligated to imitate the actresses. Eventually I said that performance could never replace genuine bodily response. One beautiful young woman in her late twenties looked at me with troubled eyes and said, "But how do you know if it's genuine?" I smiled and said, "You can feel it. Its unmistakable." She just looked at me, her troubled expression deepening.

After the suicide workshop, I emailed Luke and asked him why he was so sure he could understand a subject like suicide or murder. *Really*, I asked, *you think you understand a serial killer? Can you explain that to me?* He didn't answer. He didn't come to class. I reached out to the administrator to ask if she knew anything more about him. Before she responded I got an email from Luke telling me that he was going to be taking a leave of absence. He apologized for any inconvenience that he had caused; he said he was probably going to be kicked out. "You must be relieved," said a friend. But I wasn't. I was sad.

I was even more sad — incredulous, actually — when another student wrote about suicide. During the course of the semester, four out of eight students wrote about suicide. Two

wrote about attempts they had made themselves, the other two about friends, one of whom actually died. Something to be noted about these stories: there was nothing inert or passive about them. The despair that they expressed was vivid, intense, sometimes outraged in a focused political way, sometimes in a personal and flailing way. I had never experienced anything like it at this school—or any school—before. I asked the only other creative writing teacher in the department what his experiences were like that semester, and he said no suicide but lots of violence: siblings stabbing each other, a guy poisoning his mom, animal abuse.

Which actually seemed more normal to me — not for that school, but over the course of my almost thirty years of teaching. People can let it all hang out in writing classes and sometimes "it" is very unpleasant. Prior to this particular semester, the record for unpleasantness had been held by an undergrad class I taught in Texas in 1997. By 2022, the experience of that class had become a distant, grotesquely comic anecdote. But during my most recent semester, the memory of it came back a lot. The students in both classes — the one twenty-five years ago and the one last spring — were unusual as a group (in the Texas case you could say actually kooky). Both included a strange maybe/maybe not menacing guy obsessed with violence. Both had the feeling of a controlled surface under which something awful and incoherent was making itself felt, demanding to be known. The "strange guys" in question were very different in character, behavior, and talent (which in this context matters). The more essential differences were about time and culture: these differences say a great deal about what was once not only tolerated but embraced.

At the university in Texas in 1997, there was no concept of safe spaces regarding feelings, no idea of trigger warnings or

racial sensitivity. The school was good, with a highly regarded MFA program, but otherwise not prestigious or physically opulent; there was no special claim to happiness. I was there for three semesters, and in all three of those semesters it was typical for undergraduate students, especially males, to write stories about murder. It was also normal for students, especially females, to write very sexually explicit stories; I had one girl who wrote something that was basically porn. Since she was older than average and frankly not attractive, I was afraid people would make fun of her, but to my relief they read and discussed her efforts politely.

The thing about these stories was this: they were not disturbing to me or to anyone else, because, regardless of the content, readers sensed in them no malice or aggressive desire to shock. Plainly the writers just thought they were cool stories. In the class I am writing about, however, something different happened. There were the usual boys writing about murder; there was a woman in her fifties writing about rediscovering her sexuality (protagonist joyfully masturbates on lawn while husband looks on admiringly) and a thirty-something woman writing super-degrading sex stories (bisexual boy sodomizes heroine with a carrot while declaring "I can't believe I'm attracted to such an ugly girl!").

And then there was a guy named Don — large, silent, pumped up, bald, in early middle-age — who wrote exhaustively, convincingly, and in the first person, about a sadistic killer of women. To say that one could sense malice in this project would be an understatement. His "novel" was carefully thought out, detailed, and realistic. I use scare quotes because the thing could barely be called a novel, it being rather a series of murder episodes void of character or dramatic tension.

And the kids loved it. More specifically, the girls loved it.

I remember the boys looking down nervously while the girls enthused:

"I loved the part where he killed the middle-aged jogger! It was so specific, like the part where he stomped on her head and her eyeball started to come out? It was just better than when he killed the stripper because she fought back."

"I really loved it, but I thought it would be more *sexual* for him, and I wanted to know more about that" — meaty bald guy earnestly nodding and taking notes — "like before he kills the stripper, I thought it might be good to describe her dancing some more?"

I had actually prepared a response to Don's story that was meant to make the girls feel safe, and de-fang the narrative, and lead to a thoughtful discussion about the difficulty of writing well about violence. I don't remember the actual words of my planned response; instead I remember the students' comments, especially the following exchange:

She: "So how old is this guy?"

He: "I was twenty-five at the time."

Class: high, delighted laughter.

She: "So, Don have you ever really killed anyone?"

He: "No, but I've known someone who did."

She: "*Really*?"

I found the reaction very weird, but I decided to roll with it. This wasn't sheer passivity: as noted, my ethos at the time, something I had spent energy on in classes, was the idea that art was a place to explore feelings and acts that we would avoid in life. I made a point of periodically reminding kids that some of the greatest art is about terrible people doing terrible things. In 1997 this ethos was, if not mainstream, well-represented: *Natural Born Killers* had been made only a few years earlier, Marilyn Manson was claiming in a print interview (in

41

Spin, I believe) to have lit women's breast implants on fire, and Dennis Cooper had become famous for writing novels about men sexually abusing and killing boys. In truth, I disliked all of the "art" listed above, found it shallow, grating, and gross. I felt the same way about Don's writing. But it would have gone against my grain to tell him that he could not write it.

And write it he did, getting ever more titillated reactions from the class, which I sensed were also becoming more anxious. I was definitely becoming more anxious, even fearful. I was also angry — furious, actually. I felt he was, if not exactly hijacking the class, distorting its focus. If he wants to be uncensored, I thought, then I get to be uncensored too, free to use his story as an example of failed writing about violence, comparing it instructively to work by Cormac McCarthy and Genet, among others. In a way those comparisons were quite respectful, as they indicated that I took him seriously which, actually, I did. There *was* something genuine in his writing — horrible, but genuine.

Still, after the second workshop he came up to me and said, "I don't understand your criticism." I told him he could come to my office hours if he wanted to discuss it. He said, "You should've seen the first draft. In that version I kill everybody in the class including the teacher." I said, "That's very funny Don." He laughed.

I think that was when I went to the administration with copies of his story. The woman I spoke with recognized his name immediately. She said he was a strange guy: had been attending classes at the university for about ten years, changing his major with some frequency. Sometimes his grades were excellent, sometimes he just about flunked. He also changed his appearance radically; the last time she had seen him he was very thin, with shoulder-length hair, the opposite of how he

looked at that moment. I explained my concerns; I showed her a few pages of his writing and repeated what he had said to me after class. I asked her if I could kick him out; I hadn't decided that I wanted to do that, but I did want to know if it was an option. To my astonishment she informed me that no, it was not an option, not unless he "did something." She told me that a similar situation had occurred a few years back, not in the English department but in History. A student had made a threatening remark to a teacher, was expelled from the class and went on to successfully sue the school. I don't exactly remember who this administrator was in the hierarchy; now I wonder if I might have gotten a different response had I pursued the matter further.

But I didn't pursue it further. I gritted my teeth and hoped for the best, and well, at least something interesting happened. During our final thoughtful exploration of Don's violent narrative, the woman in her fifties, probably the least popular person in class, had finally had enough. "I don't know if I should say this," she ventured, "because I don't want to end up dead in a ditch somewhere"—tolerant laughter from the class—"but I am sick of this shit. This is like porn. This is like"— pounding the table with both fists—"FUCKING FUCKING FUCKING!" The kids rolled their eyes at the uncoolness; Don glared malevolently.

And I, finally, said the most sensible, possibly the only sensible, thing I said during the entire episode: "Margery raises a valid point. Writing like this creates fear. That is its purpose." In response, every single girl on one side of the room, girls who had been enthusiastically expressing their admiration for Don, turned to me with wide, childishly frightened eyes and mutely nodded their assent. It was astonishing, because just a moment earlier they had rolled their eyes as if what Margery

The Trials of the Young: A Semester

had said was beneath them. Their feelings of titillation and fear were that connected and that labile. The semester was almost over, but somehow the admission of this more natural response defused the tension in the class at least somewhat; reality had been asserted. I felt chastened that it had taken another student (albeit an older and more mature one) to get us there.

I left Texas shortly after the semester ended. Over the next twenty-five years or so, teaching at various universities, I had a few weird, even scary students, and a scattering of gruesome stories, including two about suicide. But I never encountered anything like the instability of that class in Texas, with its fascination for violence that almost amounted to *longing*, but with such terror underneath, it was almost as if the fascination was an attempt to neutralize the terror by becoming its friend. As time went on, I came to think of the experience as a relic of a particular time — louche, careless, and ridiculous. After tragedies such as the Virginia Tech massacre, the climate changed radically; I didn't think a guy like Don would be tolerated for two minutes on the happiest campus in America.

Luke, however, was another story. He was not kicked out; after only a few days in a hospital, he returned to class with the full strength of the mental health apparatus behind him. I was encouraged by the apparatus to cut him as much slack as possible, which I was willing to do, and he seemed genuinely to appreciate the forbearance. I asked if he thought he could turn in the story that he had scheduled for workshop; it would be tight and no one could switch places with him. He said he would try his best. He also let me know that the piece he was

working on described sexual situations and used words like "faggot." He did not mention that it was a first-person murder narrative, but since the murdered character was a rich white guy who had sexually exploited the college kid who killed him, I didn't expect anyone to be offended. And they weren't. They showed real goodwill. It helped that the story was good and the killer likeable (a subjective concept with absurdly high currency in college workshops), with "relatable" self-esteem issues. My main criticism of it was its uniformity of tone and the lack of the physical world rendered descriptively.

But that wasn't so bad, given that few of them seemed able to describe anything. It is harder than it seems to accurately and evocatively "see" the world through a character's eyes. It is even harder if your own eyes are so often fixed on a tiny screen that you barely register what is actually happening in front of you. I have seen people walk into traffic while scrolling on their phones. I have nearly walked off a sidewalk platform that suddenly came to an end because I was scrolling on my phone. I know, everyone knows, that traffic accidents have happened because of people screwing around on their phones.

But there are more subtle effects. Fifteen years ago, even ten years ago, when I took a long walk, either in the city or in the natural world, it was a kind of mediation that happened without my trying. I became wholly absorbed in what was around me, in textures and shapes, in the human imprint of buildings, sidewalks, backyards, grasses, trees, fungus, worn roads, crushed leaves. It was a profoundly calming and rejuvenating reminder of the greater world and my own animal connection with it. When I go for walk now, it is different: even if I only look at my phone once or twice, the experience, while still soothing, is not as deep. My consciousness is kept from full absorption in the physical world by its neurolog-

ical attunement to the electronic portal in my pocket — or back in my house, if I didn't even bring the thing with me. My bodily connection to the environment is thus weakened. And I cannot believe I am the only one being affected in this way.

I was surprised by the final suicide story. It was written by a seemingly temperate girl who had previously written subtle, quiet stories set in small towns; I wondered if — I hoped that — she had written this thing about a guy blowing his brains out in front of a girlfriend under the influence of her peers. But in a private conference she told me that she chose the subject because four people she had known in her small town had killed themselves or tried, and she was attempting to understand it. I asked her why she thought this had happened in her town. She replied that people now find it impossible to be satisfied with themselves, that no one thinks they are good enough, that girls in particular suffer profoundly over how their bodies look and cannot separate appearances from character. She named the usual suspects: social media, particularly Tik Tok and Instagram. We talked about how crippling this distorted mirroring can be, how ephemeral the sense of self can become when electronic images are more important than the actual human bodies around you.

Towards the end of the semester, Luke started missing classes; when he did show up, he looked and acted pretty out of it. He said he was so busy with other things that he completely forgot his final workshop date, and asked if he could turn something in after the semester ended. Annoyed by his attitude, I didn't respond right away. The next day he sent me a late reply to the email that I had sent over a month earlier asking him why he thought he could understand serial murderers. He agreed that you could not know the precise reasons that individuals kill, but felt that the abstract reasons

could be located in a nexus of power, domination, and control. He referred to a forensics expert who believes that murder can best be understood not by the killer's words, but through forensic analysis of crime scenes, scenes that this expert compares to a kind of art. In fact, this expert, according to Luke, thinks that serial killers' crimes "must be thought of as art." Luke seemed enchanted by this idea and expounded on it at length, choosing as his one specific example "young men who rape old women," women they often know. He went on to opine about what it meant when the hypothetical young men mutilated the hypothetical old women, before or after death, etc.

There was more to the email which was, actually, polite and earnest in tone, that is when it wasn't weird and desperate in tone. But the old lady rape/mutilation scenario was like an infuriating noise that obscured anything else. I wrote back (politely and earnestly) that I thought the forensic expert was wrong, that murder is in no way like art, and I dutifully expressed concern for his well-being — and then I reached out to the mental health apparatus. I had no idea what to expect, but I was surprised by what happened.

The woman with whom I spoke — I believe she was an assistant dean — seemed very thoughtful and kind. She said she had been keeping tabs on Luke — she had lunch with him just a few days ago — and she thought he was doing very well. She asked if I thought there was a "safety issue" for me or anyone else. I told her that I didn't think so, but that I had found his email disturbing. I described it to her; and I may have read from it, I don't recall. She said it wasn't really enough to act on. I understood — what kind of action would one take? — but I asked her if she would like me to send the email to her just so that she would have it. She said no, she preferred that I

not send it. I asked why. She said, "Because if I see it, I'll have to do something." I asked her what she would have to do. She said she would have to report it and then Luke would be hauled before some committee or other, which in her opinion would just make the situation worse. I could actually see the sense in this. But I hung up wondering, where in hell is the safe space around here? *I want a safe space!*

I also wondered why the only options were inaction or hauling the student before a committee. I wondered what would happen if he was instead required to sit down with the assistant dean and myself and answer certain questions. *What exactly are you thinking? Why are you writing to your old lady professor about young men raping old ladies with whom they are acquainted?* I didn't suggest this for the same reason that I didn't respond to that part of the email; I did not want to feed it. But I think a face-to-face sit-down that was not about a personal relationship between him and me but which involved university personnel — someone supportive — would have been different. It could have been exactly what I think students — not just students, but most people now — are missing: physical engagement requiring that you look the person to whom you are speaking in the eye.

Of course, he could have gamed his way through it. He could have felt trapped and walked out. He could have gone back to his dorm and jerked off thinking about me and the dean raping each other. Such a meeting could have made the whole situation weirder. But given how weird it already was, I wish that I had at least made the suggestion.

I emailed Luke to tell him that he could give me his final story late, approximately a week late, on the same date that I gave another student who needed a late date due to Covid. He wrote back saying that he didn't have time to do the story at

all, and that he didn't care if he got a D-, since he was probably going to drop out anyway. I replied that the option was there if he changed his mind and wished him the best going forward. It was a perfunctory response, but it was also sincere: as exasperating and disturbing as he was, Luke was plainly suffering. I was fed up, certainly, but in spite of myself I also had empathy for him because, unlike Don, I felt that he was trying, in his own twisted way, to work with something essential; murder and despair are not bugs but essential human features.

Fascination with murder and despair is also an essential human feature, and the young have been ever-famous for their raving misery. I spent much of my twenties feeling miserable; I thought of suicide fairly often. Two of my friends attempted it. The culture of that time — the 70's and early 80's — was a delirium of insistent belief in total happiness and an exuberant fixation on violence and stylized pain. I'm thinking of the ridiculous hipster cult of the serial killer, the ironic popularity of films such as *The Texas Chainsaw Massacre*, songs such as the Talking Heads' "Psycho Killer" or the Pretenders' "Tattooed Love Boys," the latter an ecstatic ode to gang rape. I'm thinking of the laugh riot racism of Archie Bunker, the comic nihilism of punk, and the transformative genius of Richard Pryor, who, in making comedy out of his own childhood abandonment, abuse, drug addiction, imprisonment, and racist consignment to a low-status social category, located the life-force behind the cruelty and anguish of America and repurposed the crap out of it. All of it was rude, and sometimes casually mean and self-hating on purpose; it was silly sometimes not on purpose; but it was finally healing. By allowing the ugliness in and acknowledging it as part of our humanity, that cultural moment created a kind of spaciousness, even balance. It was its own kind of corrective to a false story of virtue and niceness.

49

The Trials of the Young: A Semester

This privileging of darkness, I'm pretty sure, informed my Texas students' seemingly bizarre forbearance towards someone who actually frightened them.

But these days that breed of forbearance is looking like an indulgence that we cannot afford. These days, niceness is looking pretty damn good; these days, the darkness is just too overwhelming. Young children are being slaughtered in schools, and mass shootings of all description take place weekly for weeks at a stretch, while Congressional leaders treat gun ownership as sacred; black people — actually, white people too — are being murdered by the police; white nationalists are plotting a race war; lies and disinformation are everywhere; nuclear war in Europe suddenly looks possible; the West Coast is perpetually burning and Pakistan is catastrophically flooded, as the impending wave of hell nicknamed "climate change" rises over our heads. Yes, terrible things were happening in the 1980s, and terrible things have always been happening, but...not like this.

That young people, including my students, are reacting to all of the above with fear, anguish, and rage is appropriate, even rational. (The reaction makes particular sense in a cohort that has been encouraged to believe that happiness is an expected norm.) That they are fixating on problems they can control and maybe solve (the pronouncement of offending words, gender madness, "shitty" men, "problematic" assigned reading material) is understandable. That they want the safety — or the illusion of safety — provided by the corrective apparatus is also understandable. Only a fool would not crave safety in the face of what is happening now. But while the corrective apparatus is providing a measure of control, it cannot really provide safety. Metaphorically, it is making sure that the crusts are cut off all the sandwiches and that no dishes are left in the

50

sink while zombie hoards beat on the walls and stick their hands through the windows.

I would like to end with a ringing conclusion of some kind, or at least a helpful suggestion. But I'm afraid that I can't. The only thing I can say for sure is that the young deserve better. It has become standard to complain about how inept and spoiled the young are, but my students were in some ways pretty great. Their stories confronted not only suicide and violence but also dilemmas of artificial intelligence, gender animus, caring for a sick parent and sibling during the pandemic, the tenderness of asexual love, the awfulness of age, the timelessness of war — they were ambitious, humorous, and bright in the face of everything. But even if they weren't, they would deserve better. Not only them, not only the other young people whom I met at the colleges where I taught, but also the working-class kids and the poor kids who spend hours alone in apartments that their single mothers have forbidden them to leave because their neighborhoods are dangerous, possibly sitting glued to the same Instagram accounts that make their more privileged counterparts feel so inadequate they want to die. *All* of them deserve better. I wish to God that we knew how to give it to them.

SERGEI LEBEDEV

A Passenger on the Philosophers' Steamer

I am standing on the quay in the Polish city of Szczecin. The north wind from the Baltic Sea brings a thick gray drizzle that envelops the buildings and the port cranes, creating a sense of stagnant timelessness. A tugboat on the Oder River, almost hidden by the curtain of rain and turned into a fluid silhouette, gives a loud, long blast of its horn and vanishes in the fog. But the horn still sounds, an echo out of the past.

One hundred years ago this past fall, on September 30, 1922, a ship docked here. Szczecin was called Stettin then, and it belonged to Germany. The ship had come from Petrograd, the former St. Petersburg and future Leningrad: in terms of

names, it came from a city that no longer exists to another city that no longer exists. The *Oberbürgermeister Haken* carried a group of scholars, public and political figures, and intellectuals expelled by the Bolsheviks; among them were the philosophers Nikolai Berdayev and Semyon Frank, Sergei Trubetskoi and Boris Vysheslavtsev. In mid-November another ship, the *Preussen*, arrived with a second group of deportees; others were sent out through Black Sea ports or by railroad, totaling around 250 people, including family members.

Expulsion: the strange grace of forced salvation, a gesture of absurd magnanimity on the part of the ogre. Those who remained were executed, such as the philosopher Gustav Shpet. Or they died in the Gulag, like the philosopher Lev Karsavin, a passenger on the *Preussen* who settled in Lithuania, which was later seized by the Soviets. But then, in the year of the Treaty of Rapallo, the Bolsheviks needed international recognition, needed a bit of a good reputation, and this gave the deportees a chance to survive.

During the 1980s, in the period of glasnost, this expulsion in two boatloads of an eminent if unwanted intelligentsia was known as the Philosophers' Steamer, a pejorative name, a symbol of the Soviet battle against free thought, of an enforced brain drain, and the destruction of culture and intellectual power. Today history repeats itself: Russians with undesired minds are once more being forced to leave their country, essentially using the same routes — through the Baltic states or through Turkey. The term Philosophers' Steamer is current again, used by those leaving as if to stress the continuity of their flight with the earlier one, and by state media, mockingly, as if to say that the Philosophers' Steamer was a real loss, even though the Bolsheviks were right, while today there is no one to feel sorry about losing.

A Passenger on the Philosophers' Steamer

Well, there is a bitter paradox in that irony. Russia's war against Ukraine — an imperial and colonial war — has mercilessly exposed the fundamental flaw of Russian political culture. Russia has no intellectual tradition aimed at dismantling the imperial, chauvinist matrix of consciousness and its associated institutions. But the state, alas, easily adopts historical justifications for aggression, co-opting figures from seemingly opposing camps.

One figure whose words are now widely quoted to buttress the claim that Ukraine belongs to the "Russian world," descended on September 30, 1922 onto the quay of Stettin from the *Oberbürgermeister Haken*. He was thirty-nine. His name was Ivan Alexandrovich Ilyin.

Today he is Vladimir Putin's favorite philosopher.

He was my grandmother's uncle.

After a hundred years of exile, his remains rest in Russia, re-interred at Putin's request in Moscow's Donskoy Cemetery. I live in Berlin, where he lived in the 1920s and 1930s. He returned. I left.

He, who was once considered a dangerous criminal and a reactionary ideological foe by the Soviet state, is now posthumously recognized and honored. This comes from the people who grew up in the USSR, who were brought up to despise and hate the Whites — the imperialist defenders of Old Russia whom the communists despised. Their amazing omnivorousness — they now include even Ilyin in their pantheon — merely proves that today's Russian regime opportunistically combines disparate elements of historical trajectories dating back a century ago: the totalitarian Red left and the authoritarian, and potentially fascist, White, related to Franco's Spanish regime. How did that happen?

I will try to answer the question using Ilyin as the key — or

54

as the guide into my family history in its conjunction with the history of my country.

In my Soviet childhood we often went cross-country skiing in winter, sometimes taking the train to the Ilyinskaya station, where in the midst of dachas on Kolkhoznaya Street stood a snow-covered church in the Russian Gothic style, the crosses knocked down from its dark cupolas. If someone had told me that this station had been named in honor of my distant relative, a colonel engineer named Nikolai Ilyin, who had built this railroad and had owned the nearby estate that was now a sanatorium, and that Ivan Ilyin (Nikolai's nephew) had been married in this church in 1906, I would not have believed it. I would have been unable to assimilate something so enormous into my concept of our family history.

For in fact there was no history. The past was dangerous territory that one could visit only accompanied by adults; the doses of permitted chronicles were measured out scrupulously and cautiously; I was a child, lacking in experience, and I thought that this was how it had to be.

I did not question why the family narrative began in 1917, as if "before" was nonexistence, minus-time; my closest ancestors seemed to have been born in the year of the two revolutions. In the photos I was shown, for example, my great-grandfather Nikolai Lebedev appears already in uniform with a Red Army star on his cap. How had he lived before? Where had he served? I did not ask myself. I had mastered the skill of not asking. I learned that a part of the past had to remain opaque and that some people existed only nominally: all that was left of them was a name, perhaps a

55

photo, but we should take no interest in their fate.

Yet there was a place where the past came too close: the Vvedensky Cemetery in Moscow, locally known as the German cemetery, where my father's family was buried. The old cemetery was intended for the non-Orthodox, with monuments speaking a dozen tongues, where death and the next life had diverse styles. The monuments were different, resembling sprouts of Gothic church spires, and the language of the symbols was different, too: Roman and Celtic crosses, olive branches, palm branches, and most importantly, angels. In the Orthodox tradition, angels are rarely depicted sculpturally; but here there were dozens — marble, bronze, a nesting site for angels, a sanctuary of otherworldliness.

I always asked my parents why we Russians, we Lebedevs, had a family plot in the German cemetery. Who was memorialized by these worn limestone headstones? All of my paternal grandmother's brothers had died missing in action in the war and her sisters had starved to death in the blockade of Leningrad. But there, in the cemetery, nineteenth-century German graves faced those of wounded Soviet officers who had died at the nearby military hospital, creating the illusion that the dead were still fighting the war underground. My parents replied that my great-grandfather was a military surgeon and that the hospital had given him the plot. That was only a partial truth. In the 1980s, my grandmother had written her memoirs by hand: a heavy book in a homemade cover. I read it only in the 1990s, and discovered that the nameless, ostensibly unmarked limestone monuments on our plot were the graves of our ancestors. Our German ancestors. The feeling that I was German — just a tiny bit, a minuscule fraction — was almost unbearable.

Then, for the first time in probably seventy years, the

monuments were washed, removing the protective crust of dirt, moss, and lichen, and revealing the letters: Julius Schweikert von Stadion. Dr. Julius Schweikert von Stadion, a homeopath, came to Russia from Germany in 1832 as an apostle of alternative medicine. His apostolic mission failed and he ended his days as a naturopath, a physician at a Moscow residence for the widows of state officials. The building survived and we passed it amid the fluttering of red flags when my mother would take me to the May Day demonstrations.

Dr. Schweikert was married to a Frenchwoman and left behind eight daughters. They became governesses and at least three of them married the sons of the families. The youngest, Sophia, my great-grandmother, became Orthodox and entered the noble Rtishchev family, provincial military men who found glory in the Napoleonic wars. Her older sister, Karolina, became Ekaterina Yulyevna Ilyina, a lady from a respected and wealthy family. Thus the genealogical tree that joined us to Ilyin grew out of the stone root of the old limestone monument. It was no accident that one of Ilyin's pseudonyms was Julius Schweikert.

"As sometimes happens with Russian Germans, he had a jealous love for the Russian element. Unrequited love," the insightful memoirist and poet Yevgenia Gertsyk wrote about Ilyin.

My grandmother was not a Party member, yet she worked her entire life at *Politizdat*, the Central Committee's publishing house of political literature. She, whose relatives had been sent to the camps or killed by the Bolsheviks, had edited the complete works of Lenin. I still don't know how she said it — a complete detachment from her feelings? Conformism? A readiness for martyrdom?

She wrote memoirs of her life as an editor, or more accurately, as a censor. It was only when I became a journalist and an editor

myself that I could fully appreciate her artistry in dropping a line of thought or using omissions that did not look like omissions. She recounted so many impossibly new things about her former life that it was hard to catch that the most important thing was often not said, or was hidden in the details. She wrote her text not knowing that the Soviet Union would soon collapse and the archives would be partially opened; she wrote it for publication in the USSR, desperately trying to maintain the elusive balance between permitted and unpermitted.

Actually, I could only read her memoirs properly when electronic databases appeared with histories of people arrested and killed in the war. With their help I was able to decipher the omissions, and learn the fate of characters that she had hidden or had not known. I began working in the archives, reading investigations of the 1920s and 1930s that created a second layer for my grandmother's memoir, an expanded commentary that turned into an independent text. One of the cases was that of Igor Ilyin, Ivan's brother.

Here is what my grandmother had written about Ivan Ilyin and his brothers:

In the Ilyin family, Karolina's sons had differing views. Ivan, an idealist philosopher, emigrated before the war of 1914 to Italy, settling somewhere near the Vatican. Alexander and Igor were average, apolitical, and honest working lawyers. Alexei was a Bolshevik. He died before the revolution in a clash with police. Consequently, when people came to Karolina from the GPU state police to question her about her son the émigré, or to make them move into smaller quarters, or to requisition something, she would show them some letter of protection given to her as Alexei's mother. The visits usually

ended in apologies, and Lina peacefully lived out her life in the family of her son Igor, his wife Nina, and his grandson Svyatoslav.

Almost everything in that passage is either mistaken or misleading. Ivan, as we know, was expelled in 1922 on the Philosophers' Steamer. Alexei did not die in a skirmish with the police, but after returning from exile in Siberia in 1913. Lina did not live out her life peacefully in Igor's family.

The real stories of these three brothers — Alexei, Ivan, and Igor — reflect the essence of the historic crossroads that Russia faced on the eve of the 1917 revolution.

If not for the Bolshevik revolution in October 1917, Ivan Ilyin would probably have been a theoretical philosopher, a teacher specializing in Hegel. Roman Gul, the future émigré, journalist, and publisher, and a harsh critic of Ilyin, had been his student starting in 1914 in the law school of Moscow State University. "Tall, very thin, handsome in a Mephistophelian way (even though he was blond), I. A. was a brilliant lecturer and a brilliant scholar," Gul wrote in his memoirs.

Ilyin's father had an estate in the village of Bolshiye Polyany in Ryazan Province, a wealthy homestead with a dairy farm. The local peasants who were questioned in 1937 about Igor remembered his brother Ivan as well: he taught in Moscow at the university. After the revolution the estate was confiscated and Ilyin's mother and aunt were briefly arrested.

According to Yevgenia Gertsyk, in his youth Ilyin paid tribute to leftist ideas and even attended the congress of the Russian Social Democratic Labor Party in Finland in 1905. (It

was there that Lenin and Stalin first met.) Subsequently he withdrew from revolutionary ideas and studied Hegel. He was radicalized by the Civil War and the Red terror. He was arrested three times between 1917 and 1922 on suspicion of anti-Soviet activity. Once abroad, he grew close to the Russian All-Military Union (ROVS), the organization of the defeated White Army, and became its de facto chief ideologue.

The Whites had lost in part because they could not present a clear alternative to the Soviet project. Ilyin tried to replay the lost war, building an alternative in case there was a historical opportunity for revenge. In fact, in the 1920s and 1930s the confrontation between conditional "reds" and "whites" played out not only in Russia: in his programmatic article "On Russian Fascism" in 1927, Ilyin refers to the experience of Hungary, Germany, and Italy. Spain, of course, was to come later.

It seems as if Ilyin had been hypnotized by the success of those various European "whites." The Civil War left him with a visceral contempt for democracy, which had been unable to defend itself in Russia. (The Bolsheviks had easily routed the Provisional Government, Russia's transitional parliament.) He acquired an exalted, mystical love for rightwing dictatorships as a practical and effective measure against communism. Ilyin regarded the tyrants from Mussolini to Hitler as a natural and necessary phenomenon: a kind of protective reflex of European civilization against communist barbarism.

In Germany, Ilyin worked at the Russian Scholarly Institute in Berlin. In 1933, he welcomed the Nazi government and for a brief period headed the institute, until he was fired in 1934, because the Nazis were not impressed by his praise. With the composer Rachmaninoff's help, he emigrated in 1938 to Switzerland, where he died in 1954.

"I still have clippings of your pro-Hitler articles, where

you tell Russians not to look at Hitlerism 'with the eyes of Jews' and sing the praises of the movement!" Roman Gul wrote to him in a postwar letter. Ilyin never reexamined or criticized his pro-fascist views publicly. This was in part owed to the political instability of the post-revolutionary Russian community abroad. Emigrés frequently became collaborators. Some secretly worked for the Soviet political police, furnishing information or helping to organize kidnappings and political murders (two chairmen of ROVS, General Kutepov and General Miller, were kidnapped and killed by Kremlin agents in Paris in 1930 and 1937). Others preferred the embraces of the Gestapo, out of ideological or practical considerations; the collaboration of some of the Whites with Nazi Germany during World War II is an especially shameful chapter in the history of the movement.

With a German grandfather and French grandmother, Ilyin could have chosen a conditional European identity, but in the sixteen years that he lived in Germany he never met with his Schweikert relatives. He conspicuously cultivated his Russianness.

Ivan Ilyin never mentioned his older brother, Alexei: not in articles, not in correspondence. He buried him in silence. It was probably because Alexei Alexandrovich Ilyin, a successful graduate of the legal and historical-philological departments of Moscow State University, was a Bolshevik. He had not been a newspaper-writing theorist or a brief fellow traveler like Ivan in his youth; he was a man of action, an agitator and a fighter.

In 1925, when Ivan was living in exile in Berlin, his mother Ekaterina (Karolina) was petitioning for a pension in Moscow,

on the grounds that she was the mother of the Soviet hero Alexei. She appended references to her petition from "Old Bolsheviks" who had joined the party before the first Russian revolution, before 1905, and who had known him personally under his party pseudonym Ermil Ivanovich.

In 1905, on orders from the Moscow Committee of Bolsheviks, Alexei Ilyin organized a militant brigade, around sixty men, on the Moscow-Kazan railroad (this is the line that includes Ilyinskaya station and the Bykovo Estate that had belonged to the family then), which took part in an armed uprising in December. The brigade fought and killed police and gendarmes; Alexei was wounded on the night of December 2. He had to live illegally, hiding out, but with the assistance of lawyers he managed to help the escape of members of his brigade who had been arrested. He was himself arrested in 1907 and exiled to Siberia.

Released in 1910, Alexei returned to his underground work, providing money and documents to people fleeing police surveillance (they could get passport booklets at his father's estate in Bolshiye Polyany, in Ryazan), and died, probably of typhus, in 1913, when Ivan Ilyin returned from two years studying in European universities to begin teaching at Moscow State University. In 1925, Fedor Konurovsky, one of the members of the railroad military brigade who obtained fake documents from Ilyin, wrote: "I ask the commission to give Ekaterina Ilyina an appropriate personal pension as the mother of a true ideological revolutionary who bore all the hardships of the first revolution."

This is the classic plot of socialist realist writing: brother against brother, one for the old, one for the new. Ivan crossed Alexei out of his life but he could not have forgotten him, which made his crusade against Bolshevism something very

personal: one recognizes that level of passion that is reserved for fighting estranged family, not strangers.

The brigade members apparently felt obliged to their late patron who laid the foundation for their political biographies. Not many survived the 1920s and 1930s. The highest-ranking member, Petr Kameron, a fighter in 1905 and Alexei's secretary in the 1910s when he returned to legal work, subsequently became chairman of revolutionary tribunals that executed the surrendered leaders of anti-Soviet rebels in Central Asia, a member of the Military Collegium of the Supreme Court of the USSR, and chairman of the legal collegium on criminal cases of the Supreme Court (in 1938!) — a man who by virtue of the positions he held had blood up to his elbows, and visited Ekaterina Ilyina until her death in 1942.

He visited and probably helped her; he certainly supported the petition for a pension in 1925. But his loyalty was strictly bounded and extended only to Alexei's mother, not to his brothers.

⤳≋

There was Ivan, there was Alexei, and there was Igor.

I obtained the case file on Igor Ilyin at the archives in Moscow when the Covid pandemic began in Russia. The guard at the door put a thermometer gun to my forehead; the number 37 flashed in the frame. History is filled with black humor: Igor Ilyin was shot to death in 1937 in Butuvo, outside Moscow.

"The equipment is acting up," said the guard, and let me in.

Opening the file, I was certain that I would find that Igor was arrested and executed for being Ivan's brother, accused of kinship with an expelled enemy of the Soviet state. The reality was simpler and more horrifying. The NKVD did not bother

making up a connection between the brothers, even though Igor honestly stated at his first interrogation that his brother had been expelled by the secret police in 1922. Igor was killed by "the apartment issue," which had "ruined Muscovites," as Bulgakov wrote in *The Master and Margarita*. A lawyer like his brothers, Igor found a loophole in Soviet legislation and managed to save the Ilyin apartment in Moscow from so-called "compaction," that is, having the authorities move in strangers and turn it into a communal flat. He arranged for official recognition that there were three family units, not one, in the apartment: he and his wife, his mother-in-law, and his mother Ekaterina Yulyevna. Juridically, that is, they were all strangers and not a family, and therefore they required three norms of living space. The equation was almost perfect, but there was just one little room of five square meters left over, and to keep strangers from moving in Igor and his wife found a distant relative who needed housing.

The relative found a boyfriend, and the two of them sued the Ilyins, demanding an entire full-fledged room. The court refused, but it also denied Igor's countersuit to evict the lodgers. In 1937, the lodgers got their revenge, denouncing Igor for alleged anti-Soviet agitation. To prove that Igor hid his "class nature," a witness stated, "Ilyin was two-faced. He was not short of money, at parties in his house he wore a tailcoat and patent leather slippers, while he went to work in torn shoes."

Igor was arrested on September 20, 1937, and after several interrogations in which the investigator scrupulously detailed how many cows, seeders, and hired workers there were at the Bolshiye Polyany estate in order to establish Ilyin's landowning background, he was shot on November 19.

Stalin died in the spring of 1953, Ivan Ilyin died in Zollikon, Switzerland, on December 21, 1954, and in the

summer of 1956, after Khruschev's "thaw" began, Igor's wife Nina Ilyin applied to the USSR Prosecutor's Office for Igor's rehabilitation. The KGB, established two years earlier, issued her a false certificate that Igor had perished from pneumonia on March 10, 1943 in a camp; such certificates were common practice, because despite the thaw, it was strictly forbidden to disclose the true cause of death — execution by firing squad, decreed by military field "troikas" according to a list. The KGB falsified death certificates on a mass scale, assigning arbitrary dates, usually belonging to the war period, so as to hide one death in the mass of others, and inventing "natural causes" of death — pneumonia, typhoid, heart attack.

In Nina's correspondence with the USSR Prosecutor's Office and the KGB, she referred to Alexei's revolutionary past as evidence of the family's trustworthiness and, naturally, never mentioned the exiled Ivan. The KGB itself did establish this connection: it dug out the archive files on his arrests by the Cheka during the Civil War and the operational materials regarding the emigré ROVS, whose ideologist Ivan was. But it left this information without consequences.

In the same correspondence, a striking detail emerges, an ominous metaphor for the entire era. Nina wrote that shortly after Igor's arrest in 1937, an NKVD officer, one of those who arrested him, moved into his room, embezzling all his belongings. And, as she testified, in 1956 he was still living there: whenever the door to the room opened, she saw their belongings and furniture, appropriated by the murderer. Twenty years of living in the same apartment with the person who led your husband to his death, not being able to move out, and seeing the murderer sitting on the murdered man's chairs, covering himself with his blanket — is there a stronger image of helplessness, of forced humiliation before evil, which

was the school that the whole country went through in those years? It was the school of cohabitation with executioners. And today the heirs of those Chekists who destroyed Igor are praising and promoting his brother Ivan.

In the 1990s, when the culture of the Russian emigré world was undergoing a revival and previously banned books were being published in enormous quantities, Ivan Ilyin was overshadowed by the other passengers on the Philosophers' Steamer, such as Berdayev, Trubetskoy, and Lossky. At the same time, the White Movement underwent a renaissance of its own with the publication of memoirs of military leaders, a fashion for "white" songs, and an idealization of the Whites as heroes to counterbalance the instant devaluation of the pantheon of Soviet heroes. And Ivan Ilyin appeared stage front in Russian history for a second time, with the ascendance of Vladimir Putin. The philosopher was forcibly "resurrected."

They say that Putin was chosen to be Yeltsin's successor through an interesting bit of casting — that several candidates were considered. We can imagine that Ilyin was selected for state-sponsored rehabilitation in a similar way. We must bear in mind that the surveillance of Russian anti-Soviet emigrés, of the ROVS, was a specific field of professional activity inside the KGB. The secret police was a loyal reader of their works and kept track of them — the case file on Igor Ilyin, for example, shows that a manhunt was begun in 1950 to determine Ivan Ilyin's location. The Chekists in Putin's circle could choose easily among the subjects of their operational interests.

In 2005, on Putin's orders, the remains of two Russian emigrés were reburied at the Donskoy cemetery in Moscow:

Ivan Ilyin, whose grave had been in Switzerland, and General Anton Denikin, the commander-in-chief of the White Army, whose remains were in the United States. The selection of these figures, these silent cadavers, as the foundation of the new state ideology was highly symbolic. Denikin embodied the Whites' main slogan, "Russia United and Inseparable," which opposed the Bolshevik policies that accepted secession of former Russian Empire territories, such as Finland or Poland. The White slogan became the official name of Putin's governing party, United Russia, in December 2003.

And Ilyin was selected for the role of ideologist and prophet. Putinism does not have a holy text, a main book: it is enormously eclectic and malleable, wherein lies its strength. But Putin's regime needed a higher genealogy and a conservative political language with pretensions to being a "philosophy" and a "historical tradition." Ilyin's lofty chauvinism did the trick. Yet Ilyin did not set the course of Russian history; on the contrary, Russian history moved in the direction of his ideas. After an extreme swing to the left, the pendulum swung to the right.

After 1991, whether its residents were aware of it or not, Russia faced the question of what it was, whether the Russian Federation would have real or merely nominal content. The answer came in 1994 with the First Chechen War, and the absolute rejection of the possibility of any declaration of independence by Chechnya from Russian control. The greatest fear of the 1990s was the fear that the country would come apart at the seams and devolve into an anarchy of national republics. Yeltsin exploited those fears to justify the war in Chechnya and the strengthening of the secret services.

If we summarize Ilyin's views on the post-Bolshevik future of Russia, and he was one of the few emigré minds who made such forecasts, the following picture emerges: there will be

chaos, an imaginary triumph of "freedom" and "democracy," which will be used by Russia's enemies to try to dismember it, to play the separatist card. The only salvation will lie in a strong leader, a dictator surrounded by an entourage of supporters capable of "patriotic arbitrariness" and of curbing the centrifugal tendencies at the price of civil liberties.

No wonder that for Putin and his Chekist gang Ilyin's writings looked like prophecy. After all, from the very beginning they created an image of Putin as the savior of Russia from the chaos of "democracy," using the old Soviet myth of the security services as the knights of the revolution with a shield and a sword on their emblem, a formidable echelon of selfless guardians of the state. It was no coincidence that Nikolai Patrushev, the head of the Federal Security Service, described the security services as the "new nobility," while Viktor Cherkesov, a former KGB officer who used to harass dissidents and was now chief of the Federal Drug Control Service, wrote a sensational article in 2007 about the "Chekist hook" that snagged Russia as it was falling into the abyss, and presented the security services as a warrior caste inspired by Chekism.

Putin and his cronies, in other words, have recognized themselves in Ilyin's texts: in their own eyes, he had given them, the gray men from the secret services, people with a professional habit of anonymity and conspiracy, the desired historical respectability, and enhanced it with a touch of mysticism. Ilyin was their authority that justified their innate hostility to democracy through the narrative of the messianic inevitability of dictatorship. It — that is, Putinism — is not so much a detailed ideology as a mythological frame, a hallowed image that creates a sacralized identity.

Yet how did people from the Soviet security services, for whom Ilyin in particular and White emigres in general were bitter enemies, accept these views and ideas?

As a Soviet child I had a book called *Reds and Whites*. It was a collection of illustrated stories built on a deliberate and extreme dichotomy: the Reds were always heroes, the Whites were always villains and cowards. As a child I believed in this Manichean opposition completely. When I was a teenager, however, the picture was reversed; I can't remember exactly when the transition happened; it was as if the inversion occurred all by itself. Now the Whites were noble knights and the Reds were lowly brigands. I think I breathed in the new version from the air of the age.

There is a historical misunderstanding in the overarching opposition between Reds and Whites that was caused by the savage and irreconcilable Civil War. It may be said that the division into Reds and Whites was, in a sense, conventional. The Red Army included as many former tsarist officers as the White Army. This shared collaboration, this common element, proves that the Reds and the Whites — not as a matter of ideology but of historical fact — were not at all as distinct from each other as the myths insist. The old imperial elite found a place on both sides, for the simple reason that both sides were imperialists — only of different varieties.

Still, there were significant doctrinal differences that bear upon events of the present day. White views on the national question were more conservative than those of the Reds, whereas the Soviets used the discourse of internationalism and opposed, at least rhetorically, the old imperial chauvinism. The Whites, with their idea of "one and indivisible Russia," with their physiological metaphor for empire as (in the words of Ilyin) a "natural organism," emphatically denied emancipation for the

69

A Passenger on the Philosophers' Steamer

nationalities that made up the country. This is much closer to Vladimir Putin's views, and to the practical needs of his regime: it was not for nothing that in a recent speech he reproached Lenin for "creating Ukraine," that is, allowing it to appear on the map as a political entity, albeit within the Soviet system.

It is therefore not surprising that Putin, who for propaganda purposes has declared the "denazification" of Ukraine to be the goal of the war, at the same time quotes Ilyin, an apologist for fascist dictatorships, who occasionally wrote words of praise for Hitler. It is a kind of involuntary confession. It exposes the nature of the Putin regime, built on the cult of the leader and on the racist idea of the national superiority of Russians.

In the village of Bolshiye Polyany, the ancestral home of the Ilyins, neither the farmstead nor the church remains. The farmstead was looted after a series of requisitions and finally destroyed; the church was closed, used as a warehouse, and demolished in the 1930s. The last priest, Father Nikolai Sokolov, was arrested in 1937 and shot in Butovo a month before Igor Ilyin.

Ruins and oblivion are always regrettable. Yet the history of the posthumous resuscitation of Ivan Ilyin's texts and thoughts suggests that some crypts need to be opened carefully, or not at all. It is necessary to reexamine the lost heritage critically, with ethical and historical awareness — otherwise one can end up reviving something like a virus from the past against which we have lost all immunity.

KAREN SOLIE

The Bluebird

Each old thing in its new place must prove its worth yet again.
Dust is disturbed, having made itself at home

among what former tenants have found wanting.
A friend brings a gift to brighten my room then leaves

a cruel word to move in with me.
Good and bad don't always line up opposite.

Nearing the end of an earlier journey, I'd stopped at
a roadside motel whose name ameliorated

the experience of staying there
not at all. Around it rose the dark forest of the Shield country,

endless differentiation appearing undifferentiated
though one had the sense of something slowly,

unrelentingly, being taken apart within.
Ahead lay great happiness, great sorrow, and it seems to me now

a decision was to be made between them then,
though the conditions for such a choice did not exist.

The past is so poorly constructed, so unsuited to the living
that must be done, we might wish for the forest to grow up
 around it —

but knowledge can't replace the facts
of its acquisition. They continue to perform

in the events they set in motion
whether we remember them or not.

I was hungry, it was very late. Across the four lanes
northbound, southbound, divided in my memory

by a waist-high steel girder, a gas station convenience store's
neon still awake. Seldom a break in the traffic,

footbridge miles away. To get to the other side quickly
meant taking your life in your hands.

Bad Landscape

I can't make it right. Not the shadow lying on the snow,
not the snow, terrain sloping crudely toward
the poor outcome of a structure neither representational
nor abstract, and the sketched-out town beyond
ill-proportioned, depthless, and basic. There isn't any sense
of an *origin*, of what Plato called the lower soul,
to animate what's lacking with the spark of its
remainder. Better than this were the products of
 by-numbers kits
hanging on the walls of my grandparents' home —
bird dogs, game birds —
that knew what they were, spoke at least of a steady hand
and subsequent pride in the completion of a task
for its own sake. Above the roar of the new gas furnace
installed in the living room, as there was no basement,
the volume of the brand new color television
we were warned as children we sat too close to. Blue light
of the programs on our faces, some of the outside
was already on the inside, the radiation we were told
was everywhere — power lines, radios, fluorescent light,
 telephones —
in all of what emitted that low hum of menace
we had no other word for.

Just Say The Word

I signed the papers, and the world created
out of all I have destroyed honestly doesn't look
much different. A grainy whitish wind blows in

from Little Poland, and a human form in heavy gear
screams unanswerable questions into traffic. Questions,
while inadequate to truth, are faithful to sorrow, so fair enough.

Inside the padlocked gates of Leal Rental
a grey pitbull shining like a nail could be the silver dog Argyreos
and the sun on whose mat of light he sleeps

the gold dog Khryseos
forged by the god of metalworkers, masons, to guard
 the threshold
of King Alcinous' legendary hospitality

and its founding principles of order.
I have only ever wanted to see things as they are. Until I did,
 and experience
narrowed to a fact impossible to turn around in.

Now everything I need to fix it myself resides with Leal Rental,
in whose yard a conclave of articulated boom lifts
achieves the conspiratorial symmetry of

The Calling of St. Matthew or The Supper at Emmaus,
raised basket platforms attentive, inclined in the manner
 that indicates
listening, in their posture a hint of nature

aspiring to weightlessness
and the eye follows the Baroque Diagonal into a sky of vivid,
 structural
blue, premodern and cloudless.

The craftsman never blames his tools
yet is only as good as they are, which leads
to some uncertainty as to where the fault lies. Argyreos of Leal,

allow me to linger, as I too am between jobs.
A condo development, blocks-long, modular, pre-*démodé*
has sailed in from an increasingly unaffordable future

flying the skull and crossbones of Tridel Communities
but it is pleasant to lose oneself on Dupont Street
in the comforting presence of factory colors,

thoughts on their feet high in the thought-baskets
awaiting direction, though from up here
it looks like the whole thing is going to have to come down.

Antelope

They appear out of nowhere as if they know where
 all the doors are
between our dimension and where they are called
by their true name, are not the last survivors
of their evolutionary niche. Familiarity does not diminish
their curiosity, and even the great plain aligned to the grid
 of monoculture
is not monotony, which is painful to them,
but a regularity that gives value to change, and WTF is that
walking on the road? How annoying
to be drawn into another pointless encounter with me,
 they huff,
brandish their hardware and run,
entering a sublimity of motion that is like the sublimity
 of night.
A Gothic spirit loves accumulation, magic, a big-block V8
in a Dodge Polara, they feel inside themselves the soul of
 an extra gear
that will lift them from the earth, from the prairie's hall
of mirrors, the fences whitetail leap
that they must scrabble under, tearing their cloaks on
 the barbs.
Only their old-timey machinery can digest the rough forbs.
The jackrabbit finds peace in his evening hollow, deer fold
 themselves

in elegant anxiety upon their grass couches, but the
 pronghorn's eye
has been widened in some back-room occult transaction and
 he haunts
the open country, a candle in the five-mile corridor of
 his tenfold vision,
sleeping minutes at a time under the shaking rings of Saturn.

No One's Gonna Love You More Than I Do

The bars long since closed
when the shouting begins down the street

Open the fucking door

and all my old selves leap to their feet
sick with adrenaline

rushing to the point of convergence
where things go bad.

With repetitive force the voice assumes
a switched-on hydraulic quality

a monotony allowing other aspects to intrude
the spring night at its coolest just before dawn

smell of sea fog and late-blooming lilac
air like the air of a memoir

and in the morning a neighbor comments
you'd think there was a war on.

There's a war on.

Or is this just another Friday
in an ongoing Easter of blame and remorse

you in your dark house down the street
creeping through the hallway with your phone

which lights up begins to ring

and your destiny on the threshold knocking.
Indeed. Pounding.

MICHAEL WALZER

On Moral Concern

You shall surely reprove your fellow.

LEVITICUS 19:17

A long time ago, I spent a couple of years reading Calvinist theology and Puritan treatises and sermons (for a doctoral dissertation and a first book).I don't remember many lines, but one has stuck in my mind. The Reverend Richard Baxter, author of *The Holy Commonwealth*, described in 1659 how he maintained moral discipline in his Kidderminster parish "with the help of the godly people of the place who thirsted after the salvation of their neighbors and were in private my assistants." I have thought a lot about those godly people and their peculiar "thirst." There aren't all that many men and women so strongly engaged with their neighbors' moral well-being,

but such people do appear frequently in history. We find them again and again "thirsting" after the salvation, or the rectitude, or the piety, or the political commitment, or the ideological correctness, of their neighbors. These people possess what I want to call "moral concern." (There may be a better term.) They are driven not only to worry about the moral rightness or wrongness of other people, but also to express their worry — sometimes only in private, but sometimes also in public.

Moral concern is my subject here. You might call it nosiness, but that word carries negative connotations that are too quick for my purpose. Anyway, moral concern goes far beyond nosiness: it is not just an interest in other people's beliefs and behaviors or a readiness to talk about them; it is also an eagerness to improve both. Moral concern is different from compassion, which describes a sympathetic engagement with other people's physical or material well-being — with those who are sick or poor, or victims of flood or fire, or orphans, battered wives, disabled men and women. And moral concern is also different from solidarity, which requires a commitment to help people who are oppressed or, better, who are resisting oppression, fighting for national liberation or racial or gender equality. Solidarity leads political activists to join the fight, to support the goals of the fighters. By contrast, the agents of moral concern are not committed to the goals of other people; they have their own goals. They have a very firm idea about what my moral condition should be, which probably isn't my own idea. They thirst after my religious or political salvation. And their thirst may well challenge or even override my self-concern and my liberty.

I haven't looked for help in the analysis of moral concern from the philosophical psychologists, who may well have a lot to say about these thirsty people. I am a political theorist, and I

will consider the role that morally concerned men and women have played in political history. In line with contemporary practice, I should say up front that I believe that moral concern often leads to moral over-reach, and that it has had perverse effects, especially in left politics, but not only there. At the same time, isn't there something admirable about people who think not only about themselves but also about others, who worry about you and me?

This concern for the morality of others begins, I think, with parental solicitude — and also parental anxiety. Both of these are no doubt salutary: we want parents to worry about the morality of their children and to work hard to teach them right and wrong — not only how to behave but how to think about how to behave. But doing and not doing comes first, as in this injunction to parents from a seventeenth-century Puritan text on "family government."

> The young child which lieth in the cradle [is] both
> wayward and full of affections: and though his body
> be but small, yet he hath a great heart, and is altogether
> inclined to evil.... If this sparkle be suffered to increase,
> it will rage over and burn down the whole house. For
> we are changed and become good not by birth, but
> by education.... Therefore parents must be wary and
> circumspect, that they never smile or laugh at any words
> or deeds of their children done lewdly...naughtily,
> wantonly...they must correct and sharply reprove their
> children for saying or doing ill....

A high level of moral concern would be required to follow this disciplinary program. It is, perhaps, an extreme example — or, better, given the politics of seventeenth-century Puritanism, a revolutionary example. It calls on parents to enforce a radical discipline. And it tells us two important things about how concern for the morality of others works when it becomes a project. The project begins with the conviction that the men and women about whom we are concerned are in a bad state — perhaps not utterly depraved as in Puritan theology, but seriously wrongheaded — religiously, politically, ideologically incorrect. We are "wary" about the others, sure that they need help. And then our concern is expressed in clear-cut ways: we help the others by sharp reproval and firm correction.

But if we move from children to neighbors, the concern will have to be expressed a little less sharply. Parents have full control over their children; when children "run wild," family government has failed. Our neighbors, by contrast, are free men and women, so when we exercise our moral concern we are likely to engage in some version of what the Puritans called "brotherly admonition." Still, admonition is shadowed by the hope for something stronger, something more like firm correction. Early seventeenth-century Puritans might urge their neighbors not to attend frivolous and wanton performances of Shakespeare's plays, but their ultimate goal was to close the theaters. So moral concern reaches toward politics — from family government to the government of the state, from admonition to coercion.

The most obvious example of official moral concern is state censorship: subversive or licentious books and magazines are banned in order to make sure that no one in the country gets subversive, dissident, or wanton ideas. Subversive ideas are not only politically dangerous, they are also commonly

taken by the censors to be morally wrong. They undermine or deny divinely established authority or legitimate government or the will of the People (expressed by their Maximal Leader) or the course of History (represented by the ideological vanguard). Or they encourage sexually illicit conduct and undermine family values.

People in power are naturally concerned with the beliefs and the commitments of their subjects; they seek obedience to moral codes and political regulations, but what is more important, they seek *willing* obedience. They want to shape the moral habits of the men and women they rule. Censorship is always politically instrumental, but it is often driven also by a genuine abhorrence of the ideas that are censored. The powerful few want the others to recognize the rightness of sexual propriety, political authority, and their own subjection.

The missionaries who followed colonial armies, thirsting after the salvation of the natives, provide an example of semi-official moral concern. They could not do their godly work without the background support of the army, and they also serve to advance the colonialist cause — or its pretended moral purpose: to civilize the benighted peoples of Africa, say, or wherever the armies conquered.

Yet moral concern can also be expressed in more egalitarian ways and, again, the Puritans had the right words: "holy watching," a phrase that describes a strong form of mutual surveillance, the work of men and women who feel themselves to be each other's equals and are wary about each other's moral condition. They watch one another, looking for signs of false beliefs, licentious affections, or deviant commitments — eager to offer correction. We see this most clearly in revolutionary situations, when moral concern comes into its own, when it is released from the everyday inhibitions of

courtesy and respect for privacy. The Puritan revolution of the 1640s and 1650s is certainly not the first example of this release (think of Savonarola's Florence), but it is first in the modern history of revolution and perhaps the best known— since the Puritans were, after all, puritanical. They aimed to create the holy commonwealth described by Richard Baxter, and "brotherly admonition" and "holy watching" were instrumental to that creation. As were their "experience meetings": these were special sessions of Puritan congregations held "to resolve doubts," to listen to accusations and confessions from the members, and to reprimand and punish sinners.

Experience meetings were convened not only in England but also by Calvinists in Geneva and by the French Huguenots; they are the direct ancestor of the Jacobin *épuration* or purification. "This tribunal of conscience," one of the revolutionaries wrote, "is terrible indeed, but it is also just. The most practiced audacity, the most refined hypocrisy, disappeared before the watchful and penetrating eyes of the sound members of the society..." The "sound members" are the French version of Baxter's "godly people," and like godliness, soundness indicated a highly developed moral concern. The "sound members" thirsted after the secular salvation of their fellows, looking to turn unsound citizens into "patriots" (rather than Protestant saints). I am not sure whether revolutions produce people like that or people like that produce revolutions. Perhaps the people are always there, waiting for political opportunity.

Moral concern at such moments reaches very far into the life of the sinful or unpatriotic others. The chief aim of the Jacobin militants was, of course, to uncover and correct royalist sentiments, to overcome habits of submission and deference. But the work of correction extended much further — to something very much like Puritan morality. Here is

Crane Brinton's summary description of what went on in provincial Jacobin clubs, from his classic book *The Anatomy of Revolution*. The members, the sound members, resolved that

Citizen W should keep his dog tied up; citizen X should be made to marry the girl; citizen Y should be admonished against outbursts of temper; rich citizen Z should be made to give his consent to the marriage of his daughter to a poor but honest Jacobin youth in good standing with the club.

You might say that the revolutionaries had taken over the role assigned by Jean-Jacques Rousseau to gossiping women. "How many public scandals," he wrote, "are prevented for fear of these severe observers?" But Rousseau was describing an ordinary form of social pressure: the gossiping women, and men, too, enforced the local mores, whatever they were. The Jacobins were a moral vanguard, and their "watchful and penetrating eyes" looked toward a new morality directed against the libertinism of the aristocracy — very much like what came to be called "bourgeois," but with a sharper edge.

The American Revolution, less radical, perhaps, than the others, produced a similar mix of political principle and everyday puritanism. Here is one of the revolutionaries worrying about the appropriate language of patriots, warning his readers against the use of titles other than "mister" (the American equivalent of the French "citizen"): we must "adopt the simple language of free government... Let us leave the titles of excellency and honorable to the abandoned servants of a tyrant King." And here is the Baltimore Committee in 1775 recommending that the people of the county "not attend the approaching fair because of its tendency to encourage horse-racing, gaming, drunkenness, and other dissipation." You need stalwart men and women to fight a revolution, and stalwart men and women want everyone to be like them.

The great defender of revolutionary stalwartness is Vladimir Lenin; he far outdoes the Baltimore Committee, and he will serve as my last historical example of moral concern. Consider his complaint against his fellow revolutionaries: he criticized their "slovenliness...carelessness, untidiness, unpunctuality, nervous haste, the inclination to substitute discussion for action, talk for work, the inclination to undertake everything under the sun without finishing anything." I think of this as a Bolshevik version of Max Weber's Protestant ethic, focused not on economic but political activity. Lenin wants comrades who will work hard, stay the course, and win in the end. And since the end, a communist society, is critically important for all humanity, this is a moral demand. It is accompanied by a recognizably puritanical morality — a morality not often associated with the Bolsheviks. Indeed, the first years of the Russian revolution were a time of sexual liberation. Unintended liberation, however: here is Lenin preaching against free love:

> Dissoluteness in sexual life is bourgeois; [it] is a
> phenomenon of decay. The proletariat is a rising class;
> it needs clarity, clarity, and again clarity. And so I repeat,
> no weakening, no waste, no destruction of forces.

The Bolsheviks took a more obvious interest in the opinions of their fellow revolutionaries; they guarded against ideological deviation. As with the Jacobin purification, that was the first purpose of the Soviet purge. But the comrades — like all the saints, citizens, misters, and patriots — were also concerned with moral well-being in the largest sense. The first soviets, Brinton reports, took steps to ban prostitution and gambling and to shut down

night life. Members of the vanguard were supposed to be something like secular ascetics, all their energy focused on revolutionary action. Or, maybe, not all, since much of their energy had to be focused on ensuring the commitment and zeal, the asceticism, of the others. You might call that the "holy watching" of "severe observers." Again, it challenges the everyday freedom of ordinary men and women.

I collected these quotations years go for a particular academic purpose: to demonstrate the similarity of revolutionary endeavor across decades and centuries, from Puritans to Bolsheviks (and Maoists). My reason for invoking them here is different. They came to mind when I was reading the articles and listening to the lectures of contemporary American "abolitionists," good leftists who want to abolish the police. There are many more people who want to defund the police, which is the reformist version, of the argument; but the abolitionists are more like revolutionaries. Indeed, one of their excited supporters wrote of the burning of the Minneapolis Police Department's Third Precinct building in late 2020 that "fire became the technology of abolition." Most of the time, though, the idea is more theoretical. Abolitionists are inspired (those of them who read political theory) by the writings of men such as Rousseau and Lenin. In *The Social Contract*, Rousseau argued for the replacement of professional politicians, professional soldiers, and professional teachers by activist citizens. The citizens of the republic, he wrote, "do everything for themselves." Today's abolitionists simply extend the argument to police work; they want the citizens to exercise their moral concern and police themselves — and each other. Perhaps they

are following Lenin's lead, who claimed — in *State and Revolution*, written in the tense months of August and September, 1917 — that in a communist society there would be "no police force distinct from the people."

That last sentence requires interpretation. I don't think it means that there will be fewer police, but rather that there will be many more: all the people policing all the people. "Control," Lenin goes on to say, "will really become universal, general, national, and there will be no way of getting away from it." This is a call for the mass mobilization of moral concern. Now consider these milder sentences written in 2019 in a (very optimistic) book describing America's democratic socialist future:

> A society governed by socialist values would likely make the conditions for transformative justice [that is, abolition] more possible. If people were regularly engaged in democratic processes at their jobs and in their neighborhoods, and had their basic needs provided for, they would be more able and willing to sustain relationships of mutual accountability.

Would they? How much moral energy would be necessary to "sustain" the accountability of everyone to everyone else? How much time would it take — time left over from our engagement in "democratic processes" at work and in our neighborhoods? And what about political participation in state politics? We would all be endlessly active. Remember the remark attributed to Oscar Wilde: "Socialism would take too many evenings." And mornings and afternoons, too. Of course, one of the objects of the moral concern of active citizens would be the reluctance of the others: the laziness, the dissipation, the frivolity of too many men and women. Here

is a hard question: do people have what Paul Lafargue, Marx's son-in-law, famously called "the right to be lazy"?

Many of the abolitionists don't imagine that everyone's moral concern will be at work all the time. They favor committee work, groups of neighbors taking turns at "watching" and "admonishing" the others. I don't know whether committee members would be elected or chosen by lot; the lottery is more likely given the democratic presumption that everyone is morally concerned. But everyone isn't equally concerned: the distinction that the Jacobins made between "sound" and "unsound" citizens will still need to be made. Some committees will work at reproof and correction much harder and more efficiently than others, and conscientious citizens will run to the less active committees with urgent information about wayward neighbors and strong suggestions for correction.

I am not sure how the neighborhood committees would deal with violent crime. Abolitionists suggest that there would be lessons in de-escalation and "harm reduction" for committee members, but the hope must lie with prevention — that the secular versions of "holy watching" will detect violent tendencies early on. And then neighbors will admonish and counsel potential criminals. White collar crime also isn't much discussed in the literature of abolition. Over time, perhaps, committee members will acquire the computational skills necessary to detect financial finagling and bank fraud — or the abolitionists may believe that over time the work of morally capable men and women will produce a virtuous society where illegal profit will not be much of a temptation.

You can see that I am a skeptic here, though I understand what drives the abolitionists. I recognize the reality of police violence — in the United States, of police racism. It is certainly

possible that civilian review boards, a kind of neighborhood committee, might improve police accountability and reform police behavior. And for that we would need morally concerned citizens, though not as many as abolition would require. For now, anyway, I prefer to be watched by men and women in uniform rather than by anonymous neighbors, so that I can watch the people watching me. But that doesn't necessarily mean that I do not value the moral concern of (some of) my neighbors.

"The ardent revolutionaries," Brinton writes, "overshoot the mark and make life unbearable for their neighbors." Right, and this point can be made more theoretically: the radical exercise of moral concern comes into conflict with individual liberty (as we have seen again and again), and ordinary men and women rise up to defend their rights. These presumably include the right to ignore the moral condition of their neighbors and the right to refuse the work of "holy watching" — the right to be lazy. The "struggle sessions" of the Chinese cultural revolution — the most recent, and I hope the last, of the "experience meetings" — suggest how important those rights are. A terrified man or woman, a "bourgeois element," is seated on a stool in the middle of a circle of neighbors and (former) friends who take turns denouncing and "reeducating" him or her. The denunciations are fierce because every person in the circle knows that they could be the next target. Their moral concern is not voluntary, and that is probably true of many participants in "holy watching" and "purification." Eventually the overreach produces "thermidor" — the month on the French revolutionary calendar when the Jacobin terror ended.

It is now the name for all such endings.

What one of the American abolitionists calls "community accountability practices" would not, if they ever became common, constitute terrorism. but I believe that they, too, would produce their own "thermidor." Morally concerned men and women, even in this gentler version, irritate their fellows, who are not, however, unconcerned. We are all capable of moral concern; it is — the egalitarians are right — a universal endowment. But most of us confine the exercise of our concern to a few relatives and friends — and the form that it takes is argument. We try to convince the people we live with and talk with to adopt what we take to be the right moral and political opinions. Sometimes we extend the argument into the wider world; we join demonstrations, carry signs, circulate petitions, write articles; we want to convince our fellow citizens of some new doctrine — but without coercing or terrorizing them. Think of the campaign in the United States for gay marriage: the aim was not only to change the law, though that was obviously important, but also to change the way Americans imagine gay life. Moral concern, in this democratically constrained version is a critical agency of social change.

This is my own version of moral concern — and the version of my political friends. We are concerned about the moral commitments of other people, and we try to set them right if we think them wrong. Do we "thirst" after their rightness? Well, we hope for it. But we don't watch them closely; surveillance isn't our style. We don't denounce them at neighborhood meetings; we don't report their incorrect opinions to a local

committee; we respect their independence. So, are we missing something important, a necessary fierceness in the exercise of our concern?

Today in the United States, we are in the midst of a very fierce outburst of moral concern. You see it everywhere, and it is expressed in political acts that lie somewhere between argument and terror. Large numbers of Americans are committed, rightly, to a historical reckoning with slavery and racism. The immediate subjects of this reckoning are long dead (George Washington, Thomas Jefferson), which is helpful in avoiding terrorism. So we, or, better, some of us, tear down the statues and the reputations of men (it's mostly men) who were once greatly admired. And we call for a rewriting of our national history — a rewriting especially of the textbooks with which that history is taught in our schools. Much of this is to the good; we argue about these issues because we are concerned about the moral views of our fellow citizens — and of our children. But this concern has now reached to practices that look too much like "holy watching" and firm correction.

The official version of moral concern, as I suggested early on, is state censorship, and we now have in America an avalanche of laws, proposed laws, and local regulations aimed at controlling the textbooks that can be used and the things that teachers can say in classrooms around the country — and the books allowed in school and public libraries. Rightwing politicians play to parental worries about what children are being taught. The parents have a right to worry; the political play is crudely manipulative. Some of the politicians probably do believe that teaching about racism in American history will exacerbate the tensions of identity politics. They aim to minimize the tensions — and also to maintain the racial status quo and uphold the

reputation (and secure the votes) of the white majority. Moral concern mixes with political ambition, as I suppose it also does in revolutionary situations. And, as the freedom of ordinary men and women is endangered in those situations, so the freedom of teachers and students is in danger today.

The unofficial version of moral concern today is closer to my own intellectual home; it is most visible in the American academy. What is called "cancel culture" is the work of students and professors determined to make sure that no opinions that differ from theirs are defended in the classroom or by visiting lecturers. The offending opinions mostly have to do with race and gender, and they are often expressed inadvertently by good liberals or stalwart conservatives who aren't sufficiently sensitive to, or sufficiently sympathetic to, what is now politically correct. So visiting lectures are called off because the speaker's opinions might corrupt the listening students; or individual students are harassed by their fellows who judge them already corrupted; and teachers are disciplined by administrators because they have said something that their "sound" students believe is morally or politically dangerous. I don't think that the aim of the cancelations, the harassment, and the discipline is to reform the immediate subject, the harassed individual, but rather to save the others. The concern is with the moral well-being or, better, the ideological correctness, of the greater number, but perhaps there is also the hope of "re-educating" wrong-headed individuals. On some campuses, the politics has gotten nasty; I hope for thermidor.

We are also seeing a peculiarly American version of all this. Cancel culture has been sentimentalized. The result is visible now in our high schools as well as in our universities: we must beware of hurting the feelings of our students. The official censors in some American states have decided, for example,

that focusing too much on the oppression of black people might hurt the feelings of white kids, identified as the heirs of the oppressors. That is an actual argument, perhaps politically effective, but not, in my opinion, morally serious. The unofficial censors, by contrast, worry that any teacher of American history who doesn't manage to express the full awfulness of slavery will hurt the feelings of black kids. The kids are, in effect, urged to consider themselves victims or possible victims, sensitive to real and imagined slights — rather than intellectually alert and angry students. At such moments, one longs for an activist moral concern. The black kids need to stand up and argue. Everyone else, too, as in my last example.

Some years ago, a group of Jewish students from a nearby university came to see me. They were very upset: the Black Students Association had invited Louis Farrakhan to campus, the leader of the Nation of Islam, a vicious anti-Semite. (He never came: he insisted on armed bodyguards, and the university authorities thankfully said no.) The Jewish kids were offended by the invitation; their feelings were hurt. What should they do? I didn't have the phrase, but what I told them amounted to a plea for the exercise of moral concern. This was a moment for argument: the students had to explain and 95 expose Farrakhan's lies; they had to engage with their fellow students, challenge their prejudices, try to change their minds. What was needed was brotherly admonition. There was no danger of over-reach here; the campus Jews had no coercive power. But they should have been concerned not with their own feelings but with the moral condition, the political beliefs, of the others. And in these immediate circumstances, they had no right to be lazy.

DAVID A. BELL

The Triumph of Anti-Politics

Nearly all observers today agree that politics in the United States is in a dire, poisoned state. For this they generally blame "polarization" — and the other political camp. In fact, the reasons are both more complicated and more distressing, and cannot be blamed on any single political grouping.

In his pre-pandemic best-seller *Enlightenment Now*, the psychologist Steven Pinker hailed the worldwide spread of democracy, but not in the glowing terms one might have expected from such a zealous celebrant of modernity. Democracy, he allowed, was preferable to tyranny, and offered people "the freedom to complain." But Pinker cautioned

against what he called "a civics-class idealization of democracy in which an informed populace deliberates about the common good and carefully selects leaders who carry out their preference." And he continued: "By that standard, the number of democracies in the world is zero in the past, zero in the present, and almost certainly zero in the future."

The statement was obviously true on one level, as even a glance at the "deliberation" in our media will show; but it is appallingly superficial on others. Of course, ideal democracy has never existed on the planet, and probably never will. If a key element of democracy is a universal adult right to vote, then the United States has approached democratic status only since the 1960s. But recognizing the fact that reality always falls grievously short of the ideal hardly invalidates the ideal. Pinker, having dismissed the ideal as impossible to realize, and having taken a condescending swipe at "the shallowness and incoherence of people's political beliefs," argued instead for a "minimalist conception of democracy" that leaves public policy, as much as possible, in the hands of trained experts. "To make public discourse more rational," he insisted, "issues should be depoliticized as much as is feasible..." In other words, circumscribe democracy through technocracy.

The problem with this vision is that the most important problems in public life cannot be depoliticized, because most of them do not have a single correct solution that "rational" analysis alone can determine. Men and women see different solutions, depending on their political principles and moral values, which they hold in good faith. The fact that many of them do not approach the subject in the way an Ivy League professor such as Pinker (or I) would do hardly invalidates those principles and values. Would the creation of a national healthcare system in the United States represent a step towards

The Triumph of Anti-Politics

improving the public good or an intrusion upon individual freedoms? Should we tolerate enormous inequalities of wealth so long as the poorest among us see their incomes rise? How do we balance the right to defend our homes against the dangers posed by the easy availability of deadly weapons? I have strong opinions on all these issues, and will vote for politicians who share my opinions and promise to act on them. But I recognize that others have different opinions, not because they are mistaken or ignorant or evil, but because they bring different principles and values to bear on the problems. I recognize that however strongly I feel about these issues, they do not belong beyond the bounds of political debate, with only one point of view about them permissible.

Throughout modern history, the greatest threat to democracy has come precisely from the rejection of these assumptions — indeed, of politics itself — and the consequent denial of political legitimacy to those who fail to share one's own views on key issues. Historians have devoted intensive study to the long and painful process by which the notion of a "legitimate opposition" gained acceptance in the United States and other democratic societies and the way in which it has frequently threatened to erode. Democratic politics, tending as it so often does towards hyperbole and demagoguery, all too easily generates claims about the wanton stupidity, immorality, or just plain evil of one's political opponents.

But it is not casual hyperbole, insincerely employed and quickly forgotten, that most seriously threatens democratic societies. It is when the denial of legitimate difference congeals into a system of thought, into an ideology which admits only one permissible point of view on key issues, and judges all who fail to share this point of view as *ipso facto* beyond the pale. Such systems of thought, reinforced through constant

repetition in media and by political party organizations, have led again and again not only to the erosion of democratic societies, but to their destruction.

If politics has reached such a dire state in America today, the reason is not simply "polarization," but the toxic growth of several distinct and distinctly contemporary patterns of thought that all tend to undermine the idea that citizens with different political principles and moral values can collectively deliberate on the public good. They span the political spectrum, and can be labeled, in turn, technocracy, market fundamentalism, Trumpian populism, and wokeness. Each seeks to place key issues in American life beyond the bounds of political debate, subject to only one permissible point of view, and they can, for this reason, be called antipolitical. They represent not so much a contribution to politics as a contribution to its destruction. They all have historical roots but have all evolved into new and powerful forms in recent years. Partly this is because the contemporary media environment groups like-minded people into hermetic "silos" with such dreadful efficiency, making it far more difficult to submit extreme and insistently repeated claims to even the most elementary forms of objective verification. Partly it is because these different patterns of thought have shown a surprising capacity to influence and interact with each other.

Over the past few years, this shriveling of politics has principally spurred attention among left intellectuals broadly associated with the Sanders wing of the Democratic Party. It has been a leitmotif in the work of the influential legal scholar and historian Samuel Moyn, who has done much to popularize the concept of "antipolitics," which he drew from a constellation of thinkers including the French intellectual Pierre Rosanvallon. Early in his career, Moyn used the term

to characterize the human rights crusades that took shape in the 1970's, charging them with circumscribing the field of action of progressive social movements and siphoning off their energy. More recently he has emerged as a strong critic of the authority now held by the American Supreme Court. This year, the legal scholar Jedediah Purdy picked up on the idea of "antipolitics" in a forceful book-length essay entitled *Two Cheers for Politics*. Purdy claims that "our institutional and intellectual life, our culture and common sense, are made up substantially of warnings against politics and appeals to alternative sources of order: enduring constitutions, sober norms, the wisdom of markets."

Valuable as they are, these works suffer from two problems. First, they tend to conflate the antipolitical and the antidemocratic. Purdy, for instance, holds up James Madison and Alexis de Tocqueville as "antipolitical" figures because of their strong and well-known beliefs about the dangers of untrammeled democracy. But if we think of politics as a society's collective deliberation about the common good, Madison and Tocqueville were in no sense antipolitical. They both believed passionately in what they called political liberty, and ferociously opposed systems in which a central authority decides all public matters. They both advocated what they considered a healthy, lively political life — but with safeguards against the sort of democratic excesses that they believed led to despotism, political collapse, and civil war. This makes them conservative and anti-egalitarian in certain senses, and perhaps "antidemocratic" as well — but hardly antipolitical.

Secondly, the "antipolitical" intellectuals tend to see the threat coming almost entirely from phenomena that they associate with the political right and center. They are not

wrong in what they see happening there, but they err in characterizing the rise of antipolitics as a simple question of right versus left, with the left as the heroic opposition. The left, too, is culpable for a form of antipolitics — associated with the overly broad but unavoidable term wokeness — which has become increasingly influential in American society, and whose anti-liberal excesses figures such as Moyn and Purdy have been reluctant to criticize. The existence of this left antipolitics undercuts the comforting idea that what we are living through in the United States today is essentially another chapter in the long conflict between "the people" and "the elites," and that a more successful version of Occupy or the Sanders campaign might bring about the people's triumph.

In fact, the existence of the left version of antipolitics suggests strongly that something different, and more dire is at work in America today. It suggests that the antipolitical impulses at work in America do not principally derive from a fear of politics, from a terror among elites of a powerful and unruly *demos*. To the contrary, they derive from a more generalized fear of the weakness and failure of politics, in what very quickly becomes a self-fulfilling prophecy.

The different versions of antipolitics circulating in the United States today have this in common: they all share the conviction that the political system has failed in its most important task. For technocrats, this task is to manage the fearsomely complex challenges of postindustrial society. For the market fundamentalists, it is to safeguard the sacrosanct market system from interference by disruptive interest groups. For the Trumpian populists, it is to protect real Americans, genuine Americans, from being ruined by elites and overrun by strangers who share neither their heritage nor their values. And for the

"woke," it is to protect historically oppressed groups from further oppression and to repair the damage done to them.

All these groups, of course, have their agendas and their material interests. But all have managed to craft enormously resonant messages, which our deranged media and social media systems, as they distill outrage into profit with such dreadful efficiency, amplify all too powerfully. Worse, the endless, strident competition between these groups, their demonization of each other, and the resulting political paralysis only reinforces the fundamental perception, common to all of them and grounded all too firmly in reality, that our political system is indeed failing, in what amounts to a truly mephitic positive feedback loop. In the resulting political universe, even crises on the scale of the financial collapse of 2008 and the pandemic have failed to bring about genuine change, or the popular movement that figures such as Purdy hoped might crystallize.

This is, then, the paradox of our politics today: while nearly everyone believes that our political system has failed, there also seems to be a broad consensus that the only possible response is to restrict the space of the political yet further, to place ever-larger swathes of American life beyond the reach of collective deliberation and decision-making, to further reduce the space of toleration and patience without which no responsible politics can flourish. What one group sees as the protection of sacrosanct rights, others perceive as a tyrannical imposition. In the process, all sense of a common political community and a "legitimate opposition" evaporates, and, as Foucault once put it, riffing on Clausewitz, politics becomes the continuation of war by other means.

The first pattern of antipolitical thought at work in the United States today is the one that Steven Pinker exemplifies, namely technocracy. Today technocracy is often seen, mistakenly, as a cause whose time is past. When the sociologist Daniel Bell (my father) analyzed it in 1973 in *The Coming of Post-Industrial Society*, the term summoned up images of white-coated experts working for government bureaucracies, think tanks, and large corporations such as IBM. These experts would provide direction to elected officials as they proceeded with large-scale social and economic planning. The Communist bloc, with its massive, petrified bureaucracies and its "new class" of officials and experts, seemed to offer a hypertrophied version of this sort of technocracy, while Western European institutions such as France's ultra-powerful École Nationale d'Administration and Commissariat Général du Plan offered a more compelling example. Today, the appeal of central planning has ebbed almost entirely away across most of the planet. In the sector of the economy which Bell and others saw as the principal arena for the triumph of the technocrats — information technology — the future did not belong to armies of white-coated company men from IBM and MIT. Instead, it was seized by swaggering upstart capitalists possessed, in many cases, of a distinctly counter-cultural vibe.

But as the success of Pinker's work suggests, technocracy still has powerful resonance for many Americans. One relatively benign version has found a home in the more cautious and wonky precincts of the Democratic party, among officeholders who aim to achieve their goals as much as possible through technical and regulatory changes, thereby avoiding risky political conflict. Barack Obama, for all the soaring rhetoric of his campaigns, gravitated towards these in-the-weeds policies, for instance by preferring the technical

fixes of the Dodd-Frank Act to any serious attempt to restructure the financial sector in the wake of the financial crisis of 2007-2008, and by failing to include a public option in Obamacare. His influential advisor Cass Sunstein, an authority on the theory and practice of regulation, has advocated the pursuit of reform through the careful and expertly designed "nudging" of public behavior in a wide variety of arenas. He has called this "libertarian paternalism." As Moyn has put it, "When it comes to government helping people achieve fulfillment, Sunstein insists that technocrats must rule. With a palpable sense of relief, he has confessed that he finds politics mostly a distraction and not so much about contending collective visions of the good life or about calling out the oppression that claims to expertise can mask." To be sure, technocrats are not valueless or amoral people, and Sunstein's regulatory work has been motivated by a concern for the good life, and the safe life, and the fair life.

A far more threatening form of technocracy has found advocates among American oligarchs, notably the former business partners Peter Thiel and Elon Musk. Few things do more to breed arrogant over-confidence than the acquisition of a multi-billion-dollar fortune, and these men believe they know far better than any career politician — not to mention the American public — how to solve the country's problems. To be sure, while they share the older technocrats' conviction that governance can be approached like an engineering problem, they utterly reject the idea that doing so requires a large bureaucracy. They generally have a strong libertarian streak (Thiel backed Ron Paul's presidential campaigns and has a weakness for Ayn Rand) and they take the tech startup as their organizational model: lean, fast-moving, and totally in thrall to a dominant, charismatic leader. As Sam

Adler-Bell wrote in a recent profile of Thiel's protégé, Arizona Republican Senate candidate Blake Masters: "the Thielites want to see the government hollowed out... They wish to unseat the liberal technocratic elite only so they can install their own: a more competent, compliant and unfettered one."

It is hard to know what actual political program these technocratic oligarchs envision, beyond wrecking the federal government and freeing companies like theirs from regulation and taxes. In their hunger for domination and their scorn for competition, in their sense of themselves as a priesthood that exclusively understands the esoteric needs of the hour, in their economic power and their political unaccountability, they are dangerous. Whatever is wrong with OSHA, it is not an apparatus of conquest and control. Unlike the technocrats of the 1960's, and the Democratic wonks of our day, the new technocratic vision of the future comes in considerable part from science fiction, meaning that it depends on technologies that do not yet exist and may never do so, such as Elon Musk's comic-book "hyperloop" that would solve traffic congestion problems by whisking passengers in capsules through depressurized underground tubes at seven hundred miles per hour. Most significantly, these would-be technologist-kings have a visceral contempt for democracy. Curtis Yarvin, an addled blogger admired by both Thiel and Masters, has openly suggested that a Big Tech CEO should become an American Caesar, ruling dictatorially.

Free market fundamentalism also has a very long pedigree. Nineteenth-century classical liberals promoted the notion that unfettered markets provided the most efficient way to distrib-

ute goods and services for maximum overall social benefit. Markets, they argued, were naturally self-organizing and self-regulating, and could therefore safely be left to operate in their own natural state of equilibrium, without interference from the state. This vision, just as much as the technocratic one, was of a society free from politics — a society where ordinary people had little or no recourse to political action. Pierre Rosanvallon has argued that when taken to an extreme, it can leave ordinary people almost as vulnerable to forces beyond their control as totalitarianism does. The historian Jacob Soll has demonstrated in his important book *Free Market: The History of an Idea* that the vision also broke with the long tradition of market thought that prevailed from antiquity through the eighteenth century, up to and including the work of Adam Smith. For all his paeans to the operations of the free market, Smith firmly believed that it could only operate within structures and limits devised and maintained by powerful states.

In more recent decades, free market fundamentalism has radicalized. Acolytes of Milton Friedman press for keeping government entirely out of economic life, and indeed for limiting government as much as possible to military and police functions. They insist that the need for maximum possible economic growth justifies high levels of economic inequality, coupled with powerful restraints upon taxation, regulation, economic planning, nationalization, and labor organization. So-called neoliberals put particular emphasis on freeing the financial sector of the economy from regulation, on allowing "creative destruction" and "disruption," and on insisting that free trade needs to operate on a global level, with goods and services freely circulating at maximum possible speed and volume across the world.

Unlike technocracy, free market fundamentalism no

longer has high-profile gurus like Thiel, Musk, or Pinker. The days of Friedman and Hayek — or, on a comically lower intellectual level, Ayn Rand and Arthur Laffer — are past. As Soll notes, Friedman himself had maximum visibility and overt political influence in the 1980's, the era of Ronald Reagan and Margaret Thatcher. Yet the doctrine retains enormous strength through such institutions as the U.S. Chamber of Commerce, and the corporations and hedge funds who ensure through their donations that the congressional Republican party — and much of the Democratic delegation as well — remain committed to the gospel of tax cuts. Just this past August, congressional Republicans without a single exception voted against President Biden's Inflation Reduction Act, with its 15% minimum tax for large corporations, while Democratic Senator Kyrsten Sinema engineered the preservation of the low tax provision most cherished by hedge fund managers (the "carried interest" provision). As noted, advocates of the new, stripped down, oligarchic version of technocracy, who often have libertarian backgrounds, can sound surprisingly like free market fundamentalists. Steven Pinker cheers on globalization and rails against what he calls "collectivization, centralized control, government monopolies and suffocating permit bureaucracies." He does so despite the fact that allowing markets to operate without political oversight blatantly contradicts the idea of allocating goods and services according to technocratic expertise.

With Trumpian populists, the shriveling of politics takes a very different form. In their rhetoric, at least, Donald Trump and his many acolytes have no sympathy either for technocrats

or free market fundamentalists. They excoriate and ridicule both as foolish, greedy, unpatriotic, and out-of-touch elites. They rage against "globalists" and globalization, lax immigration policies, and free market agreements such as NAFTA that allowed American corporations to move jobs beyond our borders. They scorn government experts as corrupt members of the "administrative state" or the "deep state" or the "swamp." They call for returning political power to "the people" in terms sometimes quite close to those of the Sanders left and the Occupy movement.

The catch, of course, is in how they define "the people." Few of them go as far as the tiresome reactionary Ann Coulter, who in 2016 proposed limiting the vote to people with four U.S.-born grandparents (a measure that would exclude Donald Trump, among others). But Trump himself often speaks of "real" Americans (or, in a recent fundraising letter, "REAL Americans.") He takes care not to define them in ethnic terms, but his rhetoric leaves little doubt as to whom he takes them to be. Real Americans are proudly patriotic, overtly religious, and live outside large cities ("Democrat cities," otherwise known as hellholes). They believe in the Second Amendment but not in climate change, they eat meat but not tofu, they own pickup trucks rather than Priuses. They are white. They are convinced that Trump won the 2020 election, and that Joe Biden and the Democrats are consciously plotting to "destroy" the country. Some even believe that Biden and Nancy Pelosi are kidnapping children to drink their blood. Only these Americans, in the Trumpian populist view, really deserve to have a voice in deliberations about the common good.

This idea would be noxious enough if it remained mainly a rhetorical cudgel. But in recent years, figures across the American right have drawn on it to forge what amounts to

a coherent and powerful anti-democratic ideology. They increasingly insist, buoyed by the work of intellectuals from quasi-authoritarian places such as the Claremont Institute, and drawing on James Madison's famous distinction, that America is a republic and not a democracy. They therefore justify (as somehow "republican") the gerrymandering of congressional seats, the hugely disproportionate power granted small rural states in the Senate, and the way the Electoral College gives presidential candidates the ability to win elections while losing the popular vote. They also tout the "great replacement theory" according to which elites are consciously trying to replace "real Americans" with immigrants who do not share their values, thereby casting doubt on the legitimacy of naturalized citizenship for millions. They shower praise on Hungary's Viktor Orbán, and the thuggish tactics he has used to muzzle a free judiciary and a free press. Most dangerously, they press the notion that Republican-controlled state legislatures have the right to override the popular vote. In short, the Trumpian populists believe in politics, but only for themselves, only when it produces the outcome they prefer.

In practice, over the past several decades, adherents of these three currents of antipolitical American thought have been able to make common cause, united by a shared hatred of liberal elites and government regulation. The Republican party, Newt Gingrich in 1994 through the Tea Party in 2009 to Donald Trump in 2016, proved brilliantly adept at muffling blatant contradictions and gathering oligarchic technocrats, libertarian financiers, and ethnonationalist populists into a coalition that might not command a majority of the citizenry

but could nonetheless win national elections. And so, despite the contradictions, it is easy to imagine these three currents as a single malign antipolitical force — "the right" — that a properly energized and powerful left, committed to real democracy, should have the ability to overcome. It is easy to imagine antipolitics as a left-right issue.

But unfortunately the left has its own version of antipolitics, commonly known as wokeness. It is a system of thought that stems from the best of intentions, namely to protect historically oppressed groups from further oppression and to redress the wrongs done to them. But it, too, ends up placing numerous issues outside the realm of the political, in this case by defining them as moral absolutes and matters of inalienable right.

To be sure, many left-wing intellectuals whom I would call antipolitical insist loudly on the inescapably "political" nature of their work. But their definition of the political is very different from the one I have offered here. Heavily influenced by Foucault, they see modern societies as fundamentally shaped by hegemonic belief systems grounded in exclusion (of women, people of color, sexual minorities). "Political" work consists of exposing and challenging these belief systems and the exclusionary practices that stem from them. From this point of view, collective deliberation about the public good is only authentic and productive when it takes place among those who have done the work of exposing and challenging. The only legitimate political discourse is dissent. In practice, it is a stance that makes the vast arena of legitimate political activity — both in terms of who can participate, and which issues they can debate — vanishingly small.

It goes without saying that many key issues facing the United States today do indeed involve moral absolutes and inalienable rights. Critics of wokeness often forget that things

which they themselves may now place in the "inalienable right" category — the right of gays to marry, for instance — not so long ago struck most Americans as wild progressive overreach. There are many issues which clearly should not be left up to a popular vote. Imagine, for instance, the results of a referendum on interracial marriage held in the United States in 1920. But as figures such as Madison and Tocqueville so keenly argued, political deliberation need not always be, indeed should not always be, democratic, in the sense of reflecting the conscious and immediate desires of the majority. Particularly on issues of great moral import, such deliberation may more properly involve relatively undemocratic institutions such as the courts. But it should still, in some sense, derive from national institutions and express the will, as mediated notably through the constitution, of the nation as a whole.

Wokeness, on the other hand, puts the definition of what qualifies as a moral absolute and a matter of inalienable right solely in the hands of the oppressed group itself, and its members' claims as to what constitutes harm. They are, in this view, epistemologically privileged: their experiences allow them to see further and understand more. If members of the group declare that even the discussion of an issue causes them pain, or places them in danger, others must defer to them, and set that issue beyond the bounds of deliberation entirely. This notion of deference does not just disquiet thinkers on the right. The philosopher Olúfémi O. Táíwò, an eloquent advocate of reparations to African Americans, wisely writes in his book *Elite Capture*: "For those who defer, the habit can supercharge moral cowardice. The norms provide social cover for the abdication of responsibility: it displaces onto individual heroes, a hero class, or a mythicized past the work that is ours to do now in the present."

111

The Triumph of Anti-Politics

For the moment, wokeness of this sort has the greatest influence in universities and in the elite media. Even publishing, as opposed to writing, an article deemed harmful or dangerous — for instance, Senator Tom Cotton's *New York Times* op-ed "Send in the Troops" in response to the protests following the killing of George Floyd — can cost editors their jobs. Despite the hysterical charges emanating from the right, wokeness has not taken control of public primary and secondary education (except perhaps in a handful of schools and districts), or large corporations, or the military. But it has had an undeniable effect in the Democratic party. In heavily blue districts and states — and in presidential primaries — candidates run serious risks if they express heterodox opinions on a variety of issues, including issues that large majorities of Americans consider vexed and difficult, such as abortion, or affirmative action, or hormone therapy for prepubescent children diagnosed with gender dysphoria. Invoking the notions of a moral absolute and inalienable rights, as defined by those who have suffered or may suffer harm, activists rule out political deliberation on these issues by the community — a group of people with many life experiences — as a whole. And so politics shrivels.

All of these corrosive systems of thought have long pedigrees. Antipolitics is nothing new. But in recent years it has become far more powerful, and far more of a threat to American democracy, for several reasons. First and foremost is the current media environment, in which populism and wokeness in particular thrive. Today a handful of huge corporations derive enormous profits from keeping their users in a state of

permanent outrage, driving them to click on link after link, to take in hour after hour of cable news and radio talk, and to see and hear endless advertisements carefully tailored to their demographic profile and their previous spending. Read about the Democratic "regime" and its latest dictatorial power grab! (and click here to learn about a miraculous new performance enhancer). Hear about the latest racist outrage from a right-wing professor! (and let us tell you about our new line of electric cars). And so on and so forth. Algorithms are carefully defined and refined to keep audiences exposed to the same sites and programs, depriving them of other sources of information and constantly reinforcing the same one-sided narratives. Twitter especially was designed for outbursts and invective and slogans and conformity; in a political order that depends on thoughtfulness, Twitter is most often the technology of thoughtlessness. Moreover, Trumpian populism and wokeness have long served as each other's favorite targets. Trumpistas like nothing more than to warn against woke bogeymen such as "Critical Race Theory" and transgender bathrooms. The woke, with more reason, see Trumpian populism as a thin veil draped over the cause of white supremacy.

Free market fundamentalists and technocrats do not participate in the new media environment in the same way, and as already noted, in both cases the heyday of their overt political influence is long past. But globalization, and the dynamics of what much of the left continues to call, with a rather touchingly naïve hope, "late-stage capitalism," ensures that market forces themselves remain as powerful as ever, generating money that floods the political system to protect against profit-reducing regulation. And Wall Street plutocrats have found few better investments than political campaigns. A few million directed to the right senators can save billions

in tax breaks. Meanwhile, the new breed of technocrats has proven all too skillful in forging alliances with the Trumpian populists and harnessing the populist resentments that breed so furiously online.

In fact, the different streams of thought feed off each other in often unexpected ways. As already noted, free market fundamentalists, Trumpian populists, and the new technocrats share a hostility towards most of the federal government as it currently exists, and eagerly collaborate in attacking it. The woke and the Trumpian populists, meanwhile, both direct much of their ire towards an allegedly oppressive elite establishment, even if the first sees it as embodying white supremacy, and the second, a cosmopolitan liberal contempt for ordinary people. And while the Trumpian populists fixate on border security and traditional sexual values, libertarian market fundamentalists and the woke are both more likely to celebrate sexual difference and to support increased migration. More generally, as Jedediah Purdy comments, many progressives agree with market fundamentalists that personal freedom and autonomy, albeit defined by the two groups in hugely different ways, are "too essential to be left to democracy."

Above all, though, all these streams of thought thrive on the conviction that politics itself has failed in the United States, leading to the conclusion that key elements of the public good can only be preserved and advanced by extra-political means. And, of course, the ever more bitter political strife that they generate in pursuing these extra-political means turns the conviction into a self-fulfilling prophecy, as endless outrage and controversy chokes the political system and drives it ever further into paralysis. By teaching the failure of politics they bring about the failure of politics. The Biden

administration has managed, against great odds, to pass significant legislation despite this nefarious dynamic, and for the moment has partially overcome the paralysis. But if 2025 brings us a Republican president and Congress, they will undoubtedly take as their first order of business the reversal of these achievements.

At the end of this dark road, if we continue down it, stand the new technocrats. It is they who most clearly and explicitly reject politics itself as corrupt and inefficient, and it is they who, in the long run, will benefit if the American public becomes entirely despairing about political life. It is all too easy for me, as a historian, to see how the public could, in its despair and disgust, ultimately embrace a charismatic technocratic figure promising to stand above the corrupt political fray, to manage social problems in a unifying and rational, if dictatorial, manner. The promise worked for Napoleon Bonaparte, whose version of enlightened despotism was the technocracy of his day. It worked for many others who followed in his wake. This outcome may still seem unlikely, but if the political conflict in this country turns violent (or rather more violent: it is already violent) then people will not simply despair about politics; they will start to fear it. At that point, the appeal of a Caesar could become overwhelming.

Can we save politics, real politics, a common deliberation about the common good, from this fate? Is it possible to imagine a new sort of movement arising that could bring together enough citizens to produce real achievements, and restore a faith in political life? I see no possibility of such a movement arising today out of the American right. The rot there, the rejection of politics in the name of "real Americans" and even of dictatorship, is far too strong, reinforced as it is by a conservative media machine of unprecedented power.

The Triumph of Anti-Politics

Nor is there any evidence of a significant internecine clash within the Republican Party about its future. There is more of a possibility of a pro-politics politics arising on the left, and it is worth remembering the genuine appeal that the Sanders campaign had for at least some Trump voters. But for the American left to generate such a movement successfully it has to reject its own version of antipolitics and the Puritanical moral absolutism that accompanies it. Only by turning away from this moral absolutism and focusing on causes that genuine majorities of the country can unite behind, does such a movement stand even a slim chance of success. Otherwise, genuine political life in America will continue to shrivel, until nothing at all is left of it. A society without a belief in politics is a kind of hell.

JUSTIN E. H. SMITH

The Happiness-Industrial Complex

Alongside the industrial and the digital revolutions, the
modern era has witnessed a happiness revolution. The scien-
tific study, laboratory refinement, and industrial produc-
tion of happiness are all big business. If we count among its
products the dopamine rush with which we are awarded for
our small efforts online, the happiness industry is now the
largest in the world. But just as mass-produced plastic items
lack any lingering aura of the artisanship packed into the tradi-
tional crafts these items supplant, so too the isolated, distilled,
and monetized product that has been studied and developed
and sold back to us as happiness shows little continuity with

traditional articulations of what happiness is.

I should perhaps confess at this early moment that I am not, myself, happy. With the right dosage and combination of SSRIs and anxiolytics, and a whole battery of specialists to keep me propped up, I find I can get by in this world well enough for now, and am even able to come across to those who know me as a high-functioning go-getter and an all-around genial fellow. But the cost of this is enormous, and the resulting condition remains both artificial and tenuous — like a golf course in a desert.

I bring up my own happiness deficit at the outset only because I hope it can help to reveal something almost paradoxical about the topic at hand. Ordinarily we imagine that not knowing something directly is a good reason not to write about it, especially in this age of "standpoint epistemology" and general disapproval of any effort to move out of one's "lane." You probably do not want to hear from me about what it is like to be a woman, or a victim of the historical legacy of settler colonialism (though if you do I'll probably be willing incautiously to hold forth). And yet my own constitutional unhappiness seems to me no reason at all to decline to write about happiness.

On the contrary, I suspect that someone who claims to be happy is the *last* person we would wish to hear about happiness from. Achieving the condition in question, or claiming to achieve it, appears *ipso facto* to be a mark of inexpertise. This may be in large part because those who claim to speak about happiness from direct experience often appear, especially to those of us who are constitutionally unhappy, to be lying. If they weren't lying, we often think, but were simply living their happy lives, it is unlikely that the topic of happiness would interest them enough to set themselves up in the world

as its experts and representatives. A truly happy person, we the unhappy suspect, would not be able to think of happiness as a commodity, with a price-tag and a limited supply. A truly happy person would emanate happiness somewhat in the way that the God of Neo-Platonism emanates being, as a natural magnanimous flow, so that anyone entering into that person's presence would automatically come to have some share in it, at no cost, while the emanator would not thereby be deprived of any of his own supply.

Whatever is being sold by the happiness experts, we imagine, cannot really be happiness, but can only bear a relationship to it even more distantly removed than the one a synthetic mass-produced blanket at Target has to an early American album quilt. Or the relationship here is perhaps like a nutritional supplement you might take that dubiously claims to encapsulate in a single small pill the numerous beneficial molecules known to constitute the principal dishes of a Mediterranean diet. It might be true that you can put garlic-like and fish-like compounds in a pill, but if you swallow it on top of an American diet otherwise based on corn syrup and refined flour, it is unlikely that you are going to enjoy the same health history as a nonagenarian Greek islander.

119

~≈E≋

As the happiness industry, relying on cherry-picked scientific studies, has grown more effective at isolating marketable "happiness molecules" and synthesizing them for mass production, it has largely lost any historical memory of the long and difficult efforts that philosophers have made to determine, coherently, what happiness is. Significantly, while philosophers continue to write about happiness, by far the greater

part of the recent academic work on this topic is coming from the fields of business and behavioral psychology.

Likely no recent work distills a purer essence of this approach to happiness than the social scientist Arthur C. Brooks's book, *Gross National Happiness: Why Happiness Matters for America — and How We Can Get More of It*. Brooks writes in a folksy American style reminiscent of Will Rogers and motivational sales speakers such as Zig Ziglar — he is a master of happy talk. His book is as much an extended speech-act as it is an analysis, helping to maintain in being the enduring myth of his country's *Sonderweg*. There is something so deeply American in all this lucrative uplift. Brooks sees America's uniqueness as flowing in part from the explicit value placed on "the pursuit of happiness" in one of its founding documents.

Yet the Declaration of Independence is only making room for the individual happiness of its citizens, not bringing into being a country that is itself happy. To say that America is itself happy, or to argue as Brooks does that America might hope to be even happier, is really just to point to the statistical data concerning what several individual Americans report about their own happiness. Brooks provides a twenty-page appendix of admittedly interesting tables showing such information as "Trends in Happiness, Average Income, and Income Inequality, 1972-2004," and "Happiness and Perceived Personal Freedom, 2000." But such schematic summaries, the stock-in-trade of Brooks' academic discipline and its relentless popularization in "how" and "why" books, bury over all the ambiguity and uncertainty that the individuals queried might have felt in answering questions about their own happiness. And if they did not feel uncertain, this can only be a result of overconfidence — the presumption that they had grasped a concept that in fact eluded them.

For millennia, philosophers have been aware that happiness is a concept difficult to define, as much as it is a condition difficult to achieve. Brooks offers some initial acknowledgment of the difficulty of defining the term, and in keeping with the conventions of recent research he makes a tripartite distinction between "fleeting feelings of happiness," "happiness on balance," and happiness as "moral quality of life." He notes that in antiquity it was the latter of these, which may be assimilated to Aristotle's notion of eudaimonia, that was generally preferred.

But there are other ideas about happiness in the history of philosophy that Brooks does not even consider. Many, though not all, ancient philosophers warned against conflating happiness with a current sensation of content-ment or pleasure, preferring to understand it as a long-term condition of the soul, or as a dimension of moral character. But many also argued that happiness is an objective state that attaches to a given individual whether that individual has any first-person experience of it or not. For Brooks, by contrast, "the bottom line is that we may not know much, but we do know when we're happy." Brooks must remain committed to the transparency of our own happiness, in order for the data on which he relies to retain their value. But what if things are not so simple?

In the history of philosophy and religion, strong arguments have been put forth in favor of the view that happiness is something over and above what is contained in the notion of pleasure. Happiness is, rather, conceptually distinct from pleasure, and perhaps even incompatible with it. The reason for this is not just that pleasure is sinful, though that has certainly played a role in historical efforts to separate it conceptually from happiness. It is also that philosophical

The Happiness-Industrial Complex

inquiry into happiness, as a concept, lies at some remove from the traditional study of "the passions," which partially but not entirely map onto what we today call "emotions." Happiness was not a passion, like anger or melancholy or lust, for it was not the result of some balance of humors in the body, but rather the result of a given external state of affairs.

This becomes clear from a simple consideration of the origins of the English word in question, which places it in the same semantic cloud as words like "happenstance" and "haphazard," both going back to the archaic "hap," a synonym of "luck" or "fortune." For Shakespeare, a sentence that begins with the adverb "happily" does not go on to describe a pleasurable situation, but rather tells you what happened, by chance, to transpire. In German the most common word for "happiness," *Glück*, is also the most common word for "luck." In French the word for someone who is "blessed" is *bienheureux*, which obviously connects with both the advective *heureux*, "happy," as well as the noun *bonheur*, "happiness." Someone who is happy, on the archaic reading that these words recall to mind, is simply someone who got lucky, on whom God has smiled, and the happy person might well be so without even having realized it.

"Call no man happy till he dies" is a saying that captures well this old meaning: it is not that being dead is a pleasurable condition, but only that the determination of whether one's life has been a fortunate one cannot be made until there is no more life to be lived. The only person who can be called happy, on this understanding, is one who has no subjective experience of any emotion at all, at least not in the earth-bound, embodied form in which we the living catch some small glimpses of it. By contrast, it would make no sense at all to say, "Call no man angry till he dies," or "Call no man lustful till he

dies." Anger and lust are a matter of how you feel, happiness is a matter of how you are, or how your legacy is.

Brooks assimilates Aristotelian eudaimonia to the view that happiness is connected to moral character, but this means very little until we are in a position to appreciate how he understands moral character. Aristotle's ethics is naturalistic through and through. For him our happiness is dependent on our virtue — it is "an activity of the soul expressing virtue" — while our virtue, or *areté*, is simply the particular excellence appropriate to a human being, just as the excellence of a knife is wrapped up in its cutting and the excellence of fire in its burning. This means that, in an important respect for Aristotle, an acorn that manages to become an oak, thereby realizing the particular excellence that was contained within it *in potentia*, is also happy, or at least is in a state that is not totally distinct from what we recognize as happiness in human beings.

If happiness is understood in this way, as a set of circumstances quite independent of any subjective experience of them, the project of isolating its "molecules" and selling it to the public appears downright absurd. You can sell a person a lottery ticket, but you cannot sell them the luck that would make it the winning one. That involves a whole cosmic arrangement that precedes us and frames our existence; it is not something you can accumulate through the accumulation of tokens of the things — lottery tickets, love interests, stock-market investments — in relation to which a person may be said to be lucky or unlucky.

You can sell a person a book about happiness, you can sell them a course of instruction, but if being happy or not makes no actual difference for your inner state, if happiness is something that can most appropriately be predicated of

you only when you are dead and no longer have any inner states at all, then, obviously, the happiness merchant is most akin not to the physician, but to the carnival barker who has a vial of tonic to sell you, to cure what ails you through the activation of occult forces of which you, buyer, can only feign understanding.

Perhaps the most compelling alternative to the Aristotelian identification of human happiness with a state of affairs suitable for realizing excellence is the one propounded by the Stoics, which in stark contrast maintains that human happiness, in order to count as such, must depend on no external circumstances at all, but in fact only on an inward indifference, or equanimity (*ataraxia*) in relation to all externals. Epictetus wrote that, while a person can delight in wealth and status and human relations, he should always be prepared to drop these at once, as when the captain calls a sailor back to the ship and he throws down the beautiful seashells he had just been admiring on shore. Properly understood, no turn of events is truly bad, not even the deaths of our children or some imminent mortal threat to our own lives. As long as we have access to the veins of our wrists, we are still free to commit suicide, and so even here there is, as is said all too often today, "no problem."

We might well suppose that anyone who could simply shrug their shoulders when they lose their entire family has hardened their heart so severely as surely to be suppressing a good deal of trauma, and that this is bound to catch up with them sooner or later. The Stoic requirement for self-control is one that is so difficult to attain, so manifestly superhuman, that it seems to have been handed down by a philosopher with no real sensitivity, and perhaps with some amount of contempt, for human psychology as it is actually lived. Still,

there is surely some wisdom in the admonition to recall that no one ever promised you things would turn out alright, and so when they do not turn out alright, this is not so much cosmic injustice as simply the nature of reality.

Nor is it any viable alternative to go the way of the monastics and to avoid developing the earthly attachments that expose us to risk of tragic loss. For the ecstatic union with God that might be achieved at the end of a life of strict askesis is far from what we ordinarily think of as happiness, even if the solitary, rudimentary life that is spent in preparation for this does seem to contain much of what we are able to recognize as common unhappiness. Thus, in Flaubert's *The Temptation of Saint Anthony*, the protagonist wanders around in the desert a crazed dotard, like Lear but king of nothing. Even when he succeeds in rejecting the temptations of the seductresses and the swindlers, he seems just as lost, just as empty, as he would have been had he given in to them.

You can remove yourself from earthly affairs in order not to be heartbroken by them, but that is its own sort of suffering, and once you allow yourself to get mixed up in earthly affairs you are ever at risk of losing the people, things, or circumstances that give your life purpose or satisfaction. You are caught, in sum, between being ever at risk of losing everything and having nothing to lose.

125

We have made it this far without talking about money, other than to note that it is what the self-styled happiness experts are after. Yet the academic field of what might be called "happiness studies" overlaps considerably not only with behavioral psychology but also with economics, for both of these domains

model the human good in the same etiolated terms of abstract reward. Though he denies that happiness is to be equated with pleasure, Brooks often resorts to examples drawn from studies or thought experiments concerning the sharing or hoarding of things like ice-cream cones, essentially no different from the set-up of research on cooperation in macaques. And though he denies that happiness flows from financial wealth, he nonetheless conceives it as somewhat akin to gold, in the sense that each country manages its own reserve.

In the happiness experts' efforts to isolate the fundamental molecules of happiness and to measure happiness by quantitative means, they have wittingly or not rendered happiness into something money-like, where having more units of it makes you better off and having fewer does the opposite. For them, happiness is an asset class. It is difficult to say how far back this economization of happiness reaches, and a full genealogy is beyond our present scope. But it seems at least fair to say that its roots are not American, but rather lie in the liberal philosophy of early nineteenth-century England, and in particular in Jeremy Bentham's utilitarian calculus, his "felicific calculus," which sought in effect to quantify the human good in a system of discreet measurement.

Bentham was both rigorous and original, but in its more demotic forms, particularly as they are translated across the Atlantic, the units of the new science of happiness will come to be presented as the units of the true economy, while monetary wealth in the narrow sense will often be presented as the foundation of a false happiness. Thus while happiness studies as a field is deeply invested in surmounting and contrasting itself with the science of economics, nonetheless it is often to economics that this field looks as its imperfect ancestor. Happiness studies seeks to position itself as economics with a

human face. (More precisely, with a smiley face.) One cannot but be impressed by the elaborate cultural expressions that we have evolved to conceal what it is we are really after, even if this concealment is only bullshit, in Harry Frankfurt's sense, and everyone knows that everyone knows that it is wealth and power, and not love and human fellow-feeling, that sends businesspeople out on their corporate retreats and into their infantile "trust-building" exercises. Why else would business schools hire happiness experts? Happiness studies sometimes read like what used to be called "industrial relations," like more psychology that is of use to managers for whom productivity requires happy workers, as if being happy at work has anything to do with what we mean by happiness. In some sense all of this is as at least as old as urban settlement and grain storage. Thus in the Rig Veda we find the following eminently "relatable" reflection dating from around 1500 BCE (in Wendy Doniger's translation):

> I am a poet; my dad's a physician
> and mom a miller with grinding stones.
> With diverse thoughts we all strive for wealth,
> going after it like cattle.

127

One detects however, that in its premodern forms this law of human endeavor that the poet has identified has yet to be turned successfully towards bad-faith ends; for nowhere in this striving does the poet identify any plausible expectation of happiness as its likely outcome.

The corrective that the happiness experts wish to provide, regarding the relationship between wealth and well-being, is welcome enough, when they really mean it, but they have been making it for some time now, and the fact that the basic

lesson never fully sinks in suggests that it is not simply a lack of information that causes us, year after year, to continue in our mad pursuit of Moloch. The Harvard psychologist David Gilbert, in his bestselling book, *Stumbling on Happiness*, offers a clear example of this effort to correct. He notes that must people believe "they would be better off if they ended up with more money rather than less." In fact this belief "has far fewer scientific facts to support it than you might expect." Gilbert cites studies showing that Americans who earn $50,000 per year are indeed happier than those who earn $10,000, while multimillionaires, by contrast, are not measurably happier than those who make around $100,000 per annum (in 2006 dollars, that is).

So why don't we face up to the declining marginal utility of our efforts once we hit the upper middle class, and just relax? Gilbert supposes that it is our own individual irrationality that prevents us from shaping our priorities in accordance with what is best for our future selves, and instead compels us to chase after lucre long after the benefit of having it has diminished. That there is such tapering-off at the higher end of the economic ladder cannot be disputed. One unnamed Silicon Valley CEO told the *New Yorker* recently that high-end boats are a desirable purchase not primarily because they facilitate sea voyages, but because they "absorb the most excess capital." How sad to see such a wonderful thing as a boat through the reductive prism of investment!

I probably would not protest if society were so arranged as to prevent any individual from possessing more than, say, ten million dollars (at their value in 2022), but honestly my feeling towards the tech billionaire is not one of Jacobin resentment, but only of pity, mixed with a strange sort of self-recognition. I am as an ant to him, and yet my psyche is shaped, or

misshapen, in the same way as his. I might be peculiar in some respects, but I live under the same economic system as the rest of you and I am fairly confident it does more or less the same work on all of us.

Some of my most painful memories from childhood are of the evenings we spent driving around Sacramento — my mother, my sister, and I — looking for the rare Kentucky Fried Chicken that would accept checks, which we knew were going to bounce, but which at least would keep us fed that night, unlike the cash that we did not have. My mother had been a psychology graduate from UC Berkeley who saw the events of 1968 up close, and shared in their idealism while also inheriting her country's materialism. After my sister and I were born, she finished law school and quickly opened a family-law practice specializing in the legal defense of poor, rural women survivors of domestic violence. On several occasions she ended up accepting chickens, goats, and other forms of barter in lieu of pay, and after her own divorce from my father we often had more farm animals than money (and no surviving knowledge of how to butcher them).

Notwithstanding this apparent world-renunciation, my mother also liked money and status, and was on more than one occasion able to convince the local Maserati dealership that she was a serious prospective buyer. This was enough for them to lend us a vehicle for a week-long test-drive, which afforded us kids many occasions to be picked up from swim-practice in the Italian luxury car to the imagined envy of our teammates — our little stub of a family, broke and bespoke at once. My father, meanwhile, after the divorce, had a brief flare-up as a Republican lobbyist with a retired model as his second wife, but then divorced again and slowly, atavistically returned to a state of perpetual penniless travel that was almost indistin-

The Happiness-Industrial Complex

guishable from the borderline-hoboism of some of our Dustbowl progenitors. He spent his last years in a bottom-end motel near Guadalajara.

My own relationship to money and class, and indeed to happiness, was conditioned by their histories. Until the age of forty I strove in vain to maintain a casual and bohemian relation towards money, while also seeking to keep up ordinary bourgeois connections to the world — getting married, buying furniture, and so on. The result is that I was perpetually in debt, perpetually hounded by collection agencies, and so desperately unhappy that I cannot describe the condition I was in as anything other than a disease. Having lived through this continues to deform my existence; it stays with me like the limp of a childhood polio victim. It is only in the past decade that I have become obsessive, retentive, fastidious about money. I am not at all happy about this, but on balance things are better. I probably would have been dead by now if I had not at long last surrendered to money's unbending reign.

One of the enduring symptoms of this disease is that I conduct myself somewhat like the Silicon Valley C.E.O., if at a vastly smaller scale. I seek money even though I know it does not equal happiness, because I also know that debt equals death. It is only when we climb out of debt that we become aware of the need to constantly, jealously, phobically maintain and expand the buffer that keeps us from sliding back into it. And so I work like a fiend, not because I falsely believe this will enable me to enjoy showing off my success through costly status signifiers, but because I am afraid that my spouse and I could end up elderly and broke and too enfeebled to replenish our savings, and also because I would like, for once in my life, to be able to be generous towards my loved ones. But I am my

130

father's son, and I confess at any given moment I am about forty-nine percent of the way towards dropping it all and becoming a mendicant ascetic, free of all "externals." But this would inevitably mean losing my human ties as well, to my spouse, to my nieces and nephews.

When I think about all the blame and criticism that my family has to offer up in memory of my father's moral character, I am struck by the fact that it all comes down to money: he could not afford, in his late-period vagabondage, to pay for the things that are considered, whether we say so out loud or not, prerequisites of moral goodness in adult men. The thought of being condemned to the same fate terrifies me, and so, although I am his son, I hold back from that radical move of world-renunciation, and I continue, day in and day out, to seek to acquire money. That's really all there is to it.

Psychologists such as Gilbert present our desire to accumulate money as a mark of our *own* irrationality. We do it because we have false beliefs about what makes us happy. There is little acknowledgment among those who work in Gilbert's vein that we are externally constrained to do this whether or not we know that it is not making us any happier. Here again I am coming very close to sounding like a revolutionary who would like to see this system smashed, and indeed I suppose I would, if I had any confidence at all in the ability of its would-be smashers to replace it with something more conducive to true human thriving. In the absence of such faith, my indictment of the system amounts only to a quasi-existentialist charting of my own "thrownness": this is the world I was thrown into. As Tony Soprano liked to say, what are you gonna do?

Of course, a true existentialist would also insist that what you do is up to you. You are responsible for your own happiness. And here as well, I would say, yes, I agree. Although

I am on SSRIs, I hate reductionist, medicalizing talk of "brain chemistry," as if depression were in all ways comparable, say, to diabetes. My unhappiness might be part of my thrownness, but my happiness is up to me.

We may be arriving here at another paradox, in light of the suggestion that happiness is a choice, and yet, evidently, one that I have refused to make. Some of us would appear, namely, to be happy to be unhappy, and this is something that simply does not, cannot compute, within the available language of the happiness experts, even though, once again, not surprisingly, it is well-trodden ground in the history of philosophy.

Let us now appeal to authority. Spinoza says that, for the wise man, "death is the least of things." Long before him, Epictetus fleshed this idea out by invoking a logical argument that may either be utterly compelling or utterly spurious, depending on your mood: death cannot be a misfortune, he says, because death is by definition something a person never lives through; to be dead is not to be. But even if no one can be dead, mortality is what frames our lives and makes us what we are; mortals do not, cannot, worry about the same things as immortals. In light of this "horizon of mortality," Socrates said that philosophy itself is best conceived as nothing other than the project of "preparing to die."

I have hinted that I would likely have been dead by now if I had not made certain fundamental changes — not just learning how to manage money, but also quitting drinking and getting on antidepressants. That I made the effort to do this suggests that I would like to avoid death, and one might easily imagine that there could be no good reason to go to such

trouble if I were not still holding out hope for happiness. But there is another way to look at it. If Socrates is right, then we might say that it is good that I did not die back then, when life was a fog and I was a desperate animal, simply because I was not yet prepared to die, which is really just another way of saying I was not yet wise.

Few indeed, and fortunate, are those who have adequate time for preparation. Is this fortune what we may call "happiness"? Perhaps — note that busy morpheme "hap" popping up again! — but it is certainly not the kind that might be derived from kissing, or boating, or the kind we may fail to derive from plunging "excess capital" into boats. It is the kind other people might enjoy without me, like the party in *The Mikado* that Pooh-Bah and Pish-Tush promise to Ko-Ko after his own beheading.

In the meantime, I should add that things really aren't so bad. I am not happy, but I am in the very good and enjoyable company of distinguished others who have likewise lived their lives under the dominion of black bile. This humor furnishes us a lens on the world through which a certain stratum of truth about it is revealed. This is not the whole truth, and there are other registers of experience that may not be dismissed as false. But one of the advantages of the melancholic life is our total immunity to the efforts of the happiness experts to sell us a share of their stuff. We know that happiness is not the sort of thing that can be bought or sold, and we know, I now feel emboldened to say, that we, the unhappy, are its true experts.

MICHAEL C. KIMMAGE

The Missing Delight

Delight is an orphan. Many other moods and emotions have had champions in literature and philosophy, patrons invested in their cultural standing. Melancholy can claim *The Anatomy of Melancholy*, Robert Burton's strange masterpiece from 1621. It generated a fashion for melancholy that has not entirely faded, which the Romantics powerfully refreshed, lionizing melancholy for its immediate purchase on beauty. Baudelaire liked to remark that sadness is an essential element of beauty. In *Kind of Blue* and *Sketches of Spain* and other albums, Miles Davis projected modern melancholy onto a liquid music that proves Baudelaire's point. Joy is, in this respect, like melancholy: it has

great advocates in art and perhaps the greatest musical advocate of all in Beethoven, who composed the "Ode to Joy" — via Schiller's poem, which Beethoven embedded in his ninth symphony — regal and radiant. Despair and anguish have secure homes in the arts and in letters. They haunt the literature of loss, the literature of mortality, the literature of romance, the literature of regret, the literature of war. Happiness? It is enshrined in the Declaration of Independence as an inalienable right, or at least the pursuit of it is. Stendhal believed the exact opposite of Baudelaire — that happiness is what beauty promises. And happiness can be formidable in absentia. It, too, cuts a culturally imposing figure.

Horror is widely esteemed. What else could answer the human talent for cruelty? Horror intertwines with history — with Josephus chronicling the Romans' destruction of Jerusalem or Thucydides relating his stories of plague and brutality or Gibbon summing up history itself as a record of the "crimes, follies and misfortunes of mankind." In the twentieth century, the Holocaust and other shatteringly large mass murders have deepened history's association with atrocity and crime, leaving its shadow on the face of literature. The literature of witness has many twentieth-century tributaries. It is paradigmatically modern, an entire genre governed by horror. Or horror can flourish outside the historical realm, in the psyche. It can be the ahistorical preoccupation of Edgar Allen Poe, Flannery O'Connor, Edvard Munch, Val Lewton, and Alfred Hitchcock. No video streaming service would be complete without an expanding collection of horror movies. Hollywood discovered a long time ago that even horror can give pleasure.

The more irate moods balance political with cultural stature. Raging against the dying of the light can resemble rage

at the world's injustices — the purity of political anger and the indignation that bends toward revolution. Karl Marx did not just study global commerce and speculate about alternative forms of political economy; a virtuoso of invective, he grounded his prophetic visions in fury. The dominant political mode in the United States at the moment is either anger or disgust, a point of convergence for the wrathful Right and the wrathful Left. Disgust is a mark of engagement and sensibility. Not to be disgusted is to be oblivious or simply to be stupid. For decades, disgust has colored contemporary art, which often confronts us with the extent of our rapacity, with the depth of our prejudice, and with our underlying commitment to the production not of value or of dignity but of garbage, of the waste we so callously leave behind. Disgust is definitely in vogue.

But delight is not in vogue. It almost never is. It is, as I say, an intellectual orphan. More fickle than happiness and almost physiological, a reflex as much as an emotion, delight evades easy definition. It is intensely subjective, more so perhaps than sadness or anger. It is lighter, and with fewer evident implications, and even more impermanent, than pleasure. Delight cannot be summoned. It comes when it comes and goes when it goes — usually quickly. It awaits occasions, and in their absence it cannot be spontaneously generated. Often delight owes something to surprise. Yet delight is not a less meaningful state of mind, a less fundamental human mode, than sadness or anger, rage or disgust, joy or melancholy. But where are its advocates? Its placelessness puts it in a precarious cultural position. It runs the risk of being overlooked and, by getting overlooked, of being dismissed or forgotten as trivial. It runs the risk of neglect at precisely the moment when delight might be most culturally beneficial, which is to say the

136

moment we are living in right now. Slaves of anxiety and fear, surrounded by unimpeachable reasons for pessimism, we are still in need of it.

I would like to say a few words in defense of delight.

Delight is a Latinate word. The "de" is an intensifier placed against *lactare*, to lure or to entice. Old French modified *delactare* into *delitier*, meaning to please or to charm, and around the year 1200 Middle English winnowed *delit* from *delitier*, keeping its meaning. In the sixteenth century, *delit* acquired an "h" and with this addition its modern form, which by an accident of English spelling harbors a word that does not really belong to it — light. A room is lit, a lamp can be lighted, and a person can be delighted. Words properly related to delight are: delicious, delicate, lace, elicit, and dilettante. (A dilettante, unlike an expert, is someone who is often delighted.) The root of *delight* in *lactare* reinforces one of delight's important aspects. It is an active emotion, kinetic in a way that anger and sadness are not. Compared to delight, anger and sadness can seem static.

The 1913 edition of *Webster's Dictionary* provides three definitions of delight, wavering between sense and intellect. First, it is "a high degree of gratification of mind; a high-wrought state of pleasurable feeling; lively pleasure; extreme satisfaction; joy." "Gratification of mind" is itself an interesting variation on "extreme satisfaction." "Lively pleasures" emphasize delight as a word of motion, more active than passive. Somewhat circular is *Webster's* second definition: "that which gives great pleasure or delight." And third, lest "gratification of mind" grant too much to mind and to highly wrought inner states, there is delight as "licentious pleasure;

lust." Without explanation, *Webster's* parenthetically puts the name "Chaucer" next to this third definition. The *Canterbury Tales* could reasonably be called a compendium of delights. Chaucer merged verse, humor, and bawdiness in his characters (male and female), cheerfully acknowledging the pleasure they take in sex. Chaucerian writing captures a distinctive version of delight.

Left out from the definitions in *Webster's* are delight's religious and spiritual overtones. Perhaps they are subsumed within "gratification of mind." Consider the thirty-seventh Psalm in the King James translation. Iterations of delight appear in it three times. The Psalm begins by eschewing antagonism. Its first line is an injunction: "fret not thyself because of evildoers, neither be thou envious of the workers of iniquity." Antagonism is a distraction from God and from godliness. Trust, rather, in the Lord, the Psalm contends, and "delight thyself also in the LORD; and he shall give thee the desires of thine heart." "Delight thyself in" might be a synonym here for worship, but more precisely it is an antonym to the Psalm's opening word, an antonym to "fret." To fret is to inhibit delight. To fret because of evildoers or to envy the workers of iniquity is to focus one's mind on the evildoers and the iniquity, a technique for losing sight of God. Delight — by contrast — is the path to receiving one's heart's desires through God. It is the gate, the path, and the goal. This Psalm is a document not of a tormented religious sensibility, which is amply represented in all the religions, but of a joyous one.

The thirty-seventh Psalm guarantees the transience of wickedness. It promises the eventual demise of evildoers, after which "the meek shall inherit the earth; and shall delight themselves in the abundance of peace." Together, righteousness and delight in the Lord are preludes to some period of

God-given recompense, to a time when the meek can delight themselves in abundant peace. Both means and end, delight constitutes a virtuous circle in this Psalm. Its third and final mention of delight synthesizes the word's first two appearances: "the steps of the good man are ordered by the LORD; and he delighteth in his way." Abraham is ordered to sacrifice his son Isaac; Jacob must wrestle with an angel to become Israel; Job, a good man, is subjected to fantastic suffering. Such are the imponderables of God's will and of faith in God. The thirty-seventh Psalm illuminates a separate pathway, of God ordering the steps of the good man and of the good man delighting in his way. Is delight the proof of his goodness? Is it the cause of his goodness? Is delight cause and proof simultaneously?

A more secular sensibility would link delight not to God or to goodness but to art and aesthetic experience. Delight is thinner than tragedy's catharsis, the constructive churn of emotion that arises from the spectacle of disaster. Nor is delight at all related to the awe that one feels in response to the sublime, a category of art or nature that has long fascinated philosophers. The sublime is a vertiginous awakening of the senses to the magnitude of things, one part wonder and one part horror. The sublime shades into *terribilita*, the trait claimed by Renaissance painters such as Michelangelo. Grandeur and seriousness are the markers of an artist aspiring to *terribilita*. To achieve their desired effect they must produce an art that is large-scale and riven with tension, with light and dark, good and evil, piety and sin.

Delight is smaller and there is nothing cataclysmic about it. It is, in fact, anti-cataclysmic. It is a respite from intensity. Art in search of delight, art open to delight, tends toward moderation. It runs the risk of sweetness and harmony. Dangers abound for any art oriented toward delight. Aiming to please,

to allure and to entice, it might please too much, starting in the gratification of the senses and ending in banality — the beautifully arranged image of a beautiful person in beautiful clothes contemplating a beautiful tree. Any excess will make a delightful work of art cloying. Another trap in which such easily grasped art might get caught is kitsch and commodification. Once upon a time the Impressionists were shocking, with their revolutionary fidelity to sense impressions and their exhilarating liberties with color, but their paintings have since ended up on shower curtains and coffee mugs and picture puzzles. Delight sells, not least because it seems to demand no effort, merely a momentary capture of attention. The will to delight is a mainstay in the aesthetics of advertising.

Delight's natural affinity may be less with "high art," which by definition makes demands on the viewer, than with interior and industrial design. Delight is not just the currency of advertisers and not just the advertisement. It is the iPhone itself, which gives great pleasure or delight. Delight can be an appreciation of craftsmanship. It is the effect of examining a well-made watch — the fineness of the pieces, the interlocking parts, the exquisite smallness of everything. Or delight is there to be absorbed from distinctive furniture, the Eames chair that hits every mark of style, the color of the wood, the excellence of the fabric, and the austere geometry of the chair itself. Delight in this regard cannot escape certain class connotations. It intersects with luxury, with the licentiousness of objects. Prized objects can give delight, reflecting the money and the taste that made them possible. Delight walks arm in arm with connoisseurship, with the educated ability to recognize things, preferably rare and expensive things, that rise to the level of delight.

Two other domains of human experience, food and sex,

do a lot to make delight their own. Food's claim is self-evident — the unity of smell, taste, and sight heightened and then relished by appetite. The variety of a great meal, the conviviality: the hunger to be delighted by food is instinctual, something with which we are born. Even poor people can partake of it. The social character of eating has often been praised as an enhancement of delight: when Hume sought release from philosophical perplexity, his first instinct was to dine with friends. Similarly, erotica does not have much purpose beyond delight, giving fresh meaning to "a high degree of gratification of the mind." Pornographic erotica often traffics in violence and exploitation, feeding into a high degree of rapacity of the mind, selling this rapacity to the highest bidder. It is often revolting. In milder erotica, however the mind similarly gratifies itself through fantasy, through idealizations or through idealized degradations, depending on tastes and preferences. As with food, the enjoyment of erotica is instinctive, crossing many cultures and many epochs. In ancient Pompeii, people had erotica painted into their houses without embarrassment. They displayed it with pride, as yet another way — in addition to images of field and flower — of ennobling a home with the delights of domesticity. In these examples, delight approximates the lively pleasures that are one of its defining features.

An enduring objection to delight as aesthetic experience is political. Is there such a thing as political delight? Political art might embrace sentimentality or the sublime, it may inspire or cast one down, but it has little patience with delight. Political art frets about evildoers and the workers of iniquity. It can be subtle and it can be marvelous as art, but at the very least political art must advocate. It must carry a message that can be broadcasted and received and sustained. That is

its truest function. Upton Sinclair's masterpiece of social protest, *The Jungle*, from 1906, channels the superior novels of Charles Dickens (who was an avowedly political writer) and the superior novels of Emile Zola (who was nothing if not a political writer). Sinclair was right about the intolerable labor conditions in Chicago. To remain right about this Chicago, he had to write a novel in which the modern American city is oppressive. Its stockyards are awash in blood. The city around them is dense with unhappiness. The sheer length of *The Jungle* makes it oppressive to read. Because the novel breathes the air of unhappiness, so, too, must the reader. Anything else would be a betrayal of its political purpose. In this context the genius of Dickens becomes even more pronounced. He produced novels that analyze and indict social conditions but somehow manage to layer passages of sheer delight into them, most palpably the delight Dickens always found in the written word.

If delight is not entirely an orphan, it is because it has a parent or a guardian angel in comedy. Conventional comedy has its genre requirements: the smooth passage past discordance and dissonance to resolution — the progression in romantic comedy, for example, from a relationship that makes no sense to a perfect marriage. All's well that ends well and so on. Comedy traffics in laughter, which is an outward expression of delight (among other things). The parallel between laughter and delight lies in their physicality, in the force of laughter, which mirrors the motion of delight. Laughter is sudden, it comes as a relief, it cuts through, it pulls up, it breaks through boredom, anger, anguish, complacency, worry, grief.

Beckett was the great master of such laughter. Of course not all comedy plays by the conventional rules. It can mix and combine with other emotions and genres, particularly with tragedy, its frequent fellow-traveler. Whether full-fledged or only a piece of the puzzle, well-fashioned comedy is pedagogic. By provoking laughter it teaches laughter. In this it once again resembles delight, which by provoking joy teaches joy.

Satire, an uncompromising version of comedy, is tied organically to delight. Satire takes as its point of departure evil, disaster, sanctimony, hypocrisy, vanity, and pomposity — and transforms them into laughter. Satire does not promise the eradication of misfortune. If anything, satire promises the intractability of evil. Satire and political art branch out in two separate directions: one toward reform and the other toward survival skills, the ones that can help us to co-exist with the never-ending foolishness and injustice. True satirists are not reformers. They are noticers, not just of evildoing but of the indifference that is so often the response to evil. The satirist depicts malice meticulously — most famously Swift observing how little people care about poverty in Ireland and then proving the point in his "Modest Proposal," in which he made the policy recommendation that Irish children be eaten. The laughter that Swift incites is complicated. The dark delight lies not in the mention of poverty but in Swift's complete psychological command of our unconcern. To laugh at ourselves is in this instance to see ourselves in a very unflattering mirror.

A less exacting species of delight resides in parody. By shifting registers, by altering the tone, parody exposes formula for what it is. In the film *Blazing Saddles*, Mel Brooks accomplishes a ferocious parody of the Western. Brooks gets us to laugh at ourselves in *Blazing Saddles* — at our enthusiasm for Hollywood formula — by rearranging the cowboy movie's

cliches. In *Blazing Saddles*, a man punches a horse, a visual gag and a joke about the movies. It would be nothing for a man to kill another man in a Western: the genre thrives on violence and on outlaws who upend social and ethical codes. Yet in *Blazing Saddles* the violence goes too far, exposing violence as not only wrong but absurd. A man punches a horse, and Brooks prods us to laugh at our shock and outrage. If we do, we are in the zone of delight. In 2022, one could easily imagine the film getting banned for its depiction of cruelty to animals, confirming the brilliance of Brooks' joke. In 2022, indeed, Brooks' whole film, with its parodies of racism, misogyny, anti-Semitism, homophobia, and religious piety, could never get made, which is a shame.

In 1964, Susan Sontag brought together satire, parody, and delight in "Notes on Camp." Sontag captured a well-established cultural style — she traces it back to the eighteenth century — that thrives on responding with comic appreciation to art that is overdone, that is too much, that dramatizes itself far past the limits of good taste. The epitome of such comic appreciation, Camp is "the farthest extension, in sensibility, of life as theater," Sontag writes. In this theatrical sensibility, "things are campy not when they become old — but when we have less invested in them, and can enjoy, instead of be frustrated by, the failure of the attempt." The enjoyment of failure, Camp is "a seriousness that fails" and that by failing succeeds as Camp. Less investment, greater enjoyment. Without apology, seriousness is exchanged for lightness.

Sontag was writing against the literary-critical grain of her time. She was throwing down a gauntlet to the recondite academics and to the dour servants of the avant-garde. One sees this dual program in her defense of Camp, which "refuses both the harmonies of traditional seriousness and the risk

of fully identifying with extreme states of being." More than a takedown of the overly earnest and the overly intense, "Notes on Camp" is a celebration of "the consistently aesthetic experience of the world." Camp is a method of appreciating some popular culture — or mass culture, as the editors of *Partisan Review*, the magazine in which "Notes on Camp" first appeared, would have put it. Camp is a method for having cultural fun, one that "makes the man of good taste cheerful." Not quite the thirty-seventh Psalm, this, too, is nevertheless a way of reaching the desires of one's heart. "The connoisseur of Camp is continually amused, delighted," Sontag continues. Sontag's argument for Camp is precisely that it delights.

Granting laughter and enjoyment their due as tools of delight, one must immediately add that there is a variety of delight that is not entangled in Camp's ironies or in satire's aggressions. Irony and satire are stances or attitudes. Delight is an experience. The purest delight arises from the aesthetic experience of it, as it might from experiences untethered to art: the easy delight that nature gives off, or the delight encoded in the giddier moments of friendship and love. Sensual or sensuous pleasure might issue in physical or psycho-somatic symptoms — the fabled "Stendhal syndrome" induced by art or antiquity, or in Stendhal's case, "a fierce palpita-tion of the heart" and "an attack of nerves" that followed a rapturous encounter with Volterrano's frescoes in a chapel of Florence's Santa Croce church. Delight is a different and less dramatic response. And yet, like the aesthete's ecstasy, delight is more mystical than rational; and it transforms, not forever because it passes, but still it transforms. In its own way, the art of delight elevates. It juxtaposes two contrasting truths: that we do not live elevated lives most of the time, since we always carry many burdens; and that we are capable of elevation, even

of levitation, though down we will go soon enough. The first truth might well be unbearable without the second. Delight defies the difficulties of life.

Case studies can lend these claims specificity, and I will provide three of them, traveling backwards in historical time. The first is the Chrysler Building, which was completed in 1930. This extraordinary skyscraper is profligate in the delight that it bestows on onlookers and passers-by. The second is Louis Armstrong's 1928 recording of "West End Blues," a studio performance that is evidence of Armstrong's early mastery. The third is Mozart's opera *The Marriage of Figaro*, an *opera buffa*, which first appeared on stage in Vienna in 1786 and brings us (inevitably) back to comedy as well as pedagogy. Mozart's *Figaro* shines with delight. No less does it teach its listeners or viewers to know delight, even though the story it tells is often harrowing. Like the classical style more generally, *Figaro* punctuates delight with poignancy. And the opera is an experiment in delight as philosophy, as a way of being, through which Mozart does the impossible: he sustains delight for hours, reversing the standard ratio and thereby arguing provocatively, in agreement with the thirty-seventh Psalm, that suffering is temporary but delight as eternal.

The Chrysler Building is a great work of art. It came about, though, for reasons that were to the side of artistic intention. Its architect was William Van Alen, who was born in New York City in 1883. From modest beginnings, he made his was to Paris in 1908, where he studied at the Ecole des Beaux Arts, a traditionalist haven, and then gradually acquired a taste for modernism. Van Alen's great patron turned out to be Walter

Chrysler, also of modest background. He was a man without much education and with an extreme talent for business. By 1928, Chrysler was promoting his Silver Dome car, running a booming company and seeking a prestige building in New York. He wanted it to bear the insignia of his name and his company. He wanted the advertising, and — as many did at the time — he wanted to be in on in the construction of the world's tallest building. Van Alen delivered the goods, after which their relationship soured into acrimony with a court case about payment. Van Alen won the case, but by having brought it to court he lost his professional reputation. The Chrysler Building was his only major commission. He is an artist who made only one work and it is a masterpiece.

Up into the sky it rose, between 1929 and 1930. The distinctive steel used for the Chrysler Building, Enduro KA-2, was created not much earlier, in 1926. It must have mingled in Walter Chrysler's mind with the Silver Dome, and cars were suggested and represented across the building. Its gargoyles, inspired perhaps by Van Alen's time in Paris, look like gigantic hood ornaments. The building's most notable feature, after its silvery steel, is its decorative spire, an unforgettable pattern of curving lines that suggest a sunburst, a pagan accent, and — more prosaically — the hubcaps of a Chrysler automobile. Pagan hubcaps! The Chrysler Building never shies away from business; it is all business. It bypasses the alleged tension between branding and art and between art and commerce, which curiously is a part of its glamour. Claudia Roth Pierpont once described the Chrysler Building as "the quintessential jazz baby of buildings" and as a specimen of "the honky-tonk sublime."

Ever since it went up, the Chrysler Building has sparkled in films and photographs. The photos highlight the charm

and exuberance of its many ornaments, while the aerial photographs divinize the building. Located on 42nd Street and Lexington Avenue, it is far enough from the downtown and midtown forests of skyscrapers to stand out, and to contrast its slender beauty to the many less sublime structures of the Manhattan skyline. It is less squat than the Empire State Building, less severe than the Twin Towers, of blessed memory, with less matter and more art than any of the countless other attempts to brand the New York City sky. The photographs are persuasive in admiring the Chrysler Building as New York City's loveliest skyscraper. Postcards and refrigerator magnets tell us that what the Eiffel Tower is to Paris and the Coliseum is to Rome and the leaning tower is to Pisa, the Chrysler Building is to New York. Walter Chrysler could not have been more pleased with what his building has achieved. More than the car company, the building will immortalize his name.

The Chrysler Building's involvement with delight runs along other grooves. It comes from seeing the building from the street. It comes by surprise, which is a feature of delight, when art or aesthetic experience is not what one was expecting. It comes either by day or by night. The day should be sunny. Street-level New York is loud. It overfills the eye: the signage, the foot traffic, the flood of cars. Above it are the usually multi-storied buildings, many of the them handsome, but they cannot compete with the spectacle of the near-at-hand. But cross a street, or walk into Bryant Park, and the sky reappears, and there, demarcating this blue sky perfectly, stands the Chrysler Building, its gleaming silver cleansing the eye and drawing it up to the crowning sunburst that, because it is so high, belongs more to the sky than to the city or the street. Seen purely, as an optical experience, the Chrysler Building signifies nothing but its own exquisite form. It

148

promotes nothing. It is a building rather than an icon, but a building that transforms stone and steel and masonry into the visual stuff of levitation. In this way it surprises and delights its accidental viewers. When you look up, you are lifted up.

In the evening, the Chrysler Building's steel is invisible. It is one of a thousand skyscrapers. Its sole uniqueness is its domed top, the curves of which are lit up — something that Van Alen had contemplated but was not realized until the 1980s. The curves of light belong to the building, which at night is a metropolitan lighthouse, lending the city coherence and staving off disorientation. New York is too bright, even at the darkest pitch of night, to see the stars. The Chrysler Building takes their place, the city's North Star, merging the delight of its design with the comfort of its identifiable presence. Amid the visual chaos of Manhattan the nighttime Chrysler Building is a constant, like its cousin the Empire State building, there to guide the late-night walker in the city. In the nocturnal city, which can inspire anxiety, the spire of the Chrysler Building comes as a great relief from darkness, as an answer to darkness, an image of form that playfully, cheerfully, solicitously oversees the endless city.

The Chrysler Building is a work of art ironically. Much as New York City does, Walter Chrysler wanted to impress. His adolescent eagerness to own the world's tallest building, which for a while he did, was outpaced by this same adolescent eagerness in others. By 1932, the Chrysler Building was demoted to being the world's second tallest building; and it continues to be so demoted; and it hardly matters. The Chrysler Building makes no secret of its impurity. It is neither a museum nor a monument, and it is no cathedral, except maybe to capitalism. It is an office building. Yet the sincere impurity of a building put up to celebrate gas-guzzling

149

Chryslers does nothing to tarnish its gift of delight. Its form is unimpaired by what goes on inside it. To the contrary: by asking so little of its viewers, by not being Saint Peter's Basilica or Notre Dame de Paris, it forces them to receive its gift with no expectations, without having to be aware of anything (other than the building's name), without having to give it their religious or political allegiance. It lets them be merely delighted, and the surrounding city obliges as a foil, with its fumes, its din, its grays, its gaudy colors, and its unforgiving proportions. New York's overwhelming density paves the way to the delight of a building that leaves it all behind and melts into a colorless, self-illuminated verticality. If fretful New York is the call, the Chrysler Building is the response.

Louis Armstrong came to New York in 1924. Born in New Orleans in 1901, he had moved to Chicago in 1922, a prominent member of the Great Migration from South to North. At age seventeen, Armstrong had begun playing on riverboats near New Orleans, and it was in 1923 that he made his first studio recording (in Indiana). New York, the big leagues, had the Fletcher Henderson band; but Armstrong went back to Chicago, where he made some of his most extraordinary music. Between 1925 and 1928, he recorded sixty songs — for which he received modest payment and no royalties — with different groups. Jazz was a new and fluid musical form, a work in progress, and Armstrong's recordings in these years were some its greatest revelations — jazz's scripture. There was the quality of the ensemble playing, which no other musicians could match. There were Armstrong's improvisations, which no one could match. He did not improvise decorative ornaments. He impro-

vised everything, the whole melodic line, playing with the total assurance that was his signature. Rather than find his way to a new style he brought to his recordings a new style fully formed.

A gem among these bejeweled recordings is "West End Blues." The song had been composed by Armstrong's mentor, Joe "King" Oliver, a cornet player. Its name evoked New Orleans and in particular a neighborhood, the West End, known as a summer resort. It was a popular venue for music — and the last stop on a New Orleans trolly line. On June 28, 1928, Armstrong came to the studio with the pianist Earl Hines, the clarinetist Jimmy Strong, the trombonist Fred Robinson, the banjo player Mancy Carr, and the drummer Zutty Singleton. By the racial and popular-culture strictures of the day, Armstrong was an entertainer. He resented his wife (the pianist Lil Hardin) for promoting him as "the greatest trumpet player in the world." He could not have been unaware of his genius, so fluently did it display itself in his recordings and in his concerts, but his own genius was not the point of these recordings. That much can be surmised from Earl Hines's recollection of their reaction to "West End Blues": "When it first came out, Louis and I stayed by that recording practically an hour and a half or two hours and we just knocked each other out because we had no idea it was gonna turn out as good as it did." They had no idea!

A bit over three minutes long, "West End Blues" has several discreet parts. Armstrong starts alone with a baroque chain of arpeggios and clustered notes, all bravura and virtuosity. The next part is the song's melody, a straight-up blues played by Armstrong to the underlying soft thump of his rhythm section. Armstrong makes way for a lazy trombone solo and then a clarinet solo, to which he added his voice, scat singing in dialogue with the clarinet. (Throughout his life what made

Armstrong's raspy voice into a lovely voice was the sound of delight within it.) What follows is an intricate, elegant piano solo from Earl Hines, going up the piano, staying momentarily high, shifting to the piano's middle registers and then bringing out its bass notes — urbane blues par excellence. Armstrong hits a high note in the song's climax, lingers over it, and then plays a few blues figurations, after which he and Hines trade punctuation marks, giving the song a soft landing, a minimalist conclusion to its baroque beginning. However rehearsed it was, "West End Blues" is free and seamless and floating and seemingly effortless, a languorous summer afternoon in the West End of New Orleans.

The ensemble contributes a lot to the song's delight. For its three minutes, the song moves through many textures: the cerebral clarity of the piano, the weary thickness of the trombone, the earthiness of the clarinet, and the conversational whimsicality of Armstrong's vocals. As for the solos, Armstrong generously passes the baton, which continues to get passed, a touch of competitiveness flashing when Hines dares to play with no less imagination than Armstrong, and no less flair. None of the musicians reduces the number to a personal flight of fancy. "West End Blues" is a self-creating poem in which each verse is written with a new instrument or combination of instruments, a classical drama with a beginning, a middle and an end. Nothing intrudes. Nothing obtrudes. Nothing distracts. Nothing detracts. Nothing conflicts.

The ensemble is Armstrong's of course, as is its approach to the song. His voice is lighthearted, imitating first the clarinet and then with a "wah wah wah" the trombone, not making fun of them but not taking them very seriously either. Armstrong's trumpet is the song's incomparable instrument of delight. The sound is bright and high, neither celestial (as

152

a violin might be) nor melancholic (as a cello might be). "West End Blues" radiates delight much as the Chrysler Building does. As with the Chrysler Building, it uses altitude for effect. Armstrong's introduction plunges down, a waterfall of notes that zig-zag lower and lower. Later, in his short solo, Armstrong flies up, staying as he liked to do for several seconds on a single note, the ensemble going on almost without him, as if he had forgotten about them and about the rules of gravity. Just as the eye sweeps up the Chrysler Building, the ear — and the soul — sweeps up with Armstrong's high note and briefly remains ascended, standing with the trumpeter at the top of the mountain and relishing the height and the view and the cool air.

Armstrong's rhythms complete the picture. Speeding up, slowing down, staying silent, he divides and subdivides time. The song starts with the jagged complexity of his introduction, brilliantly breaking down time and folding it in upon itself, after which Armstrong's rendition of the melody is low key. A bit faster and it would be dance music, something at which Armstrong excelled: it was Armstrong's marching-band and blues rhythms that formed the foundation for swing in the 1930s. Throughout "West End Blues" and without playing many notes, Armstrong uses syncopation to give the music its energy, its tension, its forward momentum. The biggest delight of all is that we can hear him improvise in "real time." Though the number has structure, there is something blithe and serendipitous about it — its sophistication gives way to joy. If Armstrong and Hines had no idea what they had accomplished with "West End Blues," it was not necessarily because they were modest or because they had been labeled entertainers rather than artists. They may have entered too blissfully into the moment and been too fully enchanted by

the rhythms of their ensemble and solo playing to assess their handiwork. If so, they would have something in common with those who can listen to them play — on a record, on a CD, on a phone — and be startled and delighted (delight is always startling) by the music together with the musicians who were making it on June 28, 1928.

The Marriage of Figaro is perhaps the last word on delight. Listing the greatest hits of Camp, Sontag included "much of Mozart." This is not quite right. Mozart could not fail musically, though he was certainly theatrical, and his operas were the apogee of his theatricality. *Figaro* and many of Mozart's other operas do not skimp on ridiculous plot twists and on the silliness endemic to opera, especially to opera that does not declare itself to be comic — but *Figaro* has nothing in common with the bad Broadway musical that can be twisted, by a sophisticated viewer, into a fabulously bad Broadway musical. *Figaro* is an aesthetic experience for what it is, beginning with its marvelous plot and continuing in the music, which is psychologically astute and a kind of storytelling art unto itself. Averse to glum seriousness, though the pains of love and the injustice of class relations are among its subjects, and thrillingly comic, *Figaro* is as ambitious a work of literary art as there could be. It surpasses even *Don Giovanni*, the opera that Mozart would write a year after finishing *Figaro*. By placing the laurel wreaths of artistic perfection on a comedy, *Figaro* is an invitation, in its details and in aggregate, to ponder the exquisiteness of delight.

Figaro's libretto came from the pen of Lorenzo da Ponte. Jewish by birth, Da Ponte grew up near Venice and became a less than proper Catholic priest. Having made his way to Vienna,

he was a sought-after librettist who collaborated with Mozart on *Figaro*, on *Don Giovanni*, and on *Cosi fan tutte*. As if this were not enough for an interesting life, Da Ponte eventually settled in the United States. In New York City he ran a bookstore and served as a professor of Italian literature at Columbia University. He made many contributions to the musical arts in the early republic, helping to build up an opera house that was a predecessor to the Metropolitan Opera. With *Figaro*, Da Ponte was repurposing a controversial play, *La folle journee, ou le Marriage du Figaro*, written by Pierre-Augustin Beaumarchais, an avid supporter of the American Revolution, who portrayed a world of culpable aristocrats and admirable servants. Many readers of the play, including Danton and Napoleon, regarded it as an act of political subversion. Converting the play into an opera, Da Ponte took much of its political edge off. His *Figaro* is neither radical nor sanguine about what a college student might today call privilege. It is very canny about privilege.

The story is about an errant employer. He is the Count Almaviva, who eliminated the *droit du seigneur* from his Seville household but then tries to bring it back. Count Almaviva, an obstreperous baritone in the opera, has lost interest in his wife, even in her unhappiness. The libretto implies that he has seduced the gardener's daughter, Barbarina. The action of *Figaro* revolves around Susanna, whom the servant Figaro wishes to marry and whom the Count wishes to seduce. The opera begins with Susanna's fear, which the music makes clear: a servant's bell doubling, while she sings, as an alarm bell. She is right to fear the Count's lust and his will to power. Though *Figaro* has the happy ending that comedy seems to promise, and the resolution that is a formal requirement of the classical style, its exploration of barely restrained coercion, of jealousy, of emotional abandonment, of transgression hoped for if

not always consummated, is rich and moving. In *Figaro*, these attitudes and conditions are not smothered in the myth and in the histrionics that make many operas famous for their music and infamous for their plots.

Delight has two guises in *The Marriage of Figaro*, the music and the narrative. They are not separable. A simple delight of *Figaro*'s story, augmented by its Spanish setting, is a house full of young and amorous people. It is *la folle journee*, the topsy-turvy day, on which two people are about to wed. Figaro and Susanna lend their anticipation to *Figaro*. Its first scene is Figaro measuring out the space for their marriage bed. Excitement is also instilled by Cherubino, a boyish man whose role Mozart wrote for a soprano. A character plucked from Da Ponte's libertine past, Cherubino is the eroticized cherub. He cannot hide his attraction to the Countess, to Barbarina, to love itself. Cherubino is perpetually enamored — *voi che sapete*, tell me what love is, he sings in one of the work's finest arias. No longer young, the Countess gets the opera's most heart-breaking aria, its show-stopper. "Where have the sweet moments gone?" she asks with almost unbearable regret about her wayward husband in Act Three. Lamenting the loss of love, she is pure tenderness in this aria, foreshadowing the reconciliation with the Count destined to come in Act Four.

A less simple delight in *Figaro* crystallizes around perseverance and forgiveness. Resourceful Susanna, not simple-minded Figaro, is the opera's protagonist, its heroine. Echoing the Beaumarchais play, *Figaro* celebrates Susanna as someone who can outsmart the Count. She has to outsmart her fiancée Figaro in the process. His insufficient and then overabundant jealousy threatens their relationship with ruin. Susanna's soulful perseverance, embedded in everything she sings, rises far above the aloof Countess and above the narcissistic Cherubino, not to

mention the bombastic Count. But it is this same fallible Count who breaks through to introspection and regret, getting down on his knees to beg forgiveness of the Countess, when the four-act merry-go-round of intrigue and impersonation comes to a halt and the Count finds himself eagerly trying to seduce his own wife. His missteps are certainly familiar from comedy, whether from the romantic comedies of Shakespeare or the romantic comedies of Hollywood. Yet when confronted with his wife, when recognizing her, he steps away from comedy. His request for forgiveness — the music leaves no doubt about this at all — is from the heart.

The Countess's forgiveness of the Count captivated Lionel Trilling, who slipped a mention of it into his novel, *The Middle of the Journey*. Its main character, John Laskell, is listening to *Figaro* on the radio: "it was in full flight and nearing its end in the magical last scene where farce moves to regions higher than tragedy can reach." What are these higher regions? Why can farce reach them when tragedy cannot? Ever the teacher, Trilling liked to give his readers questions without being so forward as to answer them himself. Tragedy scrutinizes error, loss, and death through nobility: the tragedy of King Lear, the tragedy of Prince Hamlet. Tragedy is surely the gateway to higher regions. Farce, if it goes higher, corresponds to daily life. It has the space in which to go up, to ascend, to gain altitude and to demonstrate — by means of delight, which is second nature to farce — that error is not necessarily followed by loss and death. Errors can pile up in such a way that from them love and forgiveness might materialize. Farce is not tangential to *Figaro*. Farce, the comedy of perpetual human error, and therefore a genre of eventual or sudden self-overcoming forgiveness, is what makes it move and what makes it moving.

The Missing Delight

Mozart's music, of course, does the rest. It is the story and the commentary on the story. Mozart is the composer for whom the prime mover is usually delight. Simplicity is one factor, because it brings out the uncluttered melodic line, which is a vocal line in all of Mozart's music, rising and falling in synch with the human voice. Mozart's melodic line is lyrical, tinged with the pastels of his harmonies, not without darkness but suffused with light. *Figaro's* music capitalizes on the conventions of *opera buffa*, mocking the Count's vanity, cherishing the mistaken identities, and honoring Mozart's own character, his irrepressible, almost angelic mirth. Mozart was born for farce. Yet his music wraps *opera buffa* in beauty, not in slapstick. The music is designed to provoke not wild laughter but a wise and grateful smile. Jealousy and self-understanding, love and deception, seesaw throughout *Figaro* in actions so petty, so humdrum, so familiar that they remind the viewers not of a fantasy-land eighteenth-century Seville but of their own twenty-first century dailiness, their own quotidian dramas. If it is "we" who are on stage in *Figaro*, failing to persevere or to forgive, misunderstanding and then misunderstanding again; it is also we who inhabit and are irradiated by the music's beauty, and it is we who can wind our way through the convolutions of farce into the higher regions of delight. In this empyrean, delight feels almost like a worldview.

Art and the artist are said to have responsibilities, especially these days. One of those responsibilities is to respond to the surrounding circumstances and to take them into account. The word "novel" derives from the French word *nouvelle*, which is less about novelty than the news. Novels bring us the news.

So too do all the arts, and these days the news is bad. Climate change has begun, standing like a roadblock before the future. Russia's war in Ukraine, which already is a long war, is not a local war. It is an attack on international comity, an attack on American aspirations to global leadership, and an attack on peace in Europe. The record of atrocities is large and getting larger — committed sometimes on the same terrain whose previous experience with mass murder yielded the phrase "never again." Climate change and war are occurring in the midst of pandemic, food shortages, and the gradual replacement of globalization (mixed blessing that it always was) with war economies guided by sanctions, military spending, and the rationing of goods that the war will soon demand. And China is on the march.

In the 1930s, the United States was an antidote to the bacillus of worldwide chaos and aggression. Italy had Mussolini, Germany had Hitler, Spain had Franco, Portugal had Salazar, and the Soviet Union had Stalin. The United States had Franklin Roosevelt. For Joe Biden's America, the bacillus is foreign and domestic: the zombie-like nature of Donald Trump, who refuses to stay buried in the political grave of his electoral defeat; an intractable economic inequality; a Congress trapped in performative outrage and real gridlock; a polarized society intoxicated by its respective particularisms that is less and less curious about its own members, less and less capable of the empathy, compromise, patience, and calm that enable democratic practice and social peace; a civil society armed to the teeth in which massacres are a regular feature of civic life; a culture that vacillates between sanctimony and indifference, egotism and self-abasement, ivory-tower jargon and social-media vulgarity. The common impulse is not so much to analyze as to diagnose the United States, though

nobody seems to know what the disease is. No matter: we are all advocating cures — more democracy, less democracy, more secularism, more Christianity, more civility, more fight, more rule of law, more attempts to storm the cockpit and prevent United 93 from crashing.

Artists have taken heed. Climate change and its causes are a more than valid subject for art. And not a new subject: you can spot an objection to industrialization in many landscape paintings of the nineteenth century, such as the train in the distance in Thomas Cole's verdant mountains. The campaign to reverse climate change speaks to greed and moral escapism. *Don't Look Up,* the recent movie on climate change, was Swiftean in its set-up, though neither clever nor cutting enough to be Swiftean in its execution. Responding to war is similarly one of the constants of art, which will be crucial to any reckoning with the war in Ukraine. Art eclipses the writing of historians in the public memory of war; it — Goya is the most powerful example — is the best aid to moral reflection, especially for events that disturb us into confusion and numbness. Art also crosses the borders that wars impose, taking people out of uniform, out of victimhood, and back to their humanity. But generally political art does not accomplish the restoration of humaneness. Art will not be capable of untangling the crossed lines of American politics, in the short term at least. Too often twenty-first century American artists surrender loudly to their politics and themselves become instances of the overarching political polarization that ails us. Needless to say, art does not come up with political solutions. To ask solutions of art is to ask a misguided question, to ask of art, even political art, more than it is able to give. Artists may think they have solutions to political problems, but the solutions will not be their art.

160

The mistake is to assume that art must take its inspiration from climate change, from war, from political dysfunction or from similar crises and public disfigurations. The irony is that these grand disturbances are far too small a palette for any artist. Art answers to a fuller spectrum of emotions and imperatives. Among them is the emotion and the imperative of delight. Even in dark times, or perhaps especially then, art cannot forgo the resources of delight, or ignore its utility, the temporary salvation from bleakness that delight provides. These three practitioners of delight, Van Alen, Armstrong, and Mozart, were not coincidentally innovators. Van Alen invented a skyscraper unlike any other, employing new materials, configuring the architecture to go as high and reflect as much light as possible. In 1928, Armstrong was pioneering the sounds and structures of jazz, and imparting its astonishing originality in the relatively novel setting of the recording studio. Mozart remade *opera buffa* into a high art form and did so with an edgy and transgressive story. (The original Beaumarchais play was banned from the Habsburg empire, a portend in 1786 of the revolution three years later.) Van Alen, Armstrong, and Mozart had problems aplenty. They did not bleach them out of their art. Neither did they fall so in love with their problems that they lost sight of their joy in creation, and in their individual genius for giving others delight.

Delight is, or had better be, an essential part of culture. It softens the rough edges. It opens the window. It balances out the indignities. It dissipates anger. It separates beauty from sadness. It converts the grapes of wrath into the wine of extreme satisfaction, of lively pleasures, of gratification of mind, when the weight of events does the exact opposite. Much as Van Alen's Chrysler Building mutely witnessed the

Great Depression, before which it was designed and during which it was built, art aligned with delight will not cast off or lessen the weight of events. Delight is impermanent. "West End Blues" lasts only three minutes. When it reaches its fourth act, *The Marriage of Figaro* is almost over, its plot about to resolve. Delight is so necessary because it will never be the rule; it is relief from the rule. Once one sees the Chrysler Building from the street, New York will heartlessly reimpose itself. It will not let you rest in that spire's glistening ambience. The Chrysler Building was not placed gracefully in a planned city. It offers momentary respite from the frenzy of promotion, the money making, the reputation making, and the thrill seeking to which New York City is unashamedly devoted. Delight's victories never last.

Yet its victories are precious nonetheless. They are restorative. While the sensation of delight passes in a rush, delight's invigorations remain. Delight is the secret spring. It reveals an entire vein of possibility. It furnishes energy for the walk through the shadows that inevitably follows an interlude of delight. The memory of delight is one of our most valuable inner resources, internalized for the undelightful *longue duree*. Delight and dread are formidable antagonists, and delight teaches us to live with those elements that engender worry, sadness, oppression, and horror. Delight was Proust's response to the scent of the madeleine: "An exquisite pleasure had invaded my senses, but individual, detached, with no suggestion of its origin," he wrote. "And at once the vicissitudes of life had become indifferent to me, its disasters innocuous, its brevity illusory." Proust started *In Search of Lost Time* before World War I, and he set down much of it during and after the war. As he rigorously documented malice and prejudice and desperation and cruelty in the people he knew and

invented, he remained devoted to delight, as a principle and as an experience, without which he could not have begun his novel or continued it or come close to completing it. It was indispensable for his spiritual survival and his exploration of the vicissitudes of life, reason enough to be forceful but never to be uninterruptedly fretful.

ADAM ZAGAJEWSKI

Another Life

You like to read biographies of poets
You rummage through another life
That sudden shock
of entering another life's dark forest
But you may leave at any moment
for the street or the park
or from a balcony at night
you may gaze at stars
belonging to no one
stars that wound like knives
without a drop of blood
stars pure and shining
cruel

The Old Painter

The old painter stands by the studio window,
where his brushes
and colors lie.

Poets wait for inspiration, but objects
and faces assault the painter,
they arrive shrieking.

Their contours, though, have
blurred and faded.
Objects turn blind, mute.

The old painter feels only
a dim wave of light,
a longing for form.

And he knows even now
that he may see again
the bitter joy of indistinction.

In the Garage

And then when you entered
the empty garage
a trumpet called
as in the Fifth Symphony
And it suddenly grew clear
that there is joy and death
and mad flies
that circle the table
where all of you sat
just moments ago
calmly chatting

The Twentieth Century in Retirement

Let's try to imagine it:
a little like old Tolstoy
he strolls the fields of Picardy,

where funny tanks once
clumsily defeated
the terrain's slight elevation.

He visits the town
where Bruno Schulz died
or sits on a riverbank

above the Vistula's dim water,
a meadow scented with warm
dandelions, burdocks, and memory.

He doesn't speak, rarely smiles.
Doctors warn him
to avoid emotion.

He says: I've learned one thing
There is only mercy —
for people, animals, trees, and paintings.

Only mercy —
always too late.

The Allegory of Good and Bad Government

Good government, *Buon Governo*,
and the good judge — we see
how Siena thrives
under the just ruler.

Peace reigns over all, revealed.
The peasants work serenely,
grapes swell with pride,
a wedding party dances in the street.

But bad government sets out
to torment justice,
who bears the lovely name Iustitia,
it lies, it sows Discord,

it delights in Wickedness
and Deceit; it ends by hiring assassins.
The town empties, fields cease
to bear fruit, houses burn.

Still, after seven centuries, just look,
(compare the two frescoes)
Evil is pale, barely legible
while Good compels our gaze
with its rich colors.

Only seven hundred years
of waiting.

Figs

Figs are sweet, but don't last long.
They spoil fast in transit,
says the shopkeeper.
Like kisses, adds his wife,
a hunched old woman with bright eyes.

Translated by Clare A. Cavanagh

ANDREW SCULL

The Fashions in Trauma

In articles that appeared in the American *Journal of Psychiatry* in
1969 and 1971, three army psychiatrists boasted that the policy
of embedding psychiatrists in Vietnam's combat units had
been a wonderful success. And so the army's statistics seemed
to show. Peter Bourne, who headed the army's psychiatric
research team, announced that henceforth "psychiatric casual-
ties need never again become a major cause of attrition in the
United States military in a combat zone." It was an assertion
that provoked fury among many of those who had been sent to
fight in the jungles of Southeast Asia. Soon enough, that anger
had tangible consequences of a profound sort.

Bourne was not the first psychiatrist to claim that his profession had the capacity to ward off the effects of war on the troops. As entry into the Second World War loomed, American psychiatry mobilized. It persuaded Washington that if it wanted to avoid the epidemic of shell-shock that had disabled so many soldiers in the First World War, the government should allow it to screen out the psychiatrically vulnerable. In that way, the damage to morale and to the army's ability to fight could be avoided, as could the waste of resources involved in training soldiers incapable of enduring combat.

One and three quarter million potential recruits were rejected on psychiatric grounds. It was a triumph of science and forward planning. Except that once combat began, it swiftly became apparent once again that modern industrialized warfare was not ideally suited to the maintenance of mental health. Placed under sufficiently appalling stress, the soldiers of the greatest generation broke down between two and three times as often as those who had fought in the First World War. At war's end, fifty thousand veterans, not all of whom had actually faced combat, languished in mental hospitals, and another half a million received pensions for psychiatric disabilities. Trauma and psychological stress, it seemed, could cause even the most apparently stable individuals to break down, to become maddened with fear, disgust, and horror.

The traumatic effects of modern military conflict had, in fact, surfaced many decades before even the mass slaughter and maiming that marked the First World War. In the aftermath of America's Civil War, the newly emerging subspecialty of neurology expected that much of its practice would consist of treating soldiers with obvious wounds of the brain and the nervous system. But such casualties were far outnumbered by

veterans who displayed no obvious physical pathology, but who insisted that they were ill and incapacitated. By the end of the war, eight percent of the Union army alone, some 175,000 men, were found to be suffering from "nostalgia" (usually a synonym for depression or panic), or from a variety of "nervous" complaints extending all the way to outright insanity.

Nobody thought to suggest that these men suffered from trauma, because in those years the word retained its original meaning. Derived from the ancient Greek word Τραύμα, it had entered the English language in the late seventeenth century, and was used to refer to physical wounds. It was derived from other words meaning twisting, bruising, piercing, and the like. Its extension to encompass emotional wounds would not occur till the late 1880s, when the French neurologist Jean-Martin Charcot and then Sigmund Freud began to employ it in a more extended sense to mean psychological responses to deeply distressing events, and to suggest that the origins of the neuroses lay in shattering emotional disturbances.

Even in contemporary medicine, of course, the original meaning persists in the designation of certain hospitals as "trauma centers," that is, places that treat physical injuries of sudden onset and severity that require immediate interventions to save live and limb. Though the psychiatric casualties of the two World Wars gave greater cultural salience to the notion of psychological trauma, the word's primary reference to physical injury still dominated. For example, when the American Psychiatric Association published the first edition of its *Diagnostic and Statistical Manual* in 1952, psychological trauma was entirely absent from its pages. The only mentions of trauma referred injuries caused by force or by seizures that were experienced by patients treated with electroshock.

The Fashions in Trauma

If the concept of psychological trauma enjoyed greater cultural and professional salience in the following two decades, this largely reflected the fact that psychoanalysis had come to dominate out-patient and academic psychiatry, at least in the United States, and to have an ever-greater influence in American culture. Freudians gave pride of place to the concept of repression and its traumatic effects in accounting for mental disturbances. Trauma in the sense of psychological injury entered common parlance.

In this changed context, Peter Bourne's suggestion that traumatic injuries were largely non-existent among the grunts who fought in Vietnam soon came under attack. Embittered veterans who were among the vocal minority that joined the anti-war movement fiercely rejected that pollyannaish narrative. On the contrary, they insisted, their experiences had left them traumatized, and they mobilized to secure official recognition of the damage that the war had done to their mental health. Sleepless nights, nightmares, flashbacks to scenes of sickening horror, unpredictable and uncontrollable episodes of anger, panic attacks, blackouts, emotional numbness, depression — a host of ills was blamed on the war by those who regarded it as an abomination, a crime against humanity in which they had been forced to collaborate.

Crucially, amid a rising tide of anti-war sentiment, these veterans soon secured allies among the psychiatric establishment, especially two prominent psychoanalysts and psychiatrists, Chaim Shatan of New York University and Robert Jay Lifton of Harvard. Shatan and Lifton joined forces to secure an official psychiatric diagnosis that recognized the reality

of these men's suffering. Shatan published a piece in *The New York Times* in 1972 in which he coined the term "post-Vietnam syndrome." He and Lifton insisted that its symptoms — the product of psychological damage inflicted on soldiers by a vicious war — could emerge and persist long after the trauma that caused them. Within eighteen months, Shatan and Lifton were campaigning to have the diagnosis recognized as a distinctive form of psychiatric illness by the American Psychiatric Association.

They chose a propitious moment. For more than a decade, evidence had been accumulating that psychiatrists had a terrible time agreeing about diagnoses. For example, one important study comparing diagnoses of patients in London and New York found that while Americans called sixty-two percent of their patients schizophrenic, doctors in England gave only thirty-four percent that label. On the other hand, while less than five percent of New York patients were diagnosed with depressive psychoses, the corresponding figure in London was twenty-four percent. But studies like these were buried in academic journals and monographs, and drew little attention outside the profession.

Then a sensational article appeared in *Science* in January, 1973. It recounted an experiment in which a series of pseudo-patients presented themselves at a variety of mental hospitals claiming to hear voices but otherwise acting normally. All were admitted, and all but one were diagnosed as schizophrenic, and they were generally institutionalized for weeks before being released as schizophrenics in remission, a devastating diagnosis. Massive media attention to the study, authored by the Stanford social psychologist David Rosenhan, held the profession up to ridicule, and in a panic the American Psychiatric Association formed a task force to revamp its

whole diagnostic system, and ensure that such embarrassing findings would not be repeated. Nearly a half century later, a New York investigative journalist, Susannah Cahalan, showed that Rosenhan's study was one of the great scientific frauds of the twentieth century. But it was a highly successful fraud, one that transformed psychiatry in ways that are still evident today.

The charge of reworking psychiatry's diagnostic system to deal with this crisis was entrusted to a Columbia psychiatrist, Robert Spitzer, who had trained as a psychoanalyst but by then had become hostile to its doctrines. He was given almost carte blanche in selecting the members of his task force, in part because the psychoanalysts who then dominated academic and high-status psychiatry regarded the assignment of diagnostic labels as silly and unworthy of their time. He and those he selected were the ones who were in charge of developing and writing the new edition of the American Psychiatric Association's *Diagnostic and Statistical Manual* (*DSM*, as it was called for short). Spitzer, who was targeted by Shatan and Lifton and their allies in the veteran community, and their efforts were in most respects remarkably successful.

Publicly, Spitzer and his colleagues on the task force presented themselves as driven by data and science. The claim to scientific objectivity was a pose, an ideological proclamation that was sharply at odds with the way in which the *DSM* task force actually conducted its business. In reality, Spitzer was a politically savvy operator, and the decisions of his committee rested upon the same sorts of clinical intuition that they attacked as unscientific when proffered by psychoanalysts. Consensus was created by horse-trading and then ratified by votes of the members. Yet in trying to convince Spitzer to agree with them, Shatan and Lifton faced a difficult problem. The majority of the task force was determined to purge

everything in the diagnostic manual that made reference to psychoanalytic ideas and claims. To do so, it had adopted a resolutely a-theoretical stance on the origins of the various disorders it recognized as varieties of mental illness, and instead undertook to define them via check lists of symptoms. Creating a new diagnosis of a mental disorder whose origins were trauma and its impact would represent a stark exception to the approach that the task force otherwise embraced. Worse yet, the proposed category of post-Vietnam syndrome would entail a particular moral and political stance toward the war, one that was intensely controversial.

Spitzer, it turned out, was highly sensitive to political pressure. In particular, unlike some of the more obdurate members of the task force, he understood that the dramatic changes the group was preparing had to pass muster with the membership of the American Psychiatric Association, whose ranks were dominated by clinicians, many of them psychoanalysts. Hence he was willing to concede principle in order to make room for the whole range of problems that brought patients into psychiatric waiting rooms, if such a concession proved necessary to gain acceptance of the revised manual. Yet his willingness to embrace the arguments for a trauma-based pathology did not extend to accepting a politically charged label. What materialized, therefore, was a much broader term: post-traumatic stress disorder was born, commonly known by its acronym, PTSD.

No field tests and no tests of reliability attended the birth of this new disease. In this way it differed from virtually all the other hundreds of diagnoses that made up the new third

edition of the manual, commonly referred to as *DSM III*. The official recognition of PTSD marked a significant broadening of the conditions brought into the ambit of psychiatry, but just how much of an expansion it would create was not immediately apparent. At this stage, the traumatic stress that was seen as precipitating the disorder had to be a major or life-threatening event that would "evoke significant symptoms of distress in almost anyone." One obvious example was exposure to the horrors of combat, but others were recognized as similarly traumatizing and liable to cause breakdowns. Rape and sexual assault, witnessing one's parent or child being shot, and being victimized by a major natural disaster were obvious comparisons. Proponents of the new diagnosis argued that for some people, though they were a minority, traumatic experiences such as these produced involuntary, recurrent, and intrusive memories, hypervigilance, emotional numbing or outbreaks of explosive anger, and persistent and deeply troublesome emotions. These in turn often produced reckless or self-destructive behavior, or violence directed at the self or others.

Embroiled in its foreign wars from the 1990s onwards, the American military and the Veterans Administration have by necessity had to grapple with a burgeoning group of veterans claiming disability and treatment for PTSD. By the late 1980s, the quarter-century long Freudian domination of American psychiatry that had marked the years after 1945 had almost completely faded away, and biology ruled the roost. The psychoanalytic perspective that had animated Shatan and Lifton's campaign was largely sidelined in the United States, replaced by a search for neurological and biological foundations for PTSD. Many veterans were tempted to embrace the idea that PTSD was a brain disorder because, like comparable myths about the chemical origins of depression, it made the condition "real" and

medical, and might thus reduce some of the stigma surrounding the condition. Logically, the explanation suggested to those in charge that PTSD would best be treated with the magic bullets of modern psychopharmacology.

But, as with the drugs used to treat depression, bipolar disorder, and schizophrenia, those magic bullets, when shot at PTSD, turn out to be not so magical after all. Despite the presence of little systematic research to support their use, antidepressants such as Zoloft, Prozac, and Paxil were prescribed to deal with the symptoms of PTSD. Weak evidence in their favor persuaded the FDA to license them in 2002 as a first line treatment of the disorder. A series of subsequent reviews of research on the pharmacological treatment of PTSD, the most recent of which was published by Matthew Hoskins and his colleagues last year, have repeatedly reached similar conclusions. As in the treatment of depression, drugs prove more effective than placebo in treating PTSD, but the differences, while statistically significant, are clinically quite modest, and the drugs fail to help many patients. Around forty percent of patients fail to respond to medication therapy, and of the remainder, the majority get some relief of symptoms, but not complete remission. At best, research to date shows that pharmacological interventions are a useful adjunctive therapy for patients with PTSD, not the gold standard of treatment they were once heralded to be.

So back to psychotherapy — not Freudian analysis, but the briefer forms of treatment provided by cognitive-behavioral therapy and its analogues. Often these involve prolonged exposure to materials designed to flood patients with memories like the ones that originally produced their trauma, but in safe surroundings. The expectation is that these recollections will, over time, desensitize them, wean

them from trauma-induced bad behaviors, and transform the original horrors into something like fiction. Unfortunately, that does not always happen. The Israeli army conducted a controlled study of the technique on soldiers traumatized by the intifada, only to discover an increase in the soldiers' psychotic symptoms, post-flooding. The Cochrane Library, which publishes high-quality independent assessments of all sorts of medical interventions, recently surveyed the available evidence on the efficacy of psychological treatments for patients with PTSD and the substance abuse that commonly accompanies it. The paper's authors comment on how clinically challenging such cases are, and they conclude that here, too, the benefits are modest, with very high dropouts in all trials, and no evidence that the forms of psychotherapy they examined provided any benefit in the treatment of the substance abuse. Of all these interventions, exposure therapy is the least popular and produces the highest drop-out rates. One expert has dubbed it "among the worst possible treatments" for trauma. In sum, though helpful for some, the various forms of psychotherapy are of only limited utility.

If the proximate cause of the inclusion of PTSD in psychiatry's diagnostic manual was pressure from some Vietnam veterans, and granting that a substantial fraction of those who have served in the armed forces from 1990 onwards have eventually been diagnosed with PTSD (estimates generally range north of ten percent), still the diagnosis that entered the *DSM* potentially encompassed a much broader range of precipitating events than combat exposure. As soon became apparent, the inclusion of a trauma diagnosis in the new *DSM* opened a Pandora's box.

The first manifestation of the potential for diagnostic creep that the new category invited did not take long to surface. Enterprising psychiatrists and psychologists soon claimed to have uncovered a whole new category of victims, those who remembered not too much, but too little. Freudians had long argued that the origins of mental illnesses were murdered memories that refused to stay dead, their repression triggering the patient's symptoms and persisting till the probing of the analyst made the unconscious conscious. Proponents of the recovered memory syndrome deployed an analogous argument: they claimed that they had found a host of new patients, people (often children) so traumatized that they had buried the memory of the horrors they had experienced, and now suffered from seeming unrelated mental disturbances. Perhaps the most famous explication of this argument, and certainly the most commercially successful, was *The Courage to Heal*, the best-seller written by Ellen Bass, a poet, and Laura Davis, a short story writer, in 1988. It sold three quarters of a million copies. It compiled an extraordinary laundry list of symptoms that could be indicative of past abuse. Some examples included feeling powerless or unmotivated; lacking interest in life; neglecting or minimizing one's talents. Borrowing from Freud's notion of resistance, the book suggested that even denying that one had been the victim of abuse could be a sign of past abuse. Accounts of abuse, Bass and Davis asserted, were *never* false, though their acknowledgment was complicated by the repressed memories that the abuse provoked.

As Bass, Davis, and others emphasized, patients whose early sexual traumas were so powerful that they had suppressed all memory of them could, in the hands of skilled therapists, subsequently recall them in vivid and exacting detail. It was the return of the repressed with a vengeance.

And vengeance was soon unleashed. A moral panic ensued, extending across the United States and rapidly creating echoes in Europe. Children, it seemed, were being abused on an extraordinary scale, often by parents (especially fathers), but also by other caretakers, such as the staff of preschools. An early example of mass hysteria was the McMartin preschool scandal, a gothic tale that gripped the media for months, and ruined many innocent lives.

Over the course of nearly a decade, beginning in 1983, members of the McMartin family, who ran a daycare center, were accused of hundreds of acts of sexual abuse of the children in their charge. The claims soon extended to allegations of satanic abuse, witchcraft, and orgies in secret tunnels under the school where unspeakable acts were perpetrated. At the hands of their "therapists," children were induced to confirm even the most bizarre stories, and two of the longest and most extensive trials in California history eventually followed. The total costs of the investigations and trials were estimated at upwards of fifteen million dollars, and they received widespread coverage in the print and broadcast media, most of it highly biased in favor of the accusers and the prosecution. It was a modern-day Salem witch trial, and even the failure to secure any convictions failed to dent the confidence of many in the truth of the allegations. Besides ruining the lives of the accused, the episode left behind hundreds of emotionally damaged children.

Throughout the 1980s and 1990s, cases of recovered memory proliferated. In Teeside, in northeast England, for instance, during five months two pediatricians diagnosed 121 local children from 57 families as suffering from sexual abuse. Numbers grew to crisis proportions, and hundreds of children were removed from their homes and placed in care. In this

instance, however, the police remained highly skeptical of the doctors' claims, though once more the accusations received massive media coverage. Eventually, the vast scale of the allegations and their growing implausibility led many to conclude that the crisis was manufactured.

But still reports kept surfacing elsewhere in Britain (as in the United States) of child abuse and satanic rituals, and academic conferences and some feminist writers insisted on the reality of recovered memories and the ubiquity of early childhood abuse. Such beliefs persist in some quarters even now, and are fiercely held, notwithstanding accumulating evidence that discredits the central tenets of recovered memory syndrome and demonstrates the suspect and deeply unsatisfactory quality of the "evidence" once proffered in its support.

The models of human memory on which the enthusiasts for recovered memory syndrome relied were increasingly undermined as those studying the subject put them to the test. Those who experienced repeated trauma, it turned out, far from forgetting, remembered being abused all too well. In the words of the Harvard psychologist Richard McNally, "The notion that the mind protects itself by repressing or dissociating memories of trauma, rendering them inaccessible to awareness, is a piece of psychiatric folklore devoid of convincing empirical support." Additionally, as critics examined how therapists had "helped" their clients to recover memories of past abuse, it became increasingly apparent that suggestion and even outright coercion had played vital roles in creating and structuring the patients' reports. None of these counterfactuals convinced the true believers in recovered memory syndrome. "Trauma," one of them truculently asserted, "sets up new rules for memory." Just as

recent public opinion polls show that seventeen percent of Americans accept that "a group of Satan-worshipping elites who run a child sex ring are trying to control our politics and media" and are impervious to any evidence to the contrary, those promoting recovered memory syndrome rejected the researchers' criticisms out of hand.

By the turn of the century, though, the movement was facing rapid eclipse. Allan Horwitz has suggested that a major factor in its decline was a spate of lawsuits against some of the more prominent therapists, one of whom was forced to pay nearly eleven million dollars in damages in a case brought by one of his patients. The increasingly outlandish recovered memories also invited skepticism. Claims of Satanic rituals, murder of babies, and cannibalism ran aground when not a single such incident could be uncovered. And the media, having once embraced and spread the movement's stories grew skeptical and then hostile, following the courageous lead of Dorothy Rabinowitz of the *Wall Street Journal*, who journalistically damaged the whole notion of repressed memories beyond repair. Within the academy, once in thrall to Freudian ideas, apostates such as Frederick Crews repeatedly ferociously dismissed Freud's ideas about the authenticity of repressed memory. (Crews and other renegades regarded Freud as a complete charlatan.) And when insurance companies ceased paying for long-term treatment of the condition, it almost miraculously disappeared from the scene.

That was not, of course, because child abuse somehow vanished as a precipitant of mental health problems, including major depression, substance abuse, and suicide. On the contrary, to cite just one major example that has proved international in scope and massive in scale, the Roman Catholic Church has had to deal with an avalanche of

lawsuits and pay billions of dollars in damages for the sexual assaults of pederastic priests and the decades (if not longer) during which the church hierarchy connived in and covered up these predatory behaviors. Notably, however, the victims of these horrors did not forget the traumas they had experienced. Rather, for years they were intimidated into silence, or were afraid or too ashamed to make public what had happened to them.

At the height of the moral panic about recovered memory, American psychiatrists had themselves contributed to the epidemic by modifying the definition of PTSD that appeared in the revised edition of the DSM that was issued in 1987. *DSM IIIR*, as it was called, added a clause to the diagnosis that allowed that trauma might not rapidly produce PTSD, but might emerge later in those with an "inability to recall an important aspect of the trauma." A subsequent revision, *DSM IV*, loosened the diagnostic criteria even further. Before the trigger had been the experience of extraordinary trauma, far outside the range of normal human experience, something that would "cause distress in almost everyone." The new edition dropped these criteria. Instead, it pronounced that PTSD could be provoked when "the person experienced, witnessed, or was confronted with events that involved actual or threatened death or serious injury, or involved a threat to the physical integrity of self or others" and felt "intense fear, helplessness, or horror." That meant that those who witnessed a loosely described traumatic event, even those who saw it on television and experienced an intense emotional reaction to it, could qualify for the diagnosis. With a new emphasis on the subjective response of the

185

individual, the stage was set for claims that all sorts of daily setbacks and experiences could suffice to induce PTSD.

Marital infidelity, the break-up of a relationship, the sudden and unexpected death of a loved one, unwelcome sexual attention that stopped well short of assault, reading upsetting material in academic classes, hate speech — any number of triggers could prove powerful enough to induce the requisite trauma. Other extensions were more plausibly related to the battlefield trauma that had led to the new diagnosis. First responders — police and firefighters in particular — have come to be seen as especially vulnerable, since their work exposes them to highly stressful and traumatic situations on a regular basis. (The evidence that these encounters actually do heighten susceptibility to PTSD is thin, but the assumption certainly makes claims for compensation easier to establish, given the unavoidable diagnostic dependence on self-reporting.)

Symptoms might surface promptly, or manifest themselves months or years after the fact, and might change over time, in keeping with the chameleon-like and utterly protean character of the disorder. And since the diagnosis often rested on subjective complaints, and what counted as evidence of PTSD was so variable and capacious, it comes as no surprise that the number of patients given the diagnosis has soared. Given the poor track record of available treatments, that has ominous implications for the fiscal burdens that American society will face. The new edition of psychiatry's diagnostic manual, *DSM-5*, published in 2013, did make some effort to tighten PTSD's definition, so that watching something on television, for example, is no longer to be seen as a sufficient trigger, and it removed references to one's emotional response to trauma, but in many ways the genie was

already out of the bottle. The loosening of the definition of trauma became a fact of American culture.

If we look first to the figures for America's fighting forces, the magnitude of the problems associated with trauma begins to become apparent. Military leaders have routinely been profoundly suspicious of complaints of combat-related trauma. They had and have a disposition to dismiss those who exhibit its symptoms as cowardly malingerers or worse, and sometimes they have acted on those beliefs, as when the British army executed some of its shell-shocked soldiers as deserters. The secondary gains of succumbing to shell shock or combat neurosis or PTSD were only too obvious: escape from the imminent probability of mutilation or death. In the end, though, the preternatural tenacity with which shellshock victims, for example, clung to their symptoms made simple claims of malingering hard to sustain. All but the most benighted generals (George Patton comes to mind) eventually acknowledged what trauma could do. Yet the problem of distinguishing the genuinely traumatized persisted, and was magnified after the World Wars and their successor conflicts by the pensions, free medical treatment, disability payments from the Social Security Administration, and other benefits a psychiatric diagnosis brought in its train.

Some statistics indicate how difficult it has become to keep the epidemic of trauma-related disorders within bounds. Between 2003 and 2012 alone, the number of veterans seeking PTSD treatment from the VA grew from 190,000 to more than half a million. In just three years, 2010–2012, the VA spent $8.5 billion on PTSD treatment, and the Department of Defense another $790 million. More than forty percent of the troops who served in Iraq and Afghanistan have already been approved for lifetime disability benefits. Although those

numbers include compensation for medical as well as psychiatric disorders, a substantial fraction of the costs of disability is being incurred for mental health treatment. Before 9/11, ten percent of veterans sought assistance for trauma-related disabilities. That fraction has recently risen to thirty-six percent. Perhaps, though it has become heretical to broach the subject, that rise is not unconnected to the very substantial monetary and other benefits the diagnosis brings in its wake. In 2014, for example, as Allan Horwitz points out, "successful claimants with 100 per cent disability received an annual tax-free benefit of $34,884 if they were single and $39,216 if they were married with two children."

In the civilian world, new legions of trauma therapists stand ready to help, attending not just to those actively complaining of traumatic disorders, but to those thought to have been exposed to traumatic events. The destruction of the Twin Towers in Manhattan, the widespread damage and destruction associated with Hurricane Katrina, the horrific aftermath of the multitude of school shootings that are now such a routine and appalling feature of American life: natural and man-made disasters are everywhere, and now are accompanied by an influx of trauma counsellors, often funded by special appropriations from Congress. Yet those moneys generally go unspent. Only a fraction of the large amounts Congress provided to treat the traumatic effects of 9/11 were used. Most people turn out to be quite resilient even in the face of these horrors, and even the great majority of those who are initially traumatized seem to recover quite promptly without professional treatment. By contrast, others exhibit symptoms of PTSD and claim the diagnosis in the aftermath of what most would regard as a quite minor stressor.

This massive broadening of the concept of trauma has had a host of undesirable effects. Perversely, encouraging people to see themselves as victims of trauma pushes them to embrace that identity. In Nick Haslam's words, we "risk over-sensitivity: defining relatively innocuous phenomena as serious problems that require outside intervention." Adversity and emotional upset are, after all, inevitable parts of all our lives. To label such misfortunes as trauma and thus to suggest that they may trigger permanent psychological damage is all too likely to prove a self-fulfilling prophecy, provoking people to see themselves as irretrievably damaged, wounded, or disordered. Such diagnostic creep gives those afflicted with the minor challenges of everyday life the same label as those who are forced to cope with catastrophically severe and life-threatening events, thus devaluing the suffering of the latter group. It conflates things that distress, disturb, or upset us with events that crush us, that shatter our lives.

There is another danger that arises from the broadening and devaluing of the concept of trauma. Universities proclaim themselves bastions of free speech. Increasingly, however, students have begun to complain about readings, discussions, and course materials that they find distressing. Their claims are amplified by the assertion that these encounters are traumatizing them. Hence the demand for so-called trigger warnings, even though there is evidence that they do not work and may even be harmful. Worse yet are demands that certain readings and viewpoints be banned because some find them injurious or "traumatizing." Those demands have come mostly from people who call themselves progressive, and it is clear they have had some success in intimidating faculty who

want to consider themselves "progressive," sometimes even securing the termination of those who fail to go along, as in two notorious cases at Yale. But the new fashion in trauma is not limited to the left. Thirty-two states in the more conservative parts of the country have employed similar arguments in arranging to restrict the teaching of the racial history of the United States. Students, as the Florida legislation proclaims, should not be made to "feel discomfort, guilt, anguish, or any other form of psychological distress on account of his or her race, color, sex, or national origin."

The specter, and even the reality, of censorship (or self-censorship) predicated on the need to avoid distress and trauma is real and immensely troubling. Many universities, institutions that ought to know better, have instead fudged the issue or actively failed to mount a principled defense of what is supposed to be their core value. In 2014, the University of Chicago spoke vigorously against the climate of intimidation. "Concerns about mutual respect," the university said, "can never be used as a justification for closing off discussion of ideas, however offensive or disagreeable those ideas may be to some members of our community.... In a word, the University's fundamental commitment is to the principle that debate or deliberation may not be suppressed because the ideas put forth are thought by some or even by most members of the University community to be offensive, unwise, immoral, or wrong-headed." At last count, eighty-seven other universities have signed this statement. What is remarkable, and disturbing, is the long list of those that have not, a list that includes Harvard, Yale, Stanford, and my own institution, the University of California.

Traumatology is now a major industry. Estimates are that the market for its wares in 2021 exceeded $1,740 billion,

and it is forecast to grow even larger over the next decade. Originally an American-made diagnosis, PTSD has spread world-wide, and aggregating the United States, five major European countries (Great Britain, Germany, France, Italy and Spain), and Japan, the total number of diagnosed cases of the disorder now exceeds five million a year. As with the statistics for major depression, that number includes under one umbrella a vast spectrum of sufferers. What Chaim Shatan and Robert Jay Lifton thought was a cultural and time-specific disorder brought into being by the impact of an immoral war on American soldiers has become a platitudinous and ever-expanding part of the psychiatric universe. Its continued growth and cultural salience are the more remarkable given the feeble therapeutic weapons that the profession is able to muster against its depredations, and given growing evidence that early interventions often prove unhelpful and even actively harmful. But as Nancy Andreasen, a leading American psychiatrist, commented at the end of the last century, "It is rare to find a psychiatric diagnosis that anyone likes to have, but PTSD seems to be one of them." If the mid-twentieth century was, in Auden's words, the Age of Anxiety, perhaps the early twenty-first century is the Age of Trauma.

ROBERT ALTER

Proust and the Mystification of the Jews

The controversy over whether Proust was in any sense a Jewish writer or, on the contrary, in some way essentially a Jewish writer, began in France only weeks after he was buried. It still persists there. But before we dip into these muddied waters, some clarifications are in order about the contradictory milieu from which he sprang.

Proust, who was born in 1871 in Auteuil near Paris, was, of course, a half-Jew, though that is not how he defined himself to others. His mother, Jeanne Weil, was the daughter of a wealthy Jewish stockbroker. Her son remained deeply attached to her all his life, and her image is affectionately inscribed in *In Search*

of Lost Time in the figure of the Narrator's mother and to some degree in that of his grandmother as well, together with his actual maternal grandmother. Jeanne's marriage with Adrien Proust, a perfunctory Catholic, was undertaken for social reasons on her part and for economic reasons on his. He was a highly ambitious physician who would attain considerable professional success, and the substantial dowry that Jeanne Weil brought to the union helped launch him on his career. The son of a grocer, he could not offer her lofty social standing through his background, but his identity as a Catholic gave her and the two sons she would bear him the necessary entrée into French society. A stipulation of their marriage contract was that any children of their union would be baptized as Catholics. Jeanne, however, never contemplated conversion, nor did her husband attempt to persuade her to convert, as far as we know.

There appears to have been no great romantic element in the marriage, and as was very common in *haute bourgeois* circles at the time, he had mistresses, including, it seems, one that he shared with his wife's uncle, Louis Weil. Proust himself was by no means a pious Catholic, though for a brief period around the age of twenty he actually thought about a vocation as a priest. The abiding appeal of Catholicism for him was aesthetic, as well as serving as a marker of identity. In 1896, in an often quoted letter to his friend Robert de Montesquiou, he states flatly that "I am Catholic like my father and my brother; on the other hand, my mother is a Jew." Why this attenuated connection with Jewish origins of a self-affirmed Catholic should enter into his enterprise as a writer is by no means evident, but the connection cannot simply be dismissed. To address this question, one must understand something of the ambiguous — or perhaps one should say,

Proust and the Mystification of the Jews

amphibian — nature of the Parisian Jewish milieu of which the Weil family was a part.

A recent book by James McAuley, *The House of Fragile Things: Jewish Art Collectors and the Fall of France*, happily offers a vivid and detailed account of this milieu. During the nineteenth century, a concentration of vastly wealthy Jewish families gathered in Paris. Many of them came from Germany or from Alsace-Lorraine (Balzac's Jewish banker speaks with a heavy German accent), though one prominent family, the Camondos, were Sephardic, their origins in Istanbul. To get some idea of the wealth these families possessed, the family patriarch Salomon Camondo was said to be the richest man in the Ottoman Empire. Many of these people remained for a time self-identified Jews, supporting synagogues and communal institutions, marrying and burying as Jews, and mostly wedding within their own social circles. The list of the affluent Jewish families is long: the Camondos, the Rothschilds, the Ephrussis (chronicled by their descendant Edmund de Waal in *The Hare with Amber Eyes*), the Reinachs, the Cahen d'Anvers, the Weils. Everyone in this milieu aspired to enter the highest echelons of French society.

Given that aspiration, it is hardly surprising that many of them intermarried, like Jeanne Weil, or converted to Catholicism, as she did not, and sought to put entirely behind them any traces of their Jewish origins, as she also did not. Alas, in the early 1940s the descendants of these families, including those who thought their Catholicism and their high social standing would protect them, were deported and murdered in the Nazi death camps. One must, of course, resist the temptation to say haughtily, "Little did they know...," an attitude against which Michael André Bernstein argued vigorously in *Foregone Conclusions*, his indispensable book on thinking

about past lives after historical catastrophe. But for a time — and certainly in Proust's lifetime — it seemed as though the offspring of these wealthy Jewish immigrants to France would continue to flourish splendidly, shining at the heights of French society and culture, whether as Jews or otherwise.

As McAuley's fine book richly illustrates, a principal avenue for this flourishing was aesthetic, and this aspect of upper-class French Jewish life has obvious relevance to Proust. Many of these families became great collectors of art. McAuley shows that their tastes tended to focus on paintings, furnishings, and objets d'art from the ancien régime, evidently out of a desire to identify with the traditional and aristocratic elements of French culture. There is an approximate analogy in this drive to collect with the wealthy New York families of the Gilded Age — one thinks of the Fricks, who left a legacy in the museum that bears their name — a group that was mainly *nouveau riche*. But the aestheticism of their French counterparts was more pronounced. In due course, they would leave their collections to national museums or turn their own grand mansions into museums. To get some notion of the sheer opulence of these collections, one has only to visit the Musée de Camondo, once the family's Paris residence.

All this ostentation of wealth in the collections elicited contradictory responses from those who considered themselves *Français de souche*, authentic native French. As the great Jewish collectors became public benefactors, they were appreciated by some for contributing to French culture. Others, predictably, resented them for their display of wealth, which in their eyes confirmed their preconception that Jews, inevitably vulgar, were concerned with nothing but the conspicuous display of wealth. The very taste of their collections was excoriated by some as a violation of true French

aesthetic values, an act of cultural subversion.

Such conflicting views are brilliantly etched in the representation of Jews and of the responses to them in the pages of *In Search of Lost Time*. This, after all, was the milieu that Marcel Proust knew through his mother. And it should be said that, Catholic though he officially declared himself to be, many of his schoolmates were acculturated secular Jews, mostly unbaptized. Although the young Marcel certainly had no desire to be thought of as a Jew, or even a so-called half-Jew, he could scarcely disengage from the awareness that the Jews were a distinct social constellation in France, encompassing even those who did not see themselves as part of it, and this visceral awareness came to play an important role in his novel.

Where does this ambiguous status of Jews in France lead one to think about the Jewish dimension, if there is one, of Proust's writing? If one may judge by the range of responses to his novel from the 1920s to the present, it leads to some strange places. Many of these responses have been documented in detail in an exhaustively researched new book by Antoine Compagnon called *Proust du côté juif*. (The extreme systematic thoroughness of documentation is perhaps not surprising in a country where doctoral dissertations often run to a thousand pages.) Compagnon is a prominent literary scholar who has written on Montaigne, Baudelaire, literary theory, and, repeatedly, on Proust. In this book, he tracks the published responses to Proust by Jewish writers from the early 1920s and then forward decade by decade. Many of these responses are rather curious. Let me add that Compagnon is party to a current debate on Proust's Jewishness, to which I shall presently turn.

Perhaps the oddest thing about the early views of Proust is that a group of young French Zionists, writing in *La Revue juive, Menorah, Palestine*, and sometimes in other journals, recruited him as an inspiration for their movement. They did not claim that he was actually a Zionist, and the famous — for some, notorious — remark in the introductory chapter of *Sodom and Gomorrah* — that "the fatal error [of homosexuals] would consist, just as a Zionist movement has been encouraged, in creating a sodomist movement and in rebuilding Sodom" — clearly does not make him a Zionist. The reasoning of those young Jewish intellectuals was along the following lines: Proust was already widely regarded as one of the major French novelists. In his big book, as they wanted to see it, this great writer offered a compelling example, chiefly through the character of Swann, of a staunch Jewish identity that was entirely secular. And this was precisely what they hoped to achieve through Zionism. In this oblique way, they contrived to see him as a Jewish writer, an extraordinary novelist they could claim as their own. The argument hardly requires refutation.

Another line of argumentation for claiming Proust as a Jewish writer was taken up in these early responses: that it was a matter of heredity. This view was typical of the common tendency to create a mystique about Jews. Frequent comparisons were made in those journals between Proust and Montaigne as purportedly Jewish writers — to be sure, with some pushback in the publications of the era. Montaigne had a grandmother whose maiden name was Lopez; she was a convert to Catholicism, and some have proposed that she was a Marrano, a crypto-Jew, despite her outward Catholicism. She was, of course, a forebear two generations removed from the writer, and there is no evidence that she could have influenced

him, even if in fact she did remain a secret Jew. Yet these young Zionist writers assumed that she preserved a distinctively Jewish consciousness which somehow percolated down to her grandson. Perhaps it was through "the blood"?

In this uncertain light, it was claimed that Montaigne's strikingly innovative mode of writing, with its frankness, its unblinking reflectiveness, and its bold analysis of mores and men, derived from his supposedly Jewish identity. Montaigne, it should be said, remained a loyal if not exactly devout Catholic, taking care to leave instructions that he should be buried according to the Catholic rite. He had, moreover, nothing like Proust's intimate relationship with a mother who remained a Jew. Yet he and Proust were said to share a distinctively Jewish ruminative style, even if the prose of one does not read much like the prose of the other. This mode of thinking, sad to say, is the positive mirror-image of the negative idea of heredity — the racist idea — that flourished after 1492 in the Spanish notion after of *limpeza de sangre*, or "purity of blood," which must be preserved by Old Christians against invasive aliens. The notion reached its monstrous apotheosis in Nazi Germany — namely, that a few drops of Jewish blood were forever determinative.

Another method of claiming Proust as a Jewish writer was through a proposed link with traditional Jewish sources, and this has persisted until our day. In the 1920s, it was contended by some that his innovative and often complicated style was "talmudic," although there is no evidence that he had the slightest acquaintance with the Talmud. The Talmud is an important Jewish text that is exotic and seemingly impenetrable to outsiders, and so it has been tempting for some as part of a general process of exoticizing the Jews to attribute a "talmudic" character to any writer having a Jewish heritage.

But "talmudic" means much more than dense or allusive. The association of Proust with the Talmud met published resistance in this early period, the objectors rightly countering that Proustian prose, however original, was thoroughly rooted in French literature.

The "talmudic" argument, with occasional exceptions, has not persisted, but an even stranger one, the association of Proust with another quasi-canonical Jewish text, the Zohar, still flourishes. The seductive appeal of the Zohar as a ground of Jewish writing is clear. If the Talmud is exotic, the Zohar, a mystical text composed in thirteenth-century Catalonia that is often deeply mystifying, is exotic to the second power. No less a French intellectual eminence than Julia Kristeva, in a study of Proust in 1994, stated with perfect confidence, though without any evidence (as Compagnon notes), that Proust drew on a translation of the Zohar when he was writing his novel. She throws into the mix of sources, moreover, the old contention about the Talmud: "One knows that Jewish tradition" — about which, of course, "one" knows almost nothing — "and especially the talmudic, to which Proust was responsive, proliferates interpretations." Having established by fiat that Proust was responsive to talmudic tradition, she confidently concludes that "in this light, Proust's experience can be said to be talmudic." This is all nonsense.

In the current French scene, the Zohar connection has been revived by Patrick Mimouni in a series of articles and in a recent book called *Proust amoureux: Vie sexuelle, vie sentimentale, vie spirituelle*. Mimouni, born in Algeria to a Jewish family, began his career as a film-maker with a sequence of films about AIDs and homosexuals. In the 1990s he began writing about Proust, soon immersing himself in the minute details of Proust's biography and repeatedly focusing on the role of

homosexuality in Proust's work. In his new book, he conveys a clear sense, following others, that Proust was not a garden-variety homosexual. It is known that, though he had a few lasting relationships, he frequented the kind of homosexual brothel catering to special tastes in which Baron Charlus is seen in the novel. Reports have circulated, passed on by Mimouni with, I think, a certain relish, that Proust attained orgasm by watching two rats savagely attacking each other, and Mimouni accepts the story that the horrific scene in the novel in which Madamoiselle Vinteuil, in the presence of her lesbian lover, spits on a photo of her dead father, actually mirrors an act by Proust in a gay brothel spitting on the image of his beloved mother.

For our present concerns, however, Mimouni devotes attention to what he contends is an important connection between Proust and the Zohar. This would be a significant feature of his *vie spirituelle*, the term in French spanning "spiritual" and "intellectual." The slender basis for this proposed familiarity with the Zohar is a passing reference by Proust to "reading" the Zohar around the time of his journey to Venice in 1900. But when he was working on *In Search of Lost Time*, a French translation of the Zohar was not available. His only access to the arcane work would have been through a Latin version. It is far from clear that his *lycée* Latin would have enabled him to get anything out of such a difficult esoteric text. Thus, Compagnon, in a rejoinder to Mimouni, expresses warranted skepticism about the notion that Proust was acquainted with the Zohar in any way. Mimouni on his part has accused Compagnon of deleting a reference to the Zohar in his edition of Proust's notebooks — a rather grave charge. The weight of evidence looks to be in favor of Compagnon, but for Mimouni and others determined to make Proust into a Jewish writer the temptation to see a link with the

Zohar is irresistible. And since few actually know what is in the Zohar, it is easy to claim that Proust drew on it, a claim that will be attractive to the many who have no informed connection with Jewish tradition but are either striving to be affirming Jews or are philosemitic gentiles, thinking of Jewish culture as something magical and mystical that was somehow transmitted to writers of Jewish extraction, however removed they were from Judaism and the Jewish tradition. To cite a small symptomatic instance in Proust's case: a brief mention in a letter to a friend in 1908 of the Jewish mourning custom of laying a small stone on the grave of the departed has been leaned on heavily by some commentators as a sign of their hero's extensive familiarity with traditional Jewish practices.

What, then, can reasonably be made of the Jewish side of Proust's great novel? A kind of baseline proposition was put forth by Edmund Wilson nearly ninety years ago in *Axel's Castle*, his pioneering study of literary modernism. With a flourish of characteristic common-sense intelligence, he wrote that "it is plain that a certain Jewish family piety, intensity of idealism and implacable moral severity, which never left Proust's habits of self-indulgence and worldly morality at peace, were among the fundamental elements of his nature." This seems just, though I am not quite sure about the intensity of idealism. One readily sees how he could have drawn these attributes from his mother, with no mystery of the blood as conduit. But the picture requires some complication.

In Search of Lost Time is certainly not a Jewish novel, but there is a noticeable presence of Jews within it, one that becomes increasingly evident in the last stages of the book.

Snobbery is involved in much of this. Proust is surely one of the most probing and subtle anatomists of snobbery in the history of the novel. He himself could definitely be regarded as a snob, but this only enabled him to understand the phenomenon all the more keenly. He was a man who loved to be loved — in the first instance, of course, by *maman*, but then especially by well-placed people in society. He did not hesitate to hobnob with vicious antisemites as long as they were sufficiently prestigious. Thus he dined at the home of Lucien Daudet, son of Alphonse Daudet, a contributor to Edmond Drumont's violently antisemitic *La France juive*, while Lucien's brother Léon belonged to the extreme nationalist right. Proust sat in silence while his host delivered himself of vituperative pronouncements on the Jews, and only later did he object in a letter to a friend. Similarly, he said nothing when his friend Robert de Montesquiou spewed a tirade against the Jews, though the next day he wrote a letter to Montesquiou, which I cited above, saying he had to differ with him on this because his mother was a Jew, though he himself was a Catholic. Evidently, he saw as the admission price to French high society a willingness to hear Jews vilified and to bear it in silence.

The vehemence of French antisemitism in this era may be a little hard to imagine now. It scarcely yields pride of place to the growing anti-Jewish fury across the border in Germany over the next several decades. That widespread hostility toward the Jews is the context of the Dreyfus Affair that split France apart as Proust was coming of age, and put a decisive stamp on the later pages of *In Search of Lost Time*. Drumont was the leading spokesman for this unrestrained hatred. Characteristically, early in the Dreyfus Affair, he writes of Joseph Reinach, who belonged to one of those wealthy Parisian Jewish families, "If his ape-like face and his deformed body

carry all the stigmata of his race, all the faults of the breed, his hateful soul swollen with venom better sums up all its evil, all its genius, disastrous and perverse." Der Stürmer did not invent anything new. It is important to realize that Proust, longing to be accepted in the best French society, was hardly moving through a neutral environment.

A number of Jewish characters, for the most part in relatively walk-on roles, cycle through the many episodes of *In Search of Lost Time*. Two of them are rather important in the imaginative economy of the novel. They are, of course, Bloch and Swann. In most respects they are altogether antithetical portraits, negative and positive, respectively. The Narrator has been an acquaintance of Bloch since the early days of both, and the Narrator has taken care to preserve a certain distance from him. Bloch is in certain ways the embodiment of the off-putting qualities that antisemites attribute to Jews. He is vulgar, unpleasantly assertive, conspicuously ambitious, and a social climber.

One of the hallmarks of Proust's greatness as a novelist is that in the course of time Bloch undergoes a transformation, whether seeming or real, like many of the other characters. When we encounter him later in the novel, he has assumed a noble-sounding name, Jacques de Rosier, married a Christian from a well-placed family, refined his manners, and contrived to attach himself to the French aristocracy. The Narrator may well invite us to regard this self-transformation as a disguise, perhaps a different manifestation of Bloch's initial vulgarity. The portrait of the new version of Bloch is amusing and etched in acid: "Thanks to the haircut, the removal of his mustache, to the general air of elegance, to the whole impression, his Jewish nose had disappeared, in the way a hunchback, if she presents herself well, can seem almost to stand straight."

Proust and the Mystification of the Jews

Yet there may be a certain element of the author in Bloch. He was, after all, the son of a Jewish mother and on his father's side a grocer's grandson. He by no means grew up as a Jew, like Bloch, but he must have been perceived as a Jew by at least some in the social stratosphere that he chose to inhabit. It was widely asserted that in the famous Nadar photo of a bearded Proust on his deathbed he looked like an Old Testament prophet — though not to me — as though at the end the Jew had emerged from the *mondaine*. Even more pointedly, some months earlier, an acquaintance, Fernand Gregh, remarked: "One evening, after for a time he had let his beard grow, it was suddenly the ancestral rabbi who appeared behind the charming Marcel we knew." Endowed with a good education and impeccable manners, Proust cultivated a polished persona that gave him easy entrée to exclusive places, and in those places he tolerated vehement antisemites. Proust certainly disapproved of Bloch, the character he invented, but I suspect that he put a little of himself in Bloch.

Swann, of course, is a much more substantial figure. Indeed, he is arguably the most complex and attractive character in the novel. Readers will recall that in the first pages of *In Search of Lost Time*, it is Swann as the dinner-guest of the Narrator's parents who distracts *maman* from going upstairs to her child desperately awaiting a goodnight kiss, although we do not immediately realize his identity. For a while in the novel we do not even know that Swann is a Jew, and I think this is a shrewd strategic choice on the part of the writer. Unlike Bloch, there is no suggestion that he has hidden his origins, but he does nothing to make people conscious of his ethnic identity. This is

not a matter of pretense or disguise. Swann is what he appears to be — a perfect gentleman, a poised socialite, a person of exquisite taste (one recalls the care he takes to go from florist to florist in order to assemble the perfect bouquet for the hosts who have invited him to dinner). He is also a loyal friend, something by no means true of everyone in this world.

Swann's one major slip is to fall in love with Odette, a young woman not as refined as he is and also a woman who has been far from chaste. She is, as the Narrator tells us more than once, not really his type. This paradox derives from Proust's always interesting assumption that the psychology of love is often quirky, unpredictable, contradictory. Proust's hapless love for his chauffeur, Alfred Agostinelli, who was obese when they met, uncultivated, and never much cared for his extravagantly indulgent benefactor, is a case in point from the writer's own life.

It is the Dreyfus Affair that flips our perception of Swann's Jewish identity. It may also have flipped something in Proust. The trumped-up charge that Dreyfus, a Jewish army captain, was guilty of treason in passing military secrets to the Germans became a litmus test for where one stood in French society. The accusation was widely believed; Dreyfus was convicted, stripped of his rank, and sent to imprisonment on Devil's Island. A retrial four years after the initial one in 1896 issued in another conviction. Only in 1906 was he exonerated and his military appointment restored with a promotion to major, after the real culprit had been exposed and fled the country. The false accusation, however, gained considerable credence and was embraced by staunch Catholics, conservatives, aristocrats, and also by some of the leading artists of the period (Degas, Cézanne, Renoir). The readiness of large numbers of the French to embrace a blatant and bigoted

falsehood has one sad explanation: there was a widespread suspicion, even among many one would have thought should have been better informed, that the Jews had never been altogether French. Their indelible foreign character thus made it plausible that one of them would be prepared to betray the vital interests of the nation to a foreign power. In Proust's novel, after Swann has declared himself a Dreyfusard, it occurs to the Duc de Guermantes that though he had always thought of Swann as a Frenchman, now he realizes that he was mistaken.

Proust himself became a defender of Dreyfus, even attending sessions of the first trial. His character Swann emulates him as a Dreyfusard. The aristocratic Guermantes, on the other hand, with just one exception, were anti-Dreyfusards, and they were prepared to discard their friendship of many years with Swann, now seeing him as a Jew. It even strikes them that Swann has been revealed to *look* like a Jew. The last physical description offered of him in the novel is shocking. He appears at the kind of elegant social gathering he has always frequented, but now he is wasted by old age and disease:

> his nose, for so long reabsorbed into a pleasing face, now seemed enormous, tumid, crimson, more of an old Hebrew than an inquisitive Valois [The Valois were a French royal line.]. Perhaps in any case, in recent days, the race had caused the physical type characteristic of it to reappear more pronouncedly in him, at the same time as a sense of moral solidarity with the other Jews, a solidarity that Swann seemed to have neglected throughout his life, but which the grafting, one onto the other, of a mortal illness, the Dreyfus Affair and anti-Semitic propaganda, had reawakened.

When Proust wrote these lines, he could have not known that he himself would be perceived by many in his photographic desk-mask as a Hebrew prophet. For the purposes of his novel he was drawing a polemical antithesis: Bloch's Jewish nose has receded through a kind of illusionist's trick while Swann's, hitherto barely noticed, had emerged in the uncompromising authenticity of his impending mortality.

A complement of sorts to this last image of Swann become a Jew occurs in the famous moment in which the Duchesse de Guermantes can spare no attention for her dying friend as she prepares to depart for a ball because she is entirely preoccupied with finding her red shoes to wear for the occasion. Proust's point in showing her in this light is clearly to illustrate how for women like her social vanity takes precedence over the mere human obligation of kindness and concern for a friend in extremis. One suspects, nevertheless, that her discovery through the Dreyfus Affair that the dying Swann is, after all, merely a Jew may have encouraged her to ignore Swann in his ultimate hour of distress.

Proust's ability to show how someone may change through time, both in regard to identity and in what happens to one's physical presence, is a signature aspect of his greatness as a novelist. It is a corollary of the long duration that he has devised for his novel, and one finds few parallels to it in other novels. One surely cannot detect any sign in this of those putative Jewish sources for his writing, the Talmud and the Zohar. Two rare precursors may be the Biblical stories of Jacob and David in the Hebrew Bible, and though these are texts that Proust knew, there is no evidence he paid any attention to scriptural precedents.

So it is hardly helpful to think of Proust as a Jewish writer,

much as some have sought to do so. He evinces no distinctive cast of mind, no special mode of writing and thinking, that can plausibly be attributed to the Jewish side of his family background. He writes about Jews in his novel because they were a visible part of the world that he set out to represent. In this limited respect, he does not differ from Philip Roth, who always objected to being labeled a Jewish novelist, even if the presence of Jews in Roth's fiction is much more predominant than in Proust's. As the son of a Jewish mother, Proust was acutely attuned to the precarious location of Jews in French society in his time, and he represents this fraught condition with penetrating understanding. If his Jewish background enters at all into the achievement of his novel, it is that, as a person pulled between two forces, something that perhaps he would not himself have admitted, he proved to be an unusually keen observer of both the French and the Jewish side of the tension. A writer needs to stand a little on the outside to see things with the greatest clarity.

The general lesson to be drawn from this strangely persistent controversy over Proust's identity as a writer is that there is nothing particularly mysterious or unique about the Jews. Granted, they are a people that has persisted in history over many long centuries, during which they produced remarkable cultural and spiritual achievements. But the Jews are like everybody else, and not even more so. To think that they possess some magical esoteric heritage that is manifested in the creative work of many writers of Jewish extraction is in the end foolish, and sometimes racist. Proust is pre-eminently a French writer whose literary lineage includes La Rochefoucauld, the *philosophes*, Stendhal, and Flaubert. Inevitably, he made use of what he knew from his mother's world and from his sometimes uneasy negotiation as his mother's son with the

French world beyond it, but then most writers make use of whatever is part of their familiar experience. Proust provides no inspiration for Jewish identity, and why should he?

STEVEN B. SMITH

What is a Statesman?

We yearn for great leaders, but we seem to resist them when they come along. This is a paradox inherent to democracies, between the demand for liberty, equality, and self-reliance among citizens and the continuing need for leadership in the unruliness of an open society. We vacillate between power and drift, between embracing strong leaders and endorsing a kind of leaderless rule. Our confusion about statesmanship is partly because we have lost the language in which to understand the term.

The term *statesman* has an old, even an antiquarian ring about it. Herbert Storing, a great historian of the American founding, once noted that there seems something almost

"un-American" about the word. While politicians pay lip service to the concept, for the most part the term is regarded as outmoded, elitist, and vaguely anti-democratic. Harry Truman once joked that a statesman is just a politician who has been dead for ten or fifteen years.

Yet it is hard to deny that today we are experiencing a dearth of statesmanship. With the exception of Volodymyr Zelensky, bless him, who is doing a stirring impression of Winston Churchill, statesmen are in short supply. Our current moment has certainly witnessed a renaissance of authoritarian figures — Putin, Xi, Modi, Bolsonaro, Orban, Trump — but none of these seem to qualify as statesmen. What is a statesman, and how do we know one when we see one?

The confusion about the concept is due in part to its unavoidably normative character. Isn't one person's statesman another's demagogue? Historians are often wedded to a kind of social determinism that regards the statesman as an agent of powerful classes, interests, and social forces which he or she may only dimly understand. Political scientists, who only feel at home in the world of big data that can be quantified and analyzed by mathematical methods, contribute to the flattening out of experience. But it is impossible to study political phenomena without evaluating them. If we are unable to distinguish a magnanimous statesman from a humble mediocrity from an insane imposter, we will be unable to understand anything about politics.

Like much of our political vocabulary, the concept of the statesman is of ancient origin. It is a translation of the Greek word *politikos*. Plato devoted an entire dialogue to this concept, although his most famous discussion of the statesman occurs in the *Republic*, where he famously asked what kind of knowledge a statesman had to possess. His answer was that the

politikos was required to be a philosopher-king, someone who blended a high degree of intellectual excellence or expertise with the skillful management of public affairs. Many people disagreed with Plato's answers — most notably Aristotle, his student — but his question is the one we have been grappling with ever since.

The understanding of statesmanship has been compromised by two tendencies fostered by modern democracy. The first view conceives the statesman as a technocrat, someone who is guided by scientific experts and who is then able to apply this knowledge to the various problems deemed to be plaguing society. This kind of statecraft is rightly called "progressive" because it regards progress in politics as dependent upon advances in scientific (and social scientific) knowledge. According to this view, as scientific knowledge increases so, too, does our ability to apply its insights to the most pressing issues of society, whether these are hunger, disease, poverty, inequality, or climate change. Social problems are regarded here as largely technical in nature and politics is seen as a form of policy science.

The idea that politics is reducible to policy is at the core of what is sometimes referred to as the administrative state. This view was imperishably expressed in Alexander Pope's couplet:

> For forms of government let fools contest;
> That which is best administered is best.

On this account, politics can be reduced to a form of problem-solving not unlike that encountered in the worlds of science, technology, business, and other aspects of a modern

capitalistic economy. The claim that we frequently hear from public officials that they are just "following the science" is a perfect illustration of this approach. Politics becomes a matter of implementing the insights of scientists, medical professionals, and other policy experts. We do not necessarily expect our leaders to be experts, but we expect them to follow the advice of experts, certainly in arcane areas such as public health and monetary policy.

The second misunderstanding confuses the statesman with the populist leader. As William Galston has argued, populism and democracy are to some degree inseparable. Every democratic leader claims to have the mandate of the people even if he holds power by only the slimmest majority, and sometimes not even by a majority at all. The populist leader was best characterized by Max Weber with the term "charisma". In his renowned essay "Politics as a Vocation," he invoked this term to distinguish the charismatic leader from the party politician. The charismatic leader is someone who claims to stand above special interests and party loyalty and speak directly to the people, and who can serve as their voice. In modern American politics, Woodrow Wilson was the greatest representative of this viewpoint.

The test of the charismatic leader is the claim to authenticity, that he speaks for the people. But how does one measure the authenticity of a leader? How does one distinguish the charismatic leader from the demagogue, the mountebank, and the fraud? How does one distinguish the true prophet from the false prophet? This is one of the oldest questions in the history of human affairs. Weber provides no acid test for charisma. There are no fixed principles, no program for action. There is only the personality of the leader. As Machiavelli said about the charismatic preacher Savonarola, he lost authority

only when the people ceased to believe in him. Charisma is very much in the eye of the beholder.

The problem with charismatic politics is its almost complete lack of content. In recent American history, Barack ("Yes We Can") Obama and Donald ("Make America Great Again") Trump have been regarded as charismatic leaders, but George H. W. Bush and Joe Biden have not. Yet a leader's charismatic properties have no bearing on the quality of his or her governance. Charisma is value-free: it can be used for good or evil. It is a means, not an end; except when it becomes an end in the form of personalist dictatorship. It is a kind of political mesmerism. There are no fixed principles of action beyond a certain theatrical gift and a demand for authenticity. In charismatic leadership, the message of the leadership is the ruler himself. Underlying this is a complete absence of, even contempt for, constraints on power. For this reason, charismatic leadership is often a recipe for extremism and violence. Weber regarded the charismatic leader as a remedy for the problems of political gridlock and stalemate, but there is only a short step from the populist leader to the *Duce* and the *Führer*. Charisma may not be incompatible with democracy, but it is dangerous to democracy.

To start at the beginning, statesmanship is about the care and oversight of states. It presupposes the bounded political units — call them states or nation-states — that have been the basis of international order ever since the Peace of Westphalia. The leaders of empires — Cyrus, Alexander, Napoleon — no matter how gifted they were in other respects, were not statesmen but conquerors and military despots. The same is true for those

who exhibit leadership skills in business, university administration, and criminal enterprises. They may express expertise but not political know-how. Statecraft fundamentally concerns securing the conditions of political legitimacy.

There are three kinds of statesmen I wish to consider: founders, preservers, and reformers.

The greatest statesmen in history are political founders, lawgivers, responsible for introducing "new modes and orders." These are inevitably revolutionary figures, people like Machiavelli's "new prince" who promise freedom and redemption from an oppressive political order. Founding statesmen have no authority other than their own words and deeds to justify them. It is their capacity to mobilize and to shape opinion that is the basis of their legitimacy.

Political founders come in all shapes and sizes, from mythic figures such as Moses, Lycurgus, and Romulus to Oliver Cromwell, George Washington, Lenin, and Mao. I would also add less well-known figures such as Atatürk in Turkey, Bismarck in Germany, Ben-Gurion in Israel, Sun Yat-sen in Taiwan, Nkrumah in Ghana, and Lee Kuan Yew in Singapore, as further examples of this creative type. These are all the "fathers of the Constitution" who create the frameworks within which later and lesser statesmen can handle changing situations.

The study of political foundings is exciting, as the never-ending flow of books, movies, and musicals about the American founders illustrates. Political founders typically try to set up the widest possible gap between themselves and the old regimes that they are attempting to overthrow. They wish to represent a rupture. In France in the 1790s, they renamed streets, remade the calendar, abolished historical provinces, reformed the language, and created new religious cults.

William Wordsworth famously recalled his own enthusiasm at the outbreak of the French Revolution,

> Bliss was it in that dawn to be alive,
> But to be young was very heaven!

Books such as Hannah Arendt's *On Revolution* and J.G.A. Pocock's *The Machiavellian Moment* celebrate revolutionary beginnings as the only times of truly creative political action. Such revolutionary moments seem almost to be breaks in political time, as Stephen Skowronek has argued.

But while it is easy to romanticize revolutionary moments in history, it is just as easy to forget precisely how tenuous and dangerous such moments are and how easily things can turn dark. Consider how quickly the Arab Spring turned into the Arab Winter, as exhilarating hopes for democracy foundered on the shoals of political reality. Even at their best, founding moments introduce a principle of disruption into political life that, once started, cannot easily be stopped. As Aristotle warned, the habit of disobeying law, even a bad law, has the tendency of making people altogether lawless. Revolution is not a bus that you can get off at will.

In 1838, in his speech on "The Perpetuation of Our Political Institutions," Lincoln warned against the dangers of the "towering genius" in politics. The American founders were men who staked their all on creating free institutions. But their nobility and their sincerity of democratic purpose does not preclude the possibility that later generations will produce Alexanders, Caesars, and Napoleons of their own. Such men will not rest content with perpetuating what has been established; they will seek new fields of glory as a testament to their own ambition and love of fame, and often

this will involve the repeal of the accomplishments of those who preceded them. "Towering genius disdains a beaten path," Lincoln warned. "It thirsts and burns for distinction and, if possible, it will have it, whether at the expense of emancipating slaves or enslaving freemen." How to channel this overreaching ambition remains a permanent challenge for any theory of statesmanship. What is a durable constitutional republic, after all, if not a beaten path?

If the political founder is the rarest type of statesman, the most familiar type is the preserver, who works within an established set of laws and institutions to maintain the coherence of a tradition. Preservers are typically conservatives such as Walpole, Burke, Adams, and Disraeli, who are responsible for maintaining the social fabric often after periods of war or social upheaval. They see themselves as custodians of continuity. Preservation is the policy of adjusting old traditions to fit new situations. Like the "Parting Hours" described by George Crabbe,

> The links that bind those various deeds are seen,
> And no mysterious void is left between.

The art of preservation may seem an unambitious role in comparison with founding, but it is the mode of political action fitted for most occasions. A founding that is not followed by preservation is doomed. Few will ever have the chance to construct a political order *de novo*, but many have the opportunity to shape and secure the polities that they already inhabit. Preservation is distinctly non-charismatic in tone.

It must present its innovations as derived from traditions, law, and institutions in order to give its methods an air of legitimacy.

The classic study of statecraft as the restoration of order is Henry Kissinger's *A World Restored*, which analyzed the role of two great European diplomats — Metternich and Castlereagh — and their part in the restoration of the balance of powers after the Napoleonic wars. Other notable restorationists were Konrad Adenauer, who helped to restore the moral and political dignity of Germany after a time of war and dictatorship, Angela Merkel, who did so much to restore a sense of German unity after the fall of communism, and Margaret Thatcher, who restored a sense of order and stability in Britain after a period of strikes and moral decay.

The best description of this form of statecraft was provided by the English Whig George Savile, Marquis of Halifax. In 1688, in his classic essay "The Character of the Trimmer," Halifax defended a policy of what might be called principled inconsistency. The first goal of the statesman, he argued, is to keep the ship of state afloat. The true statesman — or trimmer: he was not using the word pejoratively — must be prepared to shift his position, moving from one side of the boat to the other in order to correct its list. If this offends the demand for adherence to principle, so much the worse for principle. While such a policy might be condemned as opportunism or flip-flopping, Halifax argued that such prudent flexibility was the essence of political wisdom.

This image of the ship of state was repurposed by the English conservative philosopher Michael Oakeshott in his lecture on "Political Education" given at the London School of Economics in 1951. For a people who had only recently emerged victorious from a world war, Oakeshott offered only

words of caution, describing himself as a skeptic "who would do better if only he knew how." Rather than speaking about justice, liberty, or equality — the standard fare of political philosophy — he insisted that politics consists of "the pursuit of intimations," by which he meant acting in a way that is most likely to retain or to restore the coherence of a tradition. "In political activity," Oakeshott told his listeners, "men sail a boundless and bottomless sea; there is neither harbor for shelter nor floor for anchorage, neither starting-place nor destination. The enterprise is to keep afloat on an even keel."

These words capture concisely the image of the statesman as preserver, not the larger-than-life personalities of a Churchill or a de Gaulle who led their countries through times of crisis, but the George Marshalls and George Kennans charged with preserving peace and stability. Preservers are typically not futurist visionaries possessed of a grand strategy and a singular sense of purpose; they are more often diplomats and parliamentarians accustomed to working the back rooms and the corridors of power. In Machiavelli's metaphor, they tend to be foxes, not lions. Their goal is not to create justice on earth, but to establish legitimacy where this means the maintenance of stability and authority.

Finally, the third type of statesmen are the reformers, who regard statecraft as a means of affecting moral and political change. Reformers are often, but not always, outsiders to politics who agitate for change through popular protest and acts of civil disobedience. This may be because the path of ordinary political participation is closed to them, as was the case with the abolitionists and suffragettes of the nineteenth and early twentieth-centuries, or because it may seem to them that agitation and protest are the only ways of effecting meaningful change, as Black Lives Matter advocates today seem to believe.

219

In either case, this outsider status often gives reformers a richer sense of possibilities that may not occur to those who have spent their lives operating inside the corridors of power.

The classic expression of this kind of protest politics was Thoreau's *On Civil Disobedience*, which argued that any law that violated the sacred right of conscience has no claim on our loyalty. For Thoreau, this line was crossed with the American war with Mexico and the annexation of Texas, which he considered little more than a land grab. His appeal to conscience has had a powerful hold on our moral imagination, and has been an inspiration to generations of peoples worldwide, but there is a problem. This particular brand of conscience politics is essentially empty. Conscience politics has inspired everything from the abolitionist movement, to protest against the Vietnam war, to the refusal of the Kentucky county clerk who refused to issue licenses for gay marriages. Are all expressions of conscience equally valuable? Is radicalism a mark of truth? How do we know when appeals to conscience are sincere expressions of a person's deeply held moral and religious beliefs and when they are just a mask for prejudice and self-delusion? What happens when it is hard to draw the line between beliefs and prejudices? One person's voice of conscience may be another person's hypocrisy.

The task of the reformer may be the most difficult of all, because she must know how to split the difference between revolution and restoration. The question posed by the reformer is not "all or nothing" but "how much or how little." Exemplary reformers have been men such as Mikhail Gorbachev in the former Soviet Union trying to navigate the transition from communism to democracy, Deng Xiaoping opening China after the disasters of Mao's Cultural Revolution, and Nelson Mandela and F. W. de Klerk in South Africa

working to bring an end to apartheid. The interesting feature of leaders such as Gorbachev, Deng, and de Klerk is that they were once insiders who ended up advocating for change and leading their countries, at least temporarily in the case of Russia and China, into a more hopeful democratic future.

The best kinds of political reformers are those who manage to hold together both loyalty to founding principles or ancient traditions with agitation and critique. They are examples of what Michael Walzer has called "connected critics," because their standards for reform do not come from some private voice of conscience or some putatively universal principle of natural right, but from an appeal to the very standards of justice espoused by the systems they were criticizing. Examples of connected critics are Camus but not Sartre, Orwell but not Lenin, Gandhi but not Fanon, Martin Luther King but not Malcolm X. This is an idea that would benefit many social justice advocates today.

Statesmanship, as I noted earlier, rests on knowledge, but what kind of knowledge? Is statecraft a science, like mechanics or engineering, that can be codified in rules and then learned, memorized, and put into practice, as Machiavelli seems to have believed? Or is it more like an art that can only be mastered through practice and experience, and that requires the capacities of insight, imagination, and intuition, like having an ear for music or a knack for languages? I want to consider statecraft as more of an art than a science, based on the mastery of three essential skills.

The first is the statesman's role as teacher. The statesman is not simply a problem-solver in possession of technical

expertise or a tribune of the people's will, but an educator who is able to shape a vision of the political regime. By a regime I mean not just a form of government but an entire way of life, what gives a people's collective life a sense of wholeness and meaning. Each regime type creates in turn a different range of human possibilities. The differences between regime types form the basis of our ability to distinguish between the various politically relevant ways of life.

As educator-in-chief, the statesman must always be aware that opinion is the medium of society. As Hume ringingly observed, "It is on opinion only that government is founded." By opinion he did not mean the kind of information elicited through polling data or focus groups, but a structured set of sentiments, habits, and beliefs that shapes a people's character and way of life. Without a settled body of opinion, no government, not even the most authoritarian, could last a single day. No one understood the importance of opinion better than Lincoln. "With public sentiment," he wrote, "nothing can fail; without it nothing can succeed." He then went on to add: "Consequently, he who molds public sentiment goes deeper than he who enacts statutes or pronounces decisions."

The statesman's art consists, then, in the ability to educate the public mind by helping to form its beliefs and opinions. In the American case, these opinions are rooted in our founding texts — the Declaration of Independence and the Constitution — as well as the immense superstructure of laws, interpretations, and rulings that have been built upon them. These texts have in turn shaped our fundamental experiences of right and wrong, of who should rule and who should be ruled, of who governs and why. These structures of opinion are what make future change possible.

A second feature of statecraft is the capacity for communi-

cation. In the phrase frequently applied to Ronald Reagan, the statesman must be a "great communicator." This is what used to be known as the art of rhetoric. The importance of rhetoric is especially true for democracies, where statecraft consists in the ability to communicate with fellow citizens whose views are decisive in politics and to some extent in governance. It is not enough for a statesman to craft a vision for society; she must be able to harness it in language and persuade others of its power and beauty. As Edward R. Murrow said of Churchill, "He mobilized the English language and sent it into battle." This is what the greatest leaders have been able to do, namely, to immortalize in words and images what a people stand for, what they believe in, and what they look up to.

More than any other regime, democracy gives to speech a pride of place in determining the legitimacy of policy. Unlike autocracies that are governed from above, democracies require a continual flow of communication not only from the top down but from the bottom up. Democratic politics has for this reason rightly been called "logo-centric" or talk-centered, because most of what goes on takes place through the medium of language, whether in legislative assemblies, jury rooms, courts of law, newspapers, and increasingly the internet. Mill said that democracy is government by discussion.

To be sure, the importance of speech can be vastly overstated. The ideal of a rhetorical democracy — *parrhêsia* in the Greek sense of "to speak boldly" — is at the core of what Jurgen Habermas has called "an ideal speech community." Habermas apparently considers politics as a vast public seminar that should be adjudicated by the neutral standards of "public reason," in which only the force of better argument decides policy outcomes. There are two significant problems with this view. First, it holds public deliberation to a high

223

standard of language and thought that is rarely realized in existing democracies and their media. Consider only what passes for public deliberation in contemporary America: our debased discourse does not exactly rise to the standard of *parrhêsia*. Second, this view too quickly ignores the more coercive and disciplinary aspects of politics. Democracy is about public deliberation, but it is also about authority, command, and decision. A country, or a legislature, or a court, is not a seminar. The reduction of politics to speech is at the root of what the ancients called sophistry.

The dependence of democracy on speech or rhetoric can be both a strength and a weakness. This focus on speech may be a source of frustration to those who demand swift, decisive, and concerted action. But deliberation is also necessary for providing a sense of legitimacy for public decisions. As Pericles said of Athenian democracy in his Funeral Oration, "instead of looking on discussion as a stumbling-block in the way of action, we think it an indispensable preliminary to any wise action at all."

The third characteristic of the statesman is political judgment. Aristotle named this capacity *phronesis* to indicate the sphere of prudence or practical reason that he regarded as the political virtue *par excellence*. Judgment is the form of reasoning appropriate to citizens situated in juries, legislative assemblies, and deliberative bodies of all sorts. It is knowledge of the fitting or the appropriate thing to do under the circumstances. He associates it with the man — and for Aristotle it is always a man — who possesses the skills necessary to manage well the affairs of the political community.

The knowledge of the statesman differs from both the theoretical knowledge of the philosopher and the technical expertise of the specialist. While philosophical knowledge

aims at the true or the universal — the ideal regime, the idea of justice — and technical knowledge with the mastery of rules, political judgment is necessarily local and improvisational. The relation of judgment to circumstance is essential for successful statecraft. "Circumstances," Burke wrote, "give in reality to every political principle its distinguishing color and discriminating effect." In politics, circumstance is everything.

No one has thought more deeply about the role of political judgment than Isaiah Berlin. Berlin was especially interested in what distinguishes successful statesmen from philosophical genius and why, by implication, the latter often appear politically foolish. Albert Einstein may have been a brilliant theoretical physicist but his reflections on world peace seem almost touchingly naïve. Bertrand Russell was a brilliant logician but his writings on marriage, religion, and war display an alarming indifference to the complexities of political reality. What Berlin deemed essential for the statesman was what he called "a sense of reality." This meant not merely possessing more facts or information about society but having an almost intuitive grasp of its texture, both its constraints and potentials.

Judgment in politics is the ability to see possibilities that had not previously been seen or imagined. It not a matter of knowing more but of seeing further than others. It is the capacity that we associate not with the scientist who uncovers laws and uniformities, but with the creative artist, the poet, the novelist, and the playwright who seeks patterns and connections between colors, shapes, characters, and words. Judgment is almost an aesthetic perception, something like the ability to see pattern and coherence in a painting or work of art where others see only chaos and confusion. It is not just a quality of the mind but involves the entire personality, the unique temperament, of the individual.

Good judgment consists not least in the ability to improvise on the spot. Like a musician creating unfamiliar riffs on the familiar chords of a jazz standard, having judgment consists in the skill of working within an established idiom but expanding upon and developing the possibilities that are latent within it. It is a kind of analytical imagination. It is the same skill possessed by the master chef who is able to create new combinations of tastes from a familiar palette of choices. Judgment is not the mechanical application of a rule or a fixed standard to changing circumstances — something like the demand for strict consistency — but the ability creatively to adapt rules to new and unforeseen situations and master them.

Good judgment in politics is the quality necessary for successful statecraft. This is not to say that good judgment necessarily guarantees success. It is often difficult to say whether success is the outcome of judgment and foresight or just good luck. Sometimes even the best plan may need a little luck. The wisest historians have often considered luck — accident, happenstance, contingency — as a causal power in history. Machiavelli could speak of *fortuna* as a goddess that can dispense as well as withhold her favors. He claimed that even the most far-seeing statesmen could only control events half the time, leaving the other half to the vicissitudes of fate. In *Guys and Dolls*, Sky Masterson pleaded that "luck be a lady tonight." It is a sign of wisdom to recognize the limits of our capacities. Near the end of the Civil War, Lincoln confessed to Albert Hodges that "I claim not to have not controlled events, but confess plainly that events have controlled me."

Great statesmen are judged not only by how they respond to success but how well they handle failure. Do they respond with bitterness and resentment or with a sense of magnanimity in the face of defeat? Contrast, if you will, Richard Nixon's

petulant concession speech after his failed gubernatorial run in 1962 to Al Gore's magnanimous concession speech after the Supreme Court stopped the Florida recount in 2000. The statesman must know how to turn failure into success. FDR's defeat for the Vice Presidency in 1920 and then his struggle with polio was a better training for leadership than his earlier life of privilege. Occasional setbacks are a valuable test of character. Churchill is reported to have said that the mark of success is the ability to go from failure to failure with no intervening loss of enthusiasm. This is witty, but it cannot be true. A person who has met with repeated failure, however enthusiastic, could not possibly be said to have good judgment even if such a person meets with occasional success. As the saying goes, a stopped clock is still right twice a day.

Judgment is, finally, the ability to respond to unforeseen situations. Preparing for the unpredictable is always the better part of judgment. To be sure, there is no one model for the exercise of judgment. It is all a matter of context and circumstance, but if there is one feature that distinguishes the successful statesman from the day-to-day politician, it is the ability to articulate the permanent and aggregate interests of the community. This requires the ability to plan not just for today or tomorrow but for the future. As Tocqueville — who has acted indirectly as the educator of many statesmen and legislators — said in the introduction to *Democracy in America*, his book was written not to satisfy any faction or class but to see deeper and further than the different parties. "While they are occupied with the next day," he wrote, "I wanted to ponder the future."

I have said, ruefully, that the concept of statesmanship seems old-fashioned, out of touch with the times. Perhaps it is. We vacillate between the view that all politics is essentially a power struggle while at the same time holding our leaders to impossibly high standards of moral perfection. We either expect too little from our public figures or too much.

The ethics of statecraft can be summarized, I believe, in a single word: responsibility. The concept of responsibility grows out of moral and legal language. A person can be called responsible for something when she acts on her own initiative or when her actions can be regarded as the cause of some state of affairs. To be held responsible is connected with terms like causation, guilt, and accountability. Responsibility may seem to lack the grandeur of such ancient moral terms as "duty," "conscience" and "virtue," but it is also more suited to the politics of a democratic age.

This brings us back to Weber. He explored the theme of political responsibility in great depth, and regarded it as the defining characteristic of the statesman. Political life, Weber argued, is torn between two competing moralities. The first he called an ethic of conviction, which takes different guises but is typical of the moral idealist in politics. The classic form of this ethic was the Sermon on the Mount, with its injunctions to "turn the other cheek" and "resist not evil with force," but it finds similar expression in the Kantian demand that politics must give way to morality or in the Rawlsian claim that justice is "the first virtue of social institutions." In each case, politics is regarded as morality by other means. "The believer in an ethic of ultimate ends," Weber wrote, "feels 'responsible' only for seeing to it that the flame of pure intentions is not squelched."

Weber tended to associate conviction ethics with the Christian pacifism and revolutionary socialism of the World

War I generation, but it is in fact a category of belief and sentiment that has manifested itself throughout history in various times and places. It is the attitude of the moralist who identifies a particular evil — slavery, war, exploitation, injustice — and demands its eradication, not tomorrow, not next year, but today, here and now, immediately, regardless of the cost. A sense of indignation, no matter how well-meaning, then gives rise to the demand for moral action, and soon after issues in fanaticism and violence. "Those, for example, who have just preached 'love against violence' now call for the use of force for the last violent deed," the conviction ethicist proclaims, in Weber's words, "which would then lead to a state of affairs in which *all* violence is annihilated." Needless to say, the final act, like the end of history, is a condition that never arrives.

A pure example of conviction ethics was the radical abolitionist William Lloyd Garrison, who advocated no compromise with the Constitution in his opposition to slavery. On an issue like slavery, certainly, it is important to keep alive a pure moral vision, but such visions can only be held by saints, reformers, and "intellectuals." It took Frederick Douglass and Abraham Lincoln to understand that if slavery were to be abolished, it would be not be by shredding the Constitution but by embracing it. Or consider two more recent cases: the journalists Daniel Ellsberg and Julian Assange both published official state documents during wartime without considering how such materials would inevitably be distorted and misused. Men such as Garrison, Ellsberg, and Assange are what Raymond Aron once called "technicians of subversion," who prefer to see their country dismembered or defeated rather than compromise the purity of their ideals.

At the other end of the spectrum, in Weber's analysis, is the

ethic of responsibility. This phrase has been often understood to mean a form of consequentialism, a concern with what will work and what will not, or what is expedient over what is morally right. This description is not false but it fails to grasp what philosophers often call "agential" responsibility. This ethic is concerned not with the purity of intentions but with the consequences of action, especially the unintended consequences, that may follow from them. This is not to say that it is simply Machiavellianism by another name. Rather the art of the statesman is concerned with the uses of power and its moral and psychological effects on those who wield this power. What, exactly, are these effects?

First, the ethic of responsibility requires taking ownership for decisions that will invariably inflict harm upon others. Politics, as Weber warned, is always a bargain with infernal powers. There will always be situations where even the nobility of the end will be compromised by the sordidness of the means necessary to achieve it. Lincoln's decision to prosecute a war to end slavery ended up costing over six hundred thousand lives. He never doubted the rightness of the cause, but the length and the destructiveness of the war took an immense psychological toll on him. Sometimes anguish accompanies virtue. Consider Truman's decision to drop the atomic bomb on Hiroshima effectively ending World War II. The decision was, in retrospect, the correct one, but it cannot help leaving a sense of disgust in its wake. Truman never second-guessed his decision, believing that in the end he saved lives, especially American lives, although the philosopher G. E. M. Anscombe subsequently attacked him as a mass murderer. Whatever Truman's faults — he was not particularly given to moral self-reflection — his decision ended a terrible war and brought peace more swiftly than any other option.

Anscombe's protest over the decision of the University of Oxford to confer an honorary degree on Truman is a clear example of the kind of conviction ethics that Weber deplored. No complex decision will be morally blameless, and those who seek a clean conscience and a pure heart should pursue their satisfactions in private life. "The safety of the morally innocent and their freedom to lead their own lives depend upon the ruler's clear-headedness in the use of power," the philosopher Stuart Hampshire wrote, perhaps with Anscombe in mind. I would only add that whereas we should not necessarily expect our leaders to be morally paradigmatic human beings, we should at least expect them to be attentive to the needs and the interests of their fellow citizens and call them to account when they fail in this task.

Second, the ethic of responsibility accepts that moral conflict will always be the norm in politics. "We are placed into various life-spheres each of which is governed by different laws," Weber wrote. Unlike the idealist convinced that all issues must be subordinated to a single cause, the responsible statesman is aware that he operates in a world of conflicting values that are qualitatively heterogenous. There is no *summum bonum* that is equally good for all individuals, there is only a range of values the importance of which will be determined by circumstances, education, and personality. The thesis of "value pluralism," which is now most associated with Isaiah Berlin, has led some critics, notably Leo Strauss, to label Weber (and Berlin) a moral relativist who accords equal legitimacy to all values, however evil, base, or insane. This is an unfortunate misreading that robs moral life of its difficulty and its pathos. The fact that our deepest commitments stand in inalterable conflict was not meant as an exhortation to extremism or to nihilism, but as a counsel of sympathy and moderation. To

231

Barry Goldwater's call that "extremism in defense of liberty is no vice," Weber would have replied that not all things are permitted even in the pursuit of a just cause.

Statecraft is ultimately a matter of choice, not so much between good and evil, but between rival and competing goods that cannot be tidily ranked by some hierarchy of ends or derived from some first principle. There is no one value, whether it be peace, equality, freedom, justice, or rights, that always trumps all others. Rather than seeking the best, responsible statecraft seeks to avoid the worst. If we cannot expect our leaders to follow the Hippocratic Oath to "do no harm," we should at least expect them to do as little harm as possible. In politics, as in love, a sound maxim is "you can't always get what you want," which means that statecraft will always involve the art of balancing conflicting ends and purposes. Deal-making and compromises are the inevitable costs of a morally diverse and politically conflicted society. And the problem of "dirty hands" remains an ever-present possibility.

Third, an ethic of responsibility suggests responsibility to oneself. "Whoever wants to engage in politics at all," Weber warned, "is responsible for what may become of himself." Politics can do strange things to people. It can turn ordinary men and women into monsters. What Reinhold Niebuhr once said of religion is equally true of politics: it makes good people better and bad people worse. Only those who can approach politics with a sense of self-restraint — a feat akin to Ulysses having himself bound to the mast — are capable of responsible leadership. Responsibility requires a "sense of proportion," the control of the passions, and a degree of detachment from friends and associates. When presidential candidate Bill Clinton told a supporter, "I feel your pain," he was deliberately attempting to create a sense of intimacy between them,

breaking down barriers of formality and restraint, yet it is a characteristic of the greatest leaders to put a sense of distance between themselves and their followers. Lincoln remained aloof even from those who knew him best. In *The Edge of the Sword*, de Gaulle wrote movingly of the loneliness of command.

Finally, statecraft is an autonomous sphere of political activity related to but under-determined by external moral, legal, scientific, or economic principles. It must be distinguished from the narrowness of the administrator, the dogmatism of the moralist, the pedantry of the lawyer, and the zealotry of the partisan. It is a realm of its own. Statesmanship is not something for which rules — natural law, the Categorical Imperative, the greatest happiness for the greatest number, even *raison d'etat* — can be given precisely because statecraft requires a freedom or latitude to act as the situation requires. Strategy without flexibility is futile. Statecraft consists in the concrete decisions made under the force of circumstance. When the moment of truth arrives, when it becomes necessary to say, "Here I stand, I can do no other," then the statesman has found his calling and this calling will not be provided by Morality, Science, or History, or by any power other than one's own individual judgment, which is formed by education and experience. There is no set of principles that can define in advance what is to be done in all situations, because no set of principles can control for the mutability of life.

233

> Man's yesterday may ne'er be like his morrow;
> Naught may endure but Mutability.

BENJAMIN MOSER

The Shadow Master

On July 15, 1945, Rembrandt's 339th birthday, the Rijksmuseum in Amsterdam re-opened with the most emotionally charged exhibition in its history. Called "Weerzien der Meesters," or "Reunion with the Masters," the show gathered one hundred and seventy-five paintings that had spent the five years of the Occupation hidden in bunkers. During those five years, private collections were looted and museums stripped of their greatest works. For all the average person knew, these treasures, like so many others, had been stolen or destroyed in the Nazi terror.

Now they were making a triumphant return to the

center of Amsterdam. From The Hague came Fabritius's little goldfinch, Potter's big bull, Vermeer's pearl earring. From Haarlem came the great Hals group portraits, which were displayed alongside the Rijksmuseum's own collection — including, of course, the nation's famous Rembrandts.

In 1939, with war looming, the huge *Night Watch*, eleven by fourteen feet, had been taken to a castle in North Holland, where it was stored in a vault of reinforced concrete. The location proved too dangerous. In 1940, when the Germans invaded, the masterpiece was covered with a canvas borrowed from a local farmer and hastily removed to a bunker in Castricum, closer to Amsterdam: a journey of fifty kilometers that took twelve hours. At one point, when an enemy plane appeared overhead, its escorts took refuge in neighboring fields, leaving the great painting alone in the middle of the road.

When it finally reached its destination, its caretakers discovered that it was too large for the entrance, and they had to roll it up. Finally, in 1942, it was taken to a special storage site near Maastricht, where it was kept in a limestone quarry, thirty-three meters underground. The director of the Frans Hals Museum, Henk Baard, recalled the scene: "Through the slow progress of the silent bearers the remarkable spectacle, under its ghostly lighting, recalled a princely funeral."

Now it was back. One hundred and sixty-five thousand people eventually visited the show. In a country that still lacked basic provisions, many of these visitors came on an empty stomach. All understood its promise: that past glory would bring future resurrection. "A people that can display such a parade of greatness shall reclaim its special place," a journalist wrote. At the opening, a minister declared that the Canadians who liberated Holland "have also liberated Rembrandt and Frans Hals."

More than Hals, Rembrandt needed that liberation. He needed it more, in fact, than any other Dutch artist. Hitler himself had declared him "a true Aryan and German," and under the quisling regime he had become the focus of a bizarre cult, his birthday even replacing the exiled Queen Wilhelmina's as the national holiday. Now this unwitting German hero could become, once again, the symbol of the dignity of a free people.

Light had chased out darkness. It was precisely the kind of cosmic struggle that Rembrandt had illustrated in his works, though that struggle rarely had such a clean outcome. History was recapitulating the trajectory of Rembrandt's own evolution. If Vermeer was a painter of light, Rembrandt was a painter of dark, or more precisely, of dark commingled with light; and in his work the question of evil recurs more than in any other Dutch artist's — so insistently that looking at his pictures is sometimes unbearable. There are more scenes of murder, cruelty, torture, rape, betrayal, malediction, and death in Rembrandt than in any other Dutch painter's work — by far.

Vermeer painted no such scenes. Neither did Hals. Neither did any of the blither spirits, Avercamp or De Hooch or Jan Steen. At the very most, the landscapists and the still-life painters will allude, with a graceful symbol, to mortality, to the passing of time. Most Dutch paintings were made for the wealthy middle-classes, and they show things that those people liked to see. Who among them would have wanted a picture such as *The Blinding of Samson*, in which a silver dagger is plunged into the protagonist's eye? The painting is so gigantic, two by three meters, that it is hard to look away from it. It is just as hard to look at it: even Delilah can hardly contemplate her victim without a shiver.

Rembrandt was so prolific that even the most ambitious museum survey will never capture more than a slice of his work. Books aren't much use, either: the images end up crammed onto the page, and that monumental quality of Rembrandt's paintings — their patina, their glow, the sense that they give of something physical, like an extraordinary geological phenomenon — goes missing too, flattened onto smooth paper, removing the tactility, the brazenness, of his surfaces.

The etchings and drawings, originally made on paper, fare better in reproduction. But there are hundreds of them, and even the most avid eye can only absorb so much. To try to see more than a few at a time is to be reminded that, as with Dante and Shakespeare and Bach, you cannot rush an acquaintance with Rembrandt. His work took a long time to make, after all: nearly half a century between his earliest productions and the works he made in the days before his death at sixty-three.

Add, to the quantity of works and media, the quantity of genres. In England, writers were comedians or tragedians or poets, but only Shakespeare was acknowledged as the greatest in every field. In Holland, Rembrandt, who was ten when Shakespeare died, worked in nearly every specialty known to Dutch art, each of which absorbed the energies — the entire lives — of his most talented contemporaries.

And then there is the profusion of his styles. What makes it even harder to form a coherent image of Rembrandt is that he painted in so many different styles. Many Rembrandts do not look anything like the popular idea of a Rembrandt. His early work looks so different from his later work that the early works were not even recognized as such until deep into the nineteenth century. Over the years, all sorts of ghastly paintings have been attached to his name — including some that he actually painted.

There are still rediscoveries today, though these are nearly always of lesser works that seldom add more than a footnote to the image that has emerged from two hundred years of dogged scholarship. The lacunae of that scholarship only yawn in comparison to a demand for completeness. We now know as much about Rembrandt as we know about almost any figure, artistic or otherwise, of his century. We have a large group of works. We know what they show. We know when they were painted—and, often, why and for whom. We can see that some themes interested the master only for a short period. We can see that others were there from the beginning and stayed with him until the end. Some come back in every medium, in every style, at every point in his career.

One such recurring theme is violence — evil — darkness.

The spectacle of cruelty is there in his earliest signed painting, *The Stoning of St. Stephen*, painted in 1625, when he was nineteen. This work shows a crowd surrounding the first Christian martyr: stones held high, ready to smash him to pieces. Unlike the *Samson*, it is not hard to look at — it is too much of an apprentice piece to stir real emotion; but though he is not visibly joining in, it is a bit disturbing — and premonitory — to find a chubby teenaged Rembrandt among the crowd.

A few years later, the novice has matured into a master. Rembrandt was twenty-six when he painted *The Anatomy Lesson of Dr. Nicolaes Tulp*. This is a group portrait of eight men around the corpse of Aris Kindt, who had been convicted for armed robbery and executed earlier that morning. The men are wearing neat clothing, and their expressions range from technical curiosity to a keen realization that they themselves

will soon be just as dead as the body that lies before them. The way they are arranged around the body is such that you, the viewer, step right up to the circle, invited to join the grisly academic proceedings. Despite the decorous scientific proceedings and the sober expressions on the doctors' faces, the smell of rot tickles your nostrils.

You could derive a positive message from this painting. You were, in fact, intended to derive uplift by those who commissioned it, if not by the artist. The march of science! The doctor is instructing the public with lessons that demonstrate the Dutch commitment to progressive education, lessons that were commemorated with such paintings because the Dutch medical societies were prestigious and famed; Rembrandt was one of many artists invited to paint them. When, thirty years later, he returned to the theme, he showed Dr. Jan Deyman dissecting Johan Fonteyn, who had committed the crime of breaking into a draper's shop and pulling a knife. This anatomy lesson took place on the day after his execution. Of this painting, damaged in a fire in the eighteenth century, only two central figures, a spectator and the criminal, survive. All we see of Dr. Deyman are the hands peeling back Fonteyn's bright red brains.

Rembrandt's criminals have a presence that bodies in other portrayals of anatomy lessons do not. Sometimes, in these, the doctor is showing a skeleton. Frederik Ruysch, father of the still-life painter Rachel Ruysch, who succeeded Dr. Deyman as Amsterdam's city anatomist, was painted with rosily blooming cadavers, like Greek nudes, on the dissecting table. He was famed for making dead bodies look alive. Rembrandt's bodies, by contrast, are unequivocally dead—and he arranges us, like the doctors, around them.

We have to look at these cadavers, just as we have to look at poor Elsje Christiaens, a teenage girl who was strangled in

1664 for killing her landlady, apparently in self-defense. She was executed on the Dam, the central square from which the city takes its name ("the dam on the Amstel"). Her body was hung on a gibbet in Volewijk, across the River IJ, where it was to remain "until the winds and birds devour her." It was there that Rembrandt saw her, strung up like a doll. He drew her twice.

Did any other Dutch artist show a dead body this way? A well-known image of the disemboweled De Witt brothers, murdered by a mob in 1672, comes to mind; but the painter, Jan de Baen, was undistinguished, and the picture is remembered mainly because the De Witts were among the most powerful politicians in the Netherlands. The painting, shocking and grotesque, shows a significant historical event — not the death of an obscure eighteen-year-old girl.

So it goes with many other themes. Often enough, you can find something comparable, somewhere. There are plenty of dead animals in Dutch painting, for example, but there is no picture quite like the *Still Life with Peacocks* in the Rijksmuseum. Here one bird lies in a pool of its own blood. Another is hung by its feet, its mouth still agape, as if to protest its murder. It is both exquisite and excruciating: the hallmark of Rembrandt.

Look, too, at *The Slaughtered Ox*. Red as the brains of Johan Fonteyn, the dead animal hangs from a wooden beam. "Slaughtered" is not quite the right word. The French title uses *écorché* — mangled, flayed — and no Christ in the whole Louvre captures the pathos of sacrifice like this harrowing carcass. The painting contains no religious references. But it stirs the same feeling that the most sacred mysteries evoke.

Do we identify with the ox? Or with the servant girl, barely visible, looking at it? If the anatomy lessons invite us into the circle of the learned doctors, into their progressive

and prosperous institutions, our eyes go nonetheless directly to the dead men at their center. The light is on them; they radiate sanctity. They are not martyrs, but they are somehow numinous. It is not an accident that Rembrandt placed the criminals in the position where the dead Christ was placed in earlier paintings — or that he crucified the ox, and Elsje Christiaens.

These works are not overtly religious, but Rembrandt painted plenty of religious works, too. If their contents reflect the mood of the man who created them, so does their very existence, since there was so little commercial incentive to create them. In post-Reformation Holland, to the contrary, they were unfashionable to the point of career suicide. The great German art historian and curator Max Friedländer (who in 1939 had to quit Berlin for Amsterdam because he was a Jew) could credit an entire tradition to a single artist:

> A view of the whole of Dutch production in the
> seventeenth century tells us that, where it was animated
> by any receptive interest in the religious picture, this
> was Rembrandt's personal achievement or was at least
> set in motion by him. It was Rembrandt who, from
> spiritual predilection, bequeathed the non-ecclesiastical
> religious picture to the reformed North, which was
> ready to only a very limited extent to accept this present
> with gratitude.

Rembrandt's "spiritual predilection" sought extremes, and ways to portray them. Bourgeois moderation was not to

his taste. The rough clash of light and dark could be rendered graphically, in paint, as in *The Supper at Emmaus*, painted when he was twenty-two: as the resurrected Christ reveals himself to a disciple, the dark Savior is surrounded by a halo of blazing light whose hidden source lends him the majesty of a mountain. Light triumphs over darkness.

But not always. Often light does not have the last word. Rembrandt shows the damned as well as the saved. In *Belshazzar's Feast*, the impious Babylonian king gazes in terror at the ominous writing on the wall. In *Uzziah Struck With Leprosy*, a Judean king is punished for profaning the temple. There is nothing picturesque about these exotic scenes of hubris humbled. They fulminate, they rage, they terrify, they denounce; and if their warnings are warnings to others, they are also, you feel, warnings to the artist himself.

There is no gentleness here, nothing tame or easily digested. We are in the presence of an Old Testament prophet — he painted many — who, we sense, was well acquainted with the extremes that he depicted. The biographical evidence bears this feeling out. Though Rembrandt became a kind of secular saint in the nineteenth century, twentieth-century researchers discovered that he was, in Gary Schwartz's words, a "cocktail of litigiousness, untrustworthiness, recalcitrance, mendacity, arrogance, and vindictiveness." It turned out that Rembrandt's contemporaries had almost nothing nice to say about him. No artist of his time could boast the number of disagreeable incidents that peppered his life. He didn't pay his bills; he was tactless and rude and prickish; he was cruel to his mistress. "To sum it up bluntly," Schwartz writes, not uncontroversially, "Rembrandt had a nasty disposition and an untrustworthy character."

In a list of appalling incidents, Rembrandt's treatment

of Geertge Dircx stands out. When his wife, Saskia, died at the age of thirty in 1642, she left him a nine-month-old son, Titus. Rembrandt hired Geertge to take care of Titus. He and Geertge became lovers, and they were together for six years. Geertge intended to marry the widower, and she claimed that he had promised to do so — until he began a relationship with his housekeeper, Hendrickje Stoffels. Lawsuits ensued. Rembrandt promised Geertge alimony. In the meantime he collected unflattering testimony about her, which he used to have her committed to the Gouda *spinhuis*, an atrocious institution for women who had "fallen" for a long list of reasons, from prostitution to insanity. She was desperate to get out. Rembrandt was desperate to keep her there. After five years, she was released, and died soon thereafter.

A long-ago dispute between embittered former lovers can be read in any number of ways. In books and films, Geertge has been portrayed as a conniving, gold-digging temptress — and, more recently, as a victim of a man's determination to get her out of the way. If it weren't for all the rest of the abundant evidence of his rebarbative personality, we might, in this case, be more inclined to give Rembrandt the benefit of the doubt.

Why, in any case, should we care? Surely other painters 243 were obnoxious in ways that history has hidden. For all we know, Adriaen Coorte liked little girls, and Jacob van Ruisdael cheated on his taxes: when names fade and personalities fall away, only an artist's work — and then usually only a portion of it — remains for us. We do not wonder whether the painter of an Egyptian fresco was likeable.

Four hundred years later, we wouldn't wonder about Rembrandt either — except that the conflicting accounts do bother us. The reason is that we love him. We know him so well, after all. We can see him: his work, and also *him*, since

no artist ever exposed himself as repeatedly and as nakedly. From the adolescent among St. Stephen's tormentors to the valediction that Jean Genet described as "a sun-dried placenta," around eighty of his self-portraits survive. The number is astronomical. We have no idea what most painters look like, but except for his childhood we can see Rembrandt at every phase. From the proud young man to the imperious genius to the wrecked patriarch, we can watch his life pass before us; and when, in a museum, we come across him in a new guise, we greet him as an old friend. We know him so well. Is this despite his darkness, or because of it?

The darkness is not, in any case, a secret. Even today, when personal confession has become a painterly genre of its own, it is hard to think of an artist who revealed himself so remorselessly. We see him as we see Aris Kindt or Johan Fonteyn or Elsje Christiaens. The difference is that, if the ox was flayed by the butcher and Aris Kindt was dissected by the doctors, Rembrandt did this to himself. In the light of this destiny, do earthly transgressions matter?

"The West too has known a time when there was no electricity, gas, or petroleum, and yet so far as I know the West has never been disposed to delight in shadows," the Japanese novelist Junichiro Tanizaki wrote in 1933. He described traditional lacquerware that "was finished in black, brown, or red colors built up of countless layers of darkness, the inevitable product of the darkness in which life was lived."

Was Tanizaki familiar with Caravaggio, whose *tenebroso* style, which used darkness to make light shine all the more radiantly, Rembrandt perfected and transcended? (In contrast

to much Japanese painting, which dispensed entirely with light and shade.) In the West, the age without electricity had not quite ended when Tanizaki wrote those words. It stretched into living memory: the Mauritshuis, where *The Anatomy Lesson of Dr. Tulp* hangs, did not acquire electric light until 1950. How did these paintings look when our grandparents saw them in "the darkness in which life was lived" — and how did they change when first seen under artificial light? Nobody I know of recorded their impressions.

Did the Japanese really assign a moral value to darkness? The temptation to such symbolism is universal. Perhaps Tanizaki was a romantic, but at the very least — as you feel that Vermeer's light has a meaning that exceeds the visual requirement to illuminate — it is possible that Rembrandt's darkness has a role akin to the one that Tanizaki describes: "Our ancestors presently came to discover beauty in shadows, ultimately to guide shadows towards beauty's ends."

Yet Rembrandt's contemporaries did not always consider his shadows beautiful. In his lifetime and beyond, they were often criticized as no more than a murky waste of space. Many great Rembrandt portraits are indeed little more than heads, and sometimes hands, peering out of the gloom, or floating in it, and if we imagine them in pre-electric rooms under the moody skies of Holland, we have to imagine them even darker.

Look at the late portrait of Margaretha de Geer, from 1661. In the alert and penetrating eyes, and in the right hand that grips a handkerchief, and in the left hand that resolutely holds on to the arm of her chair, as if to launch her at the viewer, you can see her great power. She is one of the richest women in Europe — yet she is very old, and her face, served on a bright round millstone collar as on a platter, seems about to dissolve into the darkness that surrounds her.

The Shadow Master

For all the startling physicality of their surfaces, there is a ghostliness to these portraits, an immateriality, including to those that Rembrandt made of himself, that makes them more haunting than any other art of their time. If *The Blinding of Samson* is awful to look at, it is so theatrical that it troubles us less than Margaretha. The picture was designed to hang in her children's house. One shudders to imagine them walking past it at night, the matriarch illuminated by flickering candles.

Eventually the critical tide turned. Rembrandt's darkness acquired a positive value, eventually coming to form a crucial part of his myth: a forerunner of the nineteenth-century Parisian bohemian. Especially the tenebrous late works — those final utterances of the discarded old genius, scorned by those who once had courted him, rotting in his cheap lodgings in the Rozengracht — were equated with spiritual profundity.

Rembrandt's darkness was viewed so positively that his works were even darkened artificially. The varnish that protects paintings needs to be replaced every fifty or so years, before it decays and darkens; but sometimes, at the insistence of curators, it was deliberately left on, so as not to lighten the work. Deep into the twentieth century, some restorers added pigments to new varnish to darken the pictures. The practice was not restricted to Rembrandt. "A good painting, like a good fiddle, should be brown," wrote the painter and patron Sir George Beaumont in the nineteenth century. This brownness, known as "gallery tone," may have seemed appropriate to objects prized, among other qualities, for their antiquity; perhaps here is an echo of the "beauty in shadows" that Tanizaki did not believe existed in the West.

246

In unlit galleries, covered with decaying varnish, how shadowy these paintings must have been! Did the darkness make Rembrandt more mysterious, more *de profundis* — or did it make him illegible? If darkening seems inappropriate from a scientific perspective, it doesn't strike us as inappropriate for Rembrandt as it would for another painter. You wouldn't darken an Avercamp or a Metsu — much less a Vermeer, whose genius lies in the uncanny suffusion of light in space.

But Rembrandt *is*, after all, dark. Yet his darkness does not always have a negative implication. In his several renderings of the apocryphal story of Tobit, for example, he shows the old man whom God has blinded in order to test his faith. While their son Tobias seeks a cure — this turns out to be the entrails of a monstrous fish — Tobit and his wife Anna stay home, patient and impoverished: resigned to their lot, firm in their faith. In *Anna and the Blind Tobit*, the old man sits in a ramshackle room, his face turned from a light he cannot see. Anna uses a ray from the window to wind wool on a frame; but most of the room, and most of the painting, is dark. The mood is of humility, not of expectation. We know that Tobit will be cured, but he himself has no such knowledge. His reward is unseen, and unforeseen. Faith — darkness — faith in darkness — is all he has.

In her preface to *The Passion According to G.H.*, Clarice Lispector warned that the book should only be read by "those who know that the approach, of whatever it may be, is done gradually and painstakingly — passing through even the opposite of what it's going to approach." The phrase applies to Tobit — and to

The Shadow Master

Rembrandt too, since his darkness, even in his bleakest paintings, always contains an admixture of light.

The master was a moralist. He was a sensualist, too. The early works reveal a love of splendor — ostentation, even — and the paintings often contain a glint of gold. This was more than a color, or a taste. In the dark rooms where these paintings hung, it had a practical purpose ("the extravagant use of gold," Tanizaki wrote, "gleams forth from out of the darkness and reflects the lamplight") and a representational one. And in their way they reflected the shiny prosperity of the society in which they were painted.

In the self-portraits, as life takes its toll on the cocky young man, the light that had illuminated his figures from the outside begins to move inside. The background darkens, the atmosphere turns into mist — and the figures glow, like the fierce eyes of Margaretha de Geer, with something otherworldly. The artist becomes sadder and older — and grander, more imposing, more profound, the inner light shining all the more intensely — because of the approaching dark.

As Rembrandt ages, the light in his paintings takes on an added luster, and with it an added meaning. It reveals a view of the world as a contest between light and dark that is, at heart, religious: of the world as a theater in which good and evil are intertwined, and in which good only occasionally triumphs. Sometimes, as for Belshazzar, crime meets its just punishment. Often, as for Samson, it does not. Does Rembrandt think it matters? "He didn't care about being nice or mean, surly or patient, grasping or generous," wrote Genet of the late Rembrandt: "He didn't have to be anything more than an eye and a hand." Now life has taken everything from him. All that matters was his art — and so, "with dirty fingernails," the erstwhile lover of gold is now shuffling "from the bed to the

248

easel, from the easel to the shitter." He is beyond good and evil, or trapped in their mixture, living with light and with dark, beyond perfect clarity.

A conflicted personality has been reconciled. The artistic and the spiritual are no longer in conflict; and in his last months Rembrandt returned, after thirty years, to the parable of the prodigal son. This is the story, from the Gospel of Luke, of two brothers. One stays home faithfully with his father, while the other squanders his fortune carousing with whores. Eventually, forced to work as a swineherd, he envies the pigs. The theme had occupied Rembrandt since his youth. In the mid-1630s, he painted himself and his wife Saskia in a tavern scene, *The Prodigal Son in the Brothel*. There is a peacock pie on the table, and Rembrandt's golden sword pokes out at the viewer. It is not conventional for a painter to portray himself as a wastrel, or his wife as a hooker; but this, the painting declares, is not a man interested in convention.

Thirty years later, Saskia was dead. Titus was dead. Geertge and Hendrickje were dead. He himself would follow soon; but before he went, he painted the story one more time. Yet this time he chose another moment: the return of the prodigal son, when he comes back, humbled and repentant, causing his father to rejoice. He dresses him richly, "putting a ring on his hand, and shoes on his feet," and orders the fatted calf killed. "Lo, these many years do I serve thee, neither transgressed I at any time thy commandment: and yet thou never gavest me a kid," the virtuous son protests. "But as soon as this thy son was come, which hath devoured thy living with harlots, thou hast killed for him the fatted calf." But as Christ explains, one repentant sinner causes more joy in heaven than "ninety and nine just persons, which need no repentance."

Rembrandt, who painted so many Hebrew scenes of

249

vengeance and sacrilege, now paints this epitome of Christianity, a scene of forgiveness and redemption and love that, even by the master's own standards, is stately and symphonic: the ragged, pathetic son kneeling before his old father, who gazes at him through half-open eyes. Though they are surrounded by darkness, the light is upon them.

Without passing through darkness — through the opposite of what he meant to approach — the son could never come into the light of the father. Light cannot exist without darkness, nor virtue without sin. They are intertwined in every life. The electricity coursing between these magnetic poles — between Dr. Tulp and Aris Kindt, between Delilah and Samson, between the butcher and the ox — was the very subject of Rembrandt's art.

HELEN VENDLER

Forced to a Smile

An epitaph — the short inscription on a tombstone — normally names and praises admirable qualities of the person buried there, and then hopes for a benevolent future after death. The gravestone may speak to the viewer in the dead person's voice (as Coleridge imitates the Latin *Siste, viator*: "Stop, Christian passer-by, stop, child of God! / O, lift one thought in prayer for S. T. C.") or it may speak as a mourner addressing the buried person (as in the Latin, *Sit terra tibi levis*, "May the earth lie light upon you"). In his *Essay on Epitaphs*, written a few years after William Cowper's birth, Dr. Johnson restricts epitaphs to "heroes and wise men" deserving of praise: "We find no people

acquainted with the use of letters that omitted to grace the tombs of their heroes and wise men with panegyrical inscriptions." The readers of "Epitaph on a Hare" by William Cowper (pronounced "Cooper") would have expected just those qualities in any epitaph: it would celebrate a male either wise or heroic, and its praise would be public and formal. (The Greek roots of "panegyric" mean "an assembly of all the people".)

Against such prescriptive forms, the only obligation for an ambitious poet writing an epitaph is to be original. The form becomes memorable by dispensing with or altering conventional moves: Yeats brusquely repudiates Coleridge's Christian "Stop, passer-by," in his own succinct self-epitaph: "Cast a cold eye / On life, on death. / Horseman, pass by!" Keats, dying in his twenties, refused the first, indispensable element of an epitaph, a name, and wanted only "Here lies one whose name is writ in water."

As soon as animals became domestic pets, they could become the subject of an epitaph; Byron wrote a long epitaph on his dog, and had it inscribed on a large tombstone. (On the grounds of at least one of the colleges at Cambridge, there is a cemetery for pets of the dons which includes inscribed tombstones and small sculptured monuments.) Nowadays, in a practice that would have scandalized the pious of past eras, newspaper death notices in the United States commonly include, among the named survivors, domestic pets. The subject of Cowper's epitaph is not domesticated, but wild — "a wild Jack hare" — not a hero, not a human being, hardly even a pet, but one nonetheless named and distinguished from its fellow hares.

The most original epitaph for a pet in English literature, Cowper's "Epitaph on a Hare" is a poem utterly dependent on charm. Poets writing on death have traditionally preferred

252

to create either a somber "philosophical" meditation (on time, regret, the afterlife, and so on) or a direct expression of personal grief. By contrast, charm in lyric requires a complex management of tone: it cannot be single-mindedly earnest nor single-mindedly sorrowful, nor can it be unconscious of its hearers. It is a social utterance. It needs a stylized attitude of wistfulness and irony, a blending of the impersonal with the personal, of the independent mind with the troubled heart, and above all, it requires an evident awareness of itself and its listeners.

In real life, charm is almost as rare as exceptional beauty: beauty is Fate's gift, but charm is a quality of personality and behavior. And charm is always remarked with a lightness of tone; it concerns something small, not sublime or heroic. The praise of charm is always tinged with pathos, charm being such a transient quality. Yeats, reflecting in "Memory" on the women he had loved (if imperfectly) over a long life, comments on the relative rarity of loveliness and charm among those women: "One had a lovely face / And two or three had charm." But neither loveliness nor charm could transfix him for life, as had the wild beauty of Maud Gonne's presence:

One had a lovely face,
And two or three had charm,
But charm and face were in vain,
Because the mountain grass
Cannot forget the form
Where the mountain hare has lain.

That his love for Gonne was a quality of the flesh is stipulated by Yeats's finishing this little poem with an unignorable match of the botanical and the animal: the *mountain* grass

Forced to a Smile

cannot forget the "form" (the image impressed on it) by the couched *mountain* hare. Grass-bed and hare belong to each other not because of any human kinship of "mind" or "soul," but because (Yeats's repeated noun tells us) both are denizens of the mountain, grass and flesh born of the same territory.

Yeats chooses a formal rhyme scheme for his poem on unforgettable beauty, but his slightly unsettling scheme does not employ the familiar couplet or quatrain; instead, it is a freestanding sestet, *abcabc*. And its slant rhymes are at first uncertain: does "grass" indeed rhyme with "face?" Will "form" eventually rhyme with "charm?" Only at the sixth line, where "lain" emphatically rhymes with "vain," is the scheme fully intelligible. So unprecedented, so confusing, is heroic beauty that an unsettled air must hover over the lines until the conclusive arrival at "lain."

In Yeats's "Memory," charm is somewhat bewildering, a possession of only "two or three" in an erotic lifetime; it comes etymologically from the Latin *carmen*, "song," and is related to "incantation." It has magic power, it lays a spell, it is alluring, it overcomes resistance, it "pleases greatly" (according to my dictionary). On the other hand, unlike striking beauty, charm has to be ascribed to something relatively approachable, of a domestic size, like the "charm" on a "charm bracelet." It never claims too much; it can never be theatrical. And something about it is odd, as Robert Herrick knew: it is odd to be sexually "bewitched" by something which is rationally off-putting (distracting, neglectful, careless) but psychically fascinating, since it intimates a "wantonness" within:

A sweet disorder in the dress
Kindles in clothes a wantonness;
A lawn about the shoulders thrown

Into a fine distraction;
An erring lace, which here and there
Enthrals the crimson stomacher;
A cuff neglectful, and thereby
Ribands to flow confusedly;
A winning wave, deserving note,
In the tempestuous petticoat;
A careless shoe-string, in whose tie
I see a wild civility:
Do more bewitch me, than when art
Is too precise in every part.

Our contemporary master of charm in verse was James Merrill, who, at 62, dared to close his eight-sonnet sequence on opera, "Matinées," with a version of the "naive" note of thanks (made into halting verse) that he had sent, at the age of twelve, to his mother's friend who had invited him to join her at the Metropolitan Opera for *Das Rheingold*. Miraculously, the note has mutated into a childishly "awkward" sonnet (following on seven sonnets of symphonic eloquence):

Dear Mrs. Livingston,
I want to say that I am still in a daze
From yesterday afternoon.
I will treasure the experience always —

My very first Grand Opera! It was very
Thoughtful of you to invite
Me and am so sorry
That I was late, and for my coughing fit.

I play my record of the Overture

Over and over. I pretend
I am still sitting in the theater.

I also wrote a poem which my Mother
Says I should copy out and send.
Ever gratefully, Your little friend . . .

The "little friend" is still shaky on prosody, while proud of his rhymes. And by replicating, mistakes and all, the perfect rapture he expressed at twelve, Merrill demonstrates with witty charm that he is as susceptible now as then to the effect of the rising of the curtain on the music of the Rhine maidens, "Nobody believing, everybody thrilled." The charm also lies in his decision to let his youthful mistake stand: *Das Rheingold* has a Prelude but no "Overture."

Some usual elements of poetic "charm" in lyric, then, are a slightly perplexing initial effect, unconventional elements (of topic, of addressee), a wayward use of genre, ironic sidelights, and a playful spirit. They all meet in William Cowper's surprising epitaph-poem.

Seeing an elegiac commemoration of "a wild Jack hare," we wonder how such an epitaph came to be composed, and why it is so moving. Its success arises from the double self-awareness of the poet; he is fully conscious of his own actual grief and equally conscious of the unconventional and comic way in which he is speaking. Above all, he expects his readers to follow his own amusement at the mixed language that he must invent for such an unlikely subject without losing sight of what exigencies call forth its parodic features.

William Cowper, who was born in 1731 and died in 1800, was an English clergyman and the son of a clergyman. After a beatific episode in which he felt close to, and loved by, God, he fell into a lifelong despairing conviction that he was predestined to be damned, eternally unredeemable. He was hospitalized for months after a suicide attempt, and was unable in life to function as a clergyman. Retreating from the practice of his profession, but with a small inheritance, he took up residence with Morley Unwin, a clergyman friend, and his wife and child; and when the clergyman died, he continued to live with the compassionate wife, Mary Unwin, who devoted herself to him and was his chief human comfort during his recurrent periods of insanity.

Over time, in his saner periods, Cowper became the author of many essayistic pentameter poems that range from peaceful descriptions of pastoral life to outspoken denunciations of colonial slavery. But he also wrote trenchant introspective lyrics, of which the most famous is "The Castaway," a "posthumous" past-tense description of his own death, comparing it to the fate of a sailor who fell overboard and could not be saved. Recalling Jesus' calming of the waves of Galilee with "Peace, be still," Cowper says bitterly that he and the doomed sailor had no such resource, none:

No voice divine the storm allayed,
No light propitious shone;
When, snatched from all effectual aid,
We perished, each alone:
But I beneath a rougher sea,
And whelmed in deeper gulfs than he.

The devastating effect of "We perished, each alone" is outdone by Cowper's two-line tragic footnote, a trapdoor to a

Forced to a Smile

worse hell than the sailor's: a "rougher" and "deeper" fate lies in religious despair than in bodily death.

Cowper's mother died at his birth, and five of his siblings also died. As an adult — unmarried, childless, profoundly melancholy, suicidal, on several occasions wretchedly confined for insanity — Cowper must have been one of the loneliest poets of our language. Isolated at the house in Olney that he shared in his adult life with Mary Unwin, he built wooden cages in which he kept as pets first a single hare, which he received as a gift, but eventually three wild male hares. They spent the day in the garden, and at evening Cowper would admit them to the parlor, tenderly watching them play together in his presence. He wrote an essay-letter for *The Gentleman's Magazine* describing them — "Puss, Tiney, and Bess" (all males) — and revealing, though reticently, the extent to which they benefited him during his anguished depressions. He perceived, he confessed, "that in the management of such an animal, and in the attempt to tame it, I should find just that sort of employment which my case required."

Cowper nursed his hares when they were ill, carried them about in his arms, and dutifully took to obeying their wishes, studying their disparate temperaments. Puss, as he explained to readers of his magazine piece, was grateful to him for the care he showed, but "Not so Tiney. . . if, after his recovery I took the liberty to stroke him, he would grunt, strike with his fore feet, spring forward and bite. He was, however, very entertaining in his way; even his surliness was matter of mirth." Bess was "a hare of great humour and drollery," and became tame "from the beginning." Cowper's letter describes dispassionately the hares' diet and their seasonal preferences ("During the winter, when vegetables are not to be got, I mingled their mess [i.e. meal] of bread with shreds of

carrot," and so on). Throughout the essay, Cowper endeavors to persuade his reader that hares are the most appealing of animals: the "sportsman," hunting not for food but merely to kill, "little knows what amiable creatures he persecutes, of what gratitude they are capable, how cheerful they are in their spirits, what enjoyment they have of life."

Besides this reminiscent essay and his "Epitaph on a Hare," Cowper added, to keep Tiney alive in memory, a Latin epitaph in prose: *Epitaphium Alterum* ("Another Epitaph"). Like the English poem, it begins with the conventional *"Hic jacet,"* "Here lies," and repeats the conventional address to the passer-by, but it still divagates from the classic human epitaph in celebrating Tiney's lucky life, sheltered by his owner from both human predators and the unkindness of nature: "No huntsman's bound, no leaden ball, no snare, no drenching downpour, brought about his end." The epitaph closes unconventionally, too, as the mourner unexpectedly assimilates his own death to Tiney's: "Yet he is dead— / And I too shall die": *"Tamen mortuus est— / Et moriar ego."*

So, flanking the verse "Epitaph on a Hare," we find the detailed gentlemanly letter and the Latin epitaph, both in prose, each more public than the poem; and it is against such relatively impersonal documents that the "Epitaph on a Hare" shines in its humor and its sadness. Almost every stanza contains a surprise. In the first, we are introduced to the mysteriously protected life of an unnamed wild, not domestic, animal; in the second, we encounter the initially withheld pet-name (which "should" have immediately followed the "Here lies") and also the reversal of the usual superlatives (not "noblest" but "surliest"); in the third, the mounting list of the hare's doings, climaxing not with a heroic or saintly action but rather with the doubly stressed comic end-words, "would

bite." The mourner has been obscured, too; his relation to the hare is given only meagerly in the third stanza, with the unrevealing phrase "my hand."

These strange and deviant beginnings are, as I say, surprising in themselves, but the great triumph of the poem comes in its next four stanzas, the ones on Tiney's diet and behavior. It takes a bit of time for us to understand that Cowper is parodying the doting diction of a young mother, who assumes, in her maternal fondness, that her interlocutor-bystander is as interested as she in her baby's important dietary preferences and daily amusements. Translated to our contemporary moment, the young mother would be earnestly explaining her endeavors to feed her baby the choicest of items and expressing her chagrin when a store has run out of a favored ingredient: "Jimmy really adores the Gerber mixed berries, but there wasn't a single jar on the shelf, and I was worried, but I did find the cereal and the applesauce that he usually has for breakfast, and some favorite vegetables — puréed peas and squash. And then I found a new mix, too, with chicken in it, that he was willing to try when I gave it to him for dinner." The bystander hopes that this is the end of the recital, but no, now it is her Jimmy's behavior — how much he clings to his stuffed animals, especially the pet elephant, and how vigorously he pedals in his little swing. Nor does she stop there, but advances to her baby's preferred time of day and his response to a change in the weather: "You know, when everything settles down after dinner, he's much more playful, and then, when a storm is coming, he senses it and gets really excited." By this time the bystander is backing away.

Cowper parodies the dilated intimacy of the mother's discourse with much amusement, listening to himself.

The interminable list of foods, and the owner's anxiety if something cannot be found, spill out on the page in an excessive inventory of ten items. Difficulties yield to happy solutions as Cowper continues to imitate "maternal" anxiety ("and then, if I lacked thistles, I'd find lettuce for him"). We are made to feel the wild hare's joy as he "regales" on his special provender. (The *Oxford English Dictionary* cites John Adams in 1771, resolving to make a pool with clear water, so that "the Cattle, and Hogs, and Ducks may regale themselves here.") As the named foods become more adjectivally specific — "twigs of hawthorn," "pippins' russet peel," "juicy salads," "sliced carrot" — the owner's extravagant affection mounts. The list ends with the unconcealed triumph of the owner over seasonal scarcity, as he succeeds in substituting alternate foods for scarce ones. Has there ever been a more absurd climax than the proud victory of Tiney's owner announcing that "when his juicy salads failed, /Sliced carrot pleased him well"? And has there ever been a public epitaph that listed the epicurean delights of a lovingly chosen cuisine for an ungainly pet?

Cowper is a past master of tone and detail. Not only can we hear the tone in which each detail is given, we are even prompted to intuit tones that must have preceded the present ones. We can infer the owner's anticipatory devotion in slicing up all those carrots, reflecting how pleased Tiney will be as he approaches his dish. And Cowper is also a master of diction, knowing just how to join Tiney in his "gambols" by releasing a coarser language: Tiney "loved to . . . swing his rump around." The anatomical phrase brings a farmer's speech hovering into view.

The owner of the hares mimics his own worry about Tiney's aging by slipping directly into Tiney's very mind, imagining him counting down his years and months of self-indulgent life:

Forced to a Smile

Eight years and five round-rolling moons
He thus saw steal away,

Dozing out all his idle noons,
And every night at play.

The poet's worry was warranted; Tiney died at nine. And here
Cowper at last reveals why Tiney is allowed into his house. It is
the poet's first-person confession that makes the whole poem
grow in stature and grace:

I kept him for his humor's sake,
For he would oft beguile
My heart of thoughts that made it ache,
And force me to a smile.

The anxious diet-procurement, the seasonal schedule of
feeding, the protection from predators, the nightly play —
these indeed "beguiled" the poet, as they beguile the epitaph
itself, until aching thoughts and a forced smile expose the
death's head of the poet's suffering being. Between the
separated words "heart" and "ache" lie the terrible fears and the
hopelessness in which the poet lives. Those two monosyllabic
lines — like the fatal "deeper" and "rougher" comparatives of
"The Castaway"— intensify the atmosphere to an acute regis-
ter of pain. That intensity then casts a piercing backlight on
the whole epitaph: back over the startling characteristics in
"surliest" and "would bite"; over the foolish fondness of "juicy
salads" and "sliced carrot"; over the aesthetic appreciation
of the contrast between the hare's skips and gambols and the
heartier pleasure when he would "swing his rump around"; and
over the poet's "beguiled" observation of the hare's vicissitudes

of response to the weather. The watching, the devotion, the feeding, the cherishing — all the instances of care — are then decoded, with hindsight from the reader, as daily evidence of the aching thoughts and the rare smiles. The unsettling strobe-effect (charm/sorrow, beguilement/ache, play/loneliness) persists in every rereading. The flicker between comedy and heartache is the chief resource of Cowper's charm.

But there are many others: the genuineness of Cowper's loss flickers between the solemn epitaphic frame (from "Here lies" to the ecclesiastical "long, last home,") and his elation at Tiney's animal liveliness, between "here lies" and "would bite." We are charmed not only by the proprietorial boast of the opening: that Tiney was successfully spared, by his assiduous owner, the ritual danger of the morning hunt, but also by the closing view of the hare's affection for his two precariously remaining companions. Finally, we are touched by the way Cowper's past-tense narrative presses forward to amalgamate itself into the "now" and the "this" of the imminent moment of parting. We are made to feel the gap between the poet's relish in his pets and the implication (explicit in the alternate Latin epitaph) of the poet's own death in the closing word, "grave."

Cowper's means are simple: he offers a monosyllabic poem composed largely of monosyllabic lines cast into the familiar form of the ballad stanza, with rarely disturbed iambic rhythms. And it all appears to lead to a "Christian" pathos as Tiney "in snug concealment laid" consciously "waits" for "Puss" to keep him company in the grave. Yet once again, as in "The Castaway," Cowper adjusts the end of the poem to a darker note: Puss feels his irrevocable destiny in "the shocks from which no care can save" and knows he will eventually "partake" (take up space) in Tiney's grave. All communication then ends — between owner and hares, and among the hares

themselves, as a long silence — of the shocks, of the grave — ends the poem.

Lest charm and humor wane in a poem so mixing the two with mourning, the harsher edges of life and expression must be framed in a "softer" vision, through which nonetheless — if the poem is to ring true — the death's head must be glimpsed. Others have elegized their pets with playful fondness and appreciation, those natural emotions on losing a companion, but Cowper's many sophisticated and whimsical tones and tableaux of mourning — for himself as well as Tiney — make his epitaph a deeper commemoration.

Is charm still exerted in poetry? I have found it recently not only in Merrill but also in A.R. Ammons' no-holds-barred final book, unceremoniously titled *Bosh and Flapdoodle*. The poems, written in old age and illness, combine self-mockery and a *basso continuo* of fear. Ammons calls them "prosetry." At first I didn't know what to make of some of them, their slangy and farcical impudence routing Ammons' general inclination to serious poetry of science and nature. The charm of these "last words," is, as usual, bewildering to the reader. Incomprehensibly and grandly, one poem flaunts the title "America," even though its titular scene — the entire country — seems attached to the minor geriatric problem of dieting. Eventually, the second part of the poem enables another view: America is both personal — when you are chastised into dieting — *and* grand in landscape and weather when you delete personal annoyances in favor of casting your glance more widely. At the close of the poem, which I omit here, the charm lies in the weird separability, and ultimate twinning, of the two points of view: individual and cosmic.

The aging Ammons (in the implied narrative of the first part) has chronically bad dietary habits, and his doctor, wanting him to reform, sends him to a dietician. The poem opens on the poet's "counseling" session with the dietician. Ammons chooses to charm us here by jolting us from voice to voice: one is the voice of the severe dietician, recommending unattractive diet items (and reproving disobedient choices); the second is the voice of the adult poet satirically rephrasing the unwelcome advice; and the third is the undersong of the resentful *sotto voce* id of the patient, who defensively luxuriates in asides as he solicits the memory of appetizing items of past meals, and slips in, at the end of the diet-poem, a resolve to transgress with "an occasional piece of chocolate-chocolate cake." I have sorted out the voices here, but imagine what it feels like to read "America" fresh off the page, realizing that the title means, for part one, that everyone in the country is endlessly attempting counseling and self-discipline in eating, and endlessly falling back into appetite:

Eat anything: but hardly any: calories are
calories: olive oil, chocolate, nuts, raisins

— but don't be deceived about carbohydrates
and fruits: eat enough and they will make you

as slick as butter (or really excellent cheese,
say, parmesan, how delightful); but you may

eat as much of nothing as you please, believe
me: iceberg lettuce, celery stalks,

bran (watch carrots; they quickly turn to sugar):

Forced to a Smile

you cannot get away with anything:
eat it and it is in you: so don't eat it: &
don't think you can eat it and wear it off

running or climbing: refuse the peanut butter
and sunflower butter and you can sit on your

butt all day and lose weight: down a few
ounces of heavyweight ice cream and

sweat your balls (if pertaining) off for hrs
to no, I say, no avail: so, eat lots of

nothing but little of anything: an occasional
piece of chocolate-chocolate cake will be all
right, why worry:

The serve-and-return pattern of contradictory voicing parodies the counseling session by allowing the things the patient cannot in fact say aloud to rise to the surface. We hear not only his irritation at the attempted control by the dietician, but also his wistful glances back to the delights of parmesan cheese. The smallness of the occasion, the pathos of the geriatric plight, the defiant humor, the fluctuations of tone, the awareness of a reader of unknown gender —"sweat your balls (if pertaining) off" — the witty play with e-mail brevity ("hrs") are all characteristic of charm, in Ammons as in Merrill and Cowper. Trifling with genre always delights the poet: whether Cowper is upending the epitaph, or Merrill is inventing a child's thank-you sonnet, or Ammons is parodying patronizing advice, the poet's self-awareness together with his awareness of an audience makes for a gaily sympathetic and sophisticated performance.

But why is the title of the poem "America?" The first answer, the comic one, the poet would say, is because this is what all America (myself included) is doing — dieting while resenting dieting. But the second answer, the sublime one, arises from the last seven lines of "America," as the declining poet finds when he turns his gaze from the indignities of age to the grandeur of the American landscape. In the landscape he finds an impersonal reassurance in "disaster renewal," the cosmic self-repair of the natural seasons. Satiric "charm" falls away, replaced by awe at the natural resurrections of Spring.

"America," with its two contrasting parts, shows that the spell of charm need not be maintained throughout a poem. But the advantage of lyric charm is its capacity to relieve the unreality of an unmixed high seriousness. Instead, one sees oneself as an unimportant speck in an indifferent, if exciting, universe, finding a point of self-regard more independent than earnestness, one not omitting comic truth. Ammons is unsparing on the fact of cosmic indifference; Merrill demonstrates how a more ironic vision has replaced, in adulthood, the naive sweetness of childhood; and Cowper, like our later poets, does not obscure either the ravages of time or the power of sympathy. Cowper ranges through so many tones and tableaux while mourning his beloved hares that the poem seems not a pet-elegy, but rather a human one. As we follow its exquisite variations on charm and grief, classical reminiscence and personal hardship, we are instructed how three improbable pets, more than two centuries ago, could force a despairing poet to a smile.

JOHN HODGEN

The Safe Bet

They say Lady Godiva put everything she
had on a horse,
 but what if the wager had grown from
speculating whether
 everything on earth is always growing
steadily, incrementally,
 or whether things are inevitably falling apart?
The safe bet
 would be the latter, of course, the smart call.
You'd have
gravity on your side, that wormy apple hitting
 feckless Newton
 smack on the skull every time. There'd be
9/11, the Falling Man,
 the icy Titanic, Trump, Q, and each driverless,
non-fungible Tesla to boot.

 But *National Geographic* reports that Mount
Everest actually grew two feet
 last year. Tenzing and Norgay would've just
fallen short. Today they'd be
 leaping like slow motion Tik Tok NBA
ballers trying to hang on the rim
 of the moon. And those Oregon settlers
buried side by side in hastily dug

graves two hundred years ago just worked
their way to the surface after
 all this time, some Farmer Brown's boy's dog
sniffing at the rain-soaked
 gray cannon balls of their skulls, their ribs
curved up like little cathedrals.

 It's as if everything wants more open sky,
more canopy over our heads,
 to make room for all of what's rising, all our
loneliness growing greater
 every night, as if the earth itself is a seed
stuck in Whitman's muddy
 boots, as if the moon coming up over that
ruddy fence is the face
 of the child we've loved and have lost, as if
that's who we all
 should be out looking for, betting the house
every time.

Before a Fall

Pride comes before a fall, Solomon says, but any fool knows
that's not
true.
Take Jesus, for example, or Gump Jaworski, who did a double
half
gainer
and most of a triple *solchow* on his last day of working for
Gutters 'R'
Us
("Gutter Problems? Gutter Call Us!") when he fell off a
company
ladder
trying to steal a case of Budweiser tall boys from an open third
floor
window
of the Riverdale Co-op back in the day, and who would've
gotten
himself
a decent settlement if he'd had any disability insurance to
speak of,
but he didn't.
Come to think of it, it was the case of beer that landed first,
just
before he did,
right on top of it, breaking every bone in his head, and most
every

long-necked
bottle inside the case that wasn't broken already, a feat he took
no
pride in
whatsoever, nor should he ever, though he bragged sometimes
long after the fall
through his ill-fitting, whistling teeth that all the way down he
had
never let go
of the case. Or take Charley Pride, who sang so easy and let it
all go
with every song
he ever sang, who never fell at all as far as we know, and
deserved all
the pride
he ever felt in his life, singing "All I Have to Offer You is Me"
the way
he did,
even selling more records than Elvis for a while, a thing to be
Tennessee proud
of there for sure. There's proof for all this from the natural
world
if you want
it, and all the animal kingdoms too, the way they say lions
come in
prides,

but you can't tell me the last time you've seen one of them take
a fall,
let alone any pride in it, people laughing and spitting like
hyenas all
the time.
And puffed-up Mr. D? John Donne told him straight up *not* to
be
proud,
but he's always strutting, moving along, the country around
him like
a building
collapsing, imploding on itself. See him taking selfies on the
Capitol
steps,
proud boy, proud as hell, filled with rage, with graveyard joy,
unweaning pride, not before,
but *after* a fall.

For the Birds (Strictly)

Strictly for the birds.
HOLDEN CAULFIELD

Easy to think of what's different,
what's broken or chastened
somehow

now that I've lived longer than
my father ever did. No
nightlights back then,

for example, those steady little
stars we plant and grow about
the house now

like nightflowers to make us less
afraid. Just the moonlight then
dreaming its way

inside the open window, the
body of light lying like a
hologram across the kitchen

floor, like some sleeping hobo,
some vagrant vagrant, who'll be
sure to be gone

in the morning. And the feeder
outside, barely visible, too early
for the birds, hanging so long

and still, like the last Apache
executed at dawn at Fort Yuma,
Arizona in 1912

before World Wars began, like
the *fasces* ax and olive branch
on the Mercury Dime,

the one Wallace Stevens loved.
Perhaps you were afraid too in
that darker darkness

and could have used a little
light, something to hold on to
before the dawn,

some tiny votive burning just for
the birds when everything
seemed crazy, or

strictly for the birds, as you always
said. Maybe you told them all
that they were safe

and still alive, not dead, that
soon enough it would be time
to go to work, to sing.

CELESTE MARCUS

—

Priorism, or the Joshua Katz Affair

Teach your tongue to say: I do not know, lest you be duped.
TALMUD BERACHOT 4A

The phrase "Joshua Katz," as it is ground down and churned out by the national rumor mill, refers not to one character but to many. He is a conniving fiend; a wronged and saintly genius; a bitter man who has responded terribly to genuine mistreatment; the perpetrator of abuse; the victim of abuse; a valorous defender of independent thought; a sad sack manipulated by a powerful puppeteer named Robert George; a befuddled but well-meaning and brilliant professor, and so forth. It took me several months to notice that all of these Katzes refer to the same man, and still longer to recognize that the name, as used in public discourse, is not a name at all but a rallying cry. The

rumors that are think-pieced about Katz do not reflect any serious empirical consideration about what exactly unfolded at Princeton the summer of 2022, though that is their purported subject — but of course that is not what they are intended to do. His name is a speech act, a token, a shorthand, a move in a game. How someone invokes "Joshua Katz" depends entirely on where that individual's stands on trends that have little directly to do with the man. Ignorance is a primary fuel of opinion.

Joshua Katz, a classicist, made tenure at one of the most prestigious universities in America when he was just thirty-six years old. That is not why I know his name, though it is among the reasons that the implosion of his academic life was an affair of national significance. (Our country's pathological obsession with the glitteriest members of the Ivy League — provincial ecosystems that bear little resemblance to anything beyond their hallowed walls — is among our more embarrassing fixations.) Eighteen years after he received Princeton's President's Award for Distinguished Teaching, and fifteen years after he made tenure, Katz was *ruthlessly fired!*, or he was *canceled!*, or he was *justly punished!*, depending on which team you play for and how invested you are in your membership in the league.

Katz is among the many citizens whose private catastrophes have been seized upon and treated something like a theatrical drama in which certain breeds of nauseatingly political Americans assume their customary positions and rehearse their familiar scripts. Scavenging the relevant search engines and piecing together a timeline of the Katz affair after the fever has broken has been a fruitful, if bizarre, anthropological project. At a distance, the earnest hysteria and sanctimonious outrage of *all* the opiners seems not only ridiculous but also hollow, as if none of these pontificators really cared

about this particular drama, except as an opportunity to model the Right (or Left) View of it.

The name that I give to this style of participation in public debates is priorism, because it comes with a handy framework, an *a priori* intellectual and even cognitive filter, into which each successive news cycle or morsel of cultural gossip is smoothly fitted. Priorism is a brutish substitute for interpretation; unlike priorism, responsible interpretation awaits facts, considers developments, and suspends judgment for the duration of inquiry while it resists the impulse to extrapolate wildly from bits and pieces. The primary objective of interpretation is to yield understanding, whereas priorism yields only a comforting sense of belonging and a hackish confirmation of an established worldview. Evidence that contradicts its framework is simply ignored or discarded or mocked, and in this way priorists are never thrown into crisis. Theirs is a phony kind of certainty. They, or at least the clever ones among them, are not exactly liars. They tell selective truths, edited accounts, absorbing what is useful and strong-arming it into their system. The spirit that moves even their true opinions is not the spirit of truthfulness but of conformity. Priorism, no matter of which ideological variety, offers its members the armor of a sympathetic, validating community. They are never discomfited, they are never alone, they are only ever affirmed. This, incidentally, is why priorism has these days become a promising career path.

The national theatrical production called "Katz," like the ones that preceded it, is, among other things, tedious, no matter the pitch in which the lines are recited, because we have all heard all this before. And further, the more familiar the opinion, and the closer it clings to the script, the warmer its reception: community, and its cheap praise, is guaranteed. The

primary mode of its expression is regurgitation. (Re-tweet!) Our discourse is made up of a million platitudes, and these platitudes are repeated endlessly by the very people who purport to be, and are feted for being, our brightest. How do we manage to stay awake through each performance?

Katz does not appear to be a dazzling individual. Among the oddities of this tale is that he can command national attention at all. It is generally agreed upon that he has an enigmatic, rapacious, and sharp mind, and a captivating energy which sometimes obfuscates his lack of more obvious charms. If ever he possessed charisma, it is not evident now; he is, judging from the essays he has churned out about the terrors of cancellation and the cowardice of his former friends, a bitter man. (It is 2023 — we are connoisseurs of cancellation, and we know the difference between a dignified pariah and an embittered one.) It was surprising to learn that, before the crisis began, long before I ever heard of him, Katz basked in the adoration of the entire Princeton student body. He has a quality rating of 5/5 on ratemyprofessors.com, and 100% of students said they would take his classes again. One respondent on that site gushes that Katz was "a reason to come to Princeton." Another effused, "Don't graduate without taking a class from Katz. He is not only brilliant but dynamic and interesting as well... Will know each person in his 100-person lecture personally." And another: "Possibly the coolest teacher I had through all 4 years of college." In October 2018, when Katz was already suspended for sexual misconduct but before this fact had become common knowledge, in phase A of the scandal, the website OneClass.com ranked the top ten profes-

sors at Princeton and awarded Katz the top spot. Undergraduates used to queue in winding lines to sign up for his courses. He received more than one teaching award, and was among the professors who served as a contributing columnist for the very student newspaper that would later pioneer his destruction.

These were (some of) the facts available to the American public, and they sufficed for families gathered round their tables to engage in psychological speculation regarding the inner workings of a man they had never met. *There is a certain sort of professor for whom undergraduate adoration is infinitely more intoxicating than any drug. The deprivation of this intoxicant seems to have infuriated him more than the other attendant indignities.* Or: *See how fickle and cruel college students can be? As soon as the torchbearers came knocking they turned on a man they had revered.* And so on.

The story of Joshua Katz revolves around the man, but it isn't really about him — it is about us, about the cynical and insanely politicized world that we have constructed for ourselves, the kitsch that we slosh around in, the slogans that we slurp and spoon down one another's throats. There are no heroes in the story. There aren't any villains, either. In so far as villains are cunning, Katz doesn't make a convincing villain. This is true despite the fact that his enemies have bent over backwards for the past three years trying to dress him up like one. (I do not mean to imply that he is not guilty of sexual misconduct. He has said himself that it is a sin for which he has repented.) This is among the reasons that he has been so enthusiastically enveloped by the right — for that set of priorists, being accused of villainy by progressives is the surest certificate of purity, just as being cast as a victim has the same effect for the opposite camp.

It is easy enough to track the public response to the Joshua Katz affair, but the details of the story itself remain overwhelmingly mysterious, like a play within a play that the characters are reacting to though none of them has heard all the dialogue or seen all the action. As noted, this ignorance is an essential element of the story. Knowledge would spoil the fun. As far as I can gather, it is impossible for an outsider to figure out what actually transpired, and it is in all likelihood similarly impossible for an insider with protected but partial information to gauge what actually happened. Very little about this affair can be honestly asserted with confidence, but much has been confidently asserted.

The broadest details have by now been widely reported (and selectively forgotten). In 2018, Professor Katz was disciplined for a consensual relationship with an undergraduate that occurred sometime in the mid-2000s. (That investigation began the same year Katz was supposed to serve on the "Committee of Three" or "C/3", which is arguably the most important committee at Princeton. Serving professors help to decide, among other things, which of their peers get tenure. The fact that Katz was appointed to this powerful body speaks to the status that he enjoyed among the faculty.) An investigation into the relationship was initiated after a third party, another student with knowledge of the affair, contacted the university without the support or the consent of the woman (now graduated) with whom Katz had been entangled. She did not participate in the investigation. Based on the committee's findings, which remain confidential, Katz was suspended for the academic year of 2018-2019. It seems that at the time little was made of his absence. There was no public outcry, and the

suspension happened to fall a year after Katz had a scheduled sabbatical, so that his departure was prolonged rather than suddenly and disruptively enforced. Perhaps this experience radicalized him, or perhaps it simply coincided with political upheavals within the university that on their own shifted him rightward. Whatever the case, rightward he went.

Katz had not been entirely apolitical prior to the events with which we are presently concerned. In 2017, a year before the drama, he was a signatory to a letter penned by fifteen professors from prestigious universities which invited the freshman class of that year to resist pressure to conform politically despite the social consequences. They warned that groupthink is rampant and powerful enough that "it leads [students] to suppose that dominant views are so obviously correct that only a bigot or a crank could question them. Since no one wants to be, or be thought of, as a bigot or a crank, the easy, lazy way to proceed is simply by falling into line with campus orthodoxies. Don't do that. Think for yourself." Two years later, in this same spirit, on July 8, 2020, Katz published an essay that would vaunt him onto the national stage. It was entitled "A Declaration of Independence by a Princeton Professor" and it appeared in *Quillette*. His debut as a participant in the public debate was as a member of, or at least a contributor to, the anti-cancel-culture brigade. With one glaring exception, it was a more or less competent defense of reason and clear-headedness.

The "Declaration" was written in response to a letter by large numbers of the Princeton faculty, published on Independence Day and addressed to the president and senior administrators of the university. It put forth a suite of demands designed to combat the "Anti-Blackness" that "is foundational to America," and was signed by over three hundred

faculty members. Some of the demands were reasonable, as Katz himself states in his essay. For example: part 4, demand 10 insists that Princeton "fundamentally reconsider legacy admissions, which lower academic standards and perpetuate inequality." Or, as Katz points out, "It is reasonable to 'give new assistant professors summer move-in allowances on July 1' and to 'make [admissions] fee waivers transparent, easy to use, and well advertised.' 'Accord[ing] greater importance to service as part of annual salary reviews' and 'implement[ing] transparent annual reporting of demographic data on hiring, promotion, tenuring, and retention' seem unobjectionable." These demands were sensible and practical.

But others, as Katz goes on to point out, were ridiculous. Consider, for example, Part 1 demand 5: "Reward the invisible work done by faculty of color with course relief and summer salary... Faculty of color hired at the junior level should be guaranteed one additional semester of sabbatical on top of the one-in-six provision." Or Part 2, demand 4: "Enforce repercussions (as in, no hires) for departments that show no progress in appointing faculty of color. Reject search authorization applications and offers that show no evidence of a concerted effort to assemble a diverse candidate pool." Here, we can agree, we have left the realm of best practices and entered the netherworld of radical identity politics, though Katz claimed that such proposals would lead to civil war on campus if implemented, which seems excessive. But the ugliest of the hyperbolic indulgences in his piece was his now-infamous characterization of a Princeton student group called the Black Justice League as a "small local terrorist organization." This, from the man who not a year earlier signed a letter in which he joined in lamenting that groupthink had become so powerful that students reflexively assume only a bigot or a crank would oppose it.

Priorism, or the Joshua Katz Affair

If your fingers have been in the remote vicinity of our culture's pulse in recent years, you will have noticed that ordinary people with a bit of common sense (a locution which itself has been co-opted and converted into an ideology-brand) have devolved from independent thinkers into gang members with an axe to grind. Those who declared themselves anti-groupthink developed their own groups which developed their own asphyxiating vernaculars and codes of conduct. Katz is a freshly minted member of such a group. He wrote recently, in *Sapir*, that cancellation has allowed him to see who his real friends are. I do not mean to doubt his need for friendship, but surely he must see that the basis of these new attachments are ideological. His new friends have uses for him. If he did not parrot their own scripts with such gusto, they would not be so friendly.

The phrase "small local terrorist group" is the reason "Joshua Katz" has become part of the national chatter; it is the reason that he is reviled by the left and deified by the right. Five days after his defiant essay appeared, Princeton President Christopher Eisgruber publicly condemned Katz:

> While free speech permits students and faculty to make arguments that are bold, provocative, or even offensive, we all have an obligation to exercise that right responsibly... Joshua Katz has failed to do so, and I object personally and strongly to his false description of a Princeton student group as a 'local terrorist organization. By ignoring the critical distinction between lawful protest ad unlawful violence, Dr. Katz has unfairly disparaged members of the the Black Justice League, students who protested and spoke about controversial topics but neither threatened nor committed any violent acts.

Both sides, of course, degrade "free speech" by ping-ponging it cheaply back and forth over the ideological net. That same day, in the *American Conservative*, Rod Dreher called Eisgruber a coward whose proper role is to "defend free speech by faculty members, not kowtow to radicals." Dreher declared, in the conventional right-populist way, that Eisgruber's statement makes clear "who has privilege at Princeton and who does not." As if Katz had a right not to be disagreed with; as if the members of the administration or the faculty among whom he had just so aggressively distinguished himself had no right to respond to him. You cannot create a provocation and them complain when others are provoked; and this goes for all sides.

Here is a brief review of the most notable responses to Katz's villainy/heroism. On July 14 the *Wall Street Journal* editorial board published a column praising Katz and warning that "cancel culture doesn't need to get him fired to succeed. It succeeds by making him an outcast at his own university, and intimidating into silence others on campus who might agree." On July 22, Mihael Poliakoff, the president of the American Council of Trustees and Alumni, paid tribute to Joshua Katz for "his intellectual integrity, his heart, and his courage." and recognized him as a "Hero of Intellectual Freedom." On July 26, Katz published an op-ed in the *Wall Street Journal* titled "I survived cancellation at Princeton: it was a close call, but I won't be investigated for criticizing a faculty 'open letter' signed by hundreds." (This was the first of innumerable subsequent essays, podcasts, and talks given by Katz about surviving cancellation.) In September, the American Council of Learned

285

Societies withdrew Katz's appointment as a delegate to the Union Académique Internationale. Katz sued the ACLS for "viewpoint discrimination." A judge dismissed the lawsuit. In January of the following year, John McWhorter, writing in the *Atlantic*, praised Katz: "He is not an exemplar of white fragility, but a model for the future."

On February 2, 2021, seven months after Katz's essay in *Quillette* was published, things got darker. The *Daily Princetonian* published the findings of its own investigation into three different relationships that Katz had had with female students. Katz's lawyer slammed the article as a "planned smear... clearly yet another attempt to punish him for dissenting from the prevailing campus orthodoxy." After these findings were published, the alumna who had been the subject of the investigation in 2018 sent a detailed written complaint about Katz to the university. In response to the receipt of that letter, the university commenced a new investigation, this time concerning Katz's compliance with the previous one. This final investigation took place over the course of the subsequent thirteen months. On May 23 of the following year, the board of trustees resolved to fire Katz, and published a statement which reads in part:

> When [the alumna] came forward in 2021, she provided new information unknown to the University in 2018, and the University initiated a new investigation in accordance with its policies. The new investigation did not revisit the policy violations for which Dr. Katz was suspended without pay in 2018; it only considered new issues that came to light because of new information provided by the former student. The 2021 investigation established multiple instances in which Dr. Katz

misrepresented facts or failed to be straightforward during the 2018 proceeding, including a successful effort to discourage the alumna from participating and cooperating after she expressed the intent to do so. It also found that Dr. Katz exposed the alumna to harm while she was an undergraduate by discouraging her from seeking mental health care although he knew her to be in distress, all in an effort to conceal a relationship he knew was prohibited by University rules. These actions were not only egregious violations of University policy, but also entirely inconsistent with his obligations as a member of the Faculty. Faculty discipline at Princeton is handled in accordance with the "Rules and Procedures of the Faculty," which guarantee numerous procedural safeguards for faculty members facing proposed disciplinary action. In cases involving a proposed suspension or dismissal, the affected faculty member has the right to seek review by an independent committee composed of members of the Faculty elected by their peers.

The recommendation to dismiss Dr. Katz was reviewed by the faculty committee, known as the Committee on Conference and Faculty Appeal. After reviewing the pertinent investigation reports and Dr. Katz's submissions, and interviewing Dr. Katz and others, that committee found that the reasons presented in the dismissal recommendation of the Dean of the Faculty were supported by the record. That recommendation was subsequently submitted to the President, who evaluated it and submitted it to the Board for action.

The Board voted to dismiss Dr. Katz on the recommendation of the University President and Dean of Faculty, after a review of the extensive record by an ad hoc committee of the Board appointed to consider the matter.

That same day *The New York Times* published an article which insinuated that the investigation was simply a ruse, an excuse to fire Katz "for criticizing the anti-racist proposals made by Princeton faculty, students, and staff" — criticisms that he had made seven months *before* the investigation was opened, and over a year and a half before the committee resolved to fire him. It is unclear to me why the *Times*, of all places, and at that late date in the thought-policing to which it has itself significantly contributed, decided to use Katz's firing as an opportunity to condemn the overreach of cancel culture.

Whatever the reason, since the *Times* overtly accepted Katz's reading of the situation, it seems that many others who would otherwise resist hasty conclusions permitted themselves to believe there must have been some higher proof of gross misconduct on Princeton's part. This is the only explanation I have come up with for why so many other apparently reasonable people have repeated this line without providing persuasive evidence. On July 5, *The Chronicle for Higher Education* published "Princeton Betrays Its principles: The corrupt firing of Joshua Katz threatens the death of tenure," which is a withering condemnation of Princetonian spinelessness. If it were true that Princeton used the investigation as an excuse to fire a man whose views were a cosmetic liability for the university, such a criticism would be justified. But there is no way to know for certain that this is what was done. One can only extrapolate broadly from available information.

For instance, it is undoubtedly true that many members of a progressive mob unjustly demanded that Katz be fired simply for writing something with which they virulently disagreed. (Anyone who actually wanted Katz fired for the *Quillette* essay is guilty of precisely the progressive extremism of which Katz and his gang accuse Princeton.) It is also true that a university must thoroughly investigate a complaint submitted by a student suggesting that a professor is guilty of egregious misconduct. Is it possible that the dean of the university, a peer committee, the university president, and the board of trustees all perpetrated a hoax investigation for thirteen months because of a concerted effort to fire Katz? Perhaps. Is it manifestly evident? Certainly not.

Cancel culture has destroyed innocent lives, and has exacted numerous excessive punishments, and has achieved a tyrannical power within certain precincts of elite America. But the sheer fact of cancellation proves nothing about what is true and what is false, who is innocent and who is guilty. Cancellation is not itself one of the facts that need to be established regarding any specific case. Nor has martyrdom ever proven the truth of a faith. And one can acknowledge this even while also contending that those who ordered Katz's head on a platter simply because of a phrase in an article must be opposed even by non-bigots and non-cranks.

Similarly, is it possible that Joshua Katz wrote that infamous phrase in his *Quillette* essay because he knew that the progressives were out for his blood, and so he was throwing his lot in with the other team? Did he write it on purpose, with cunning, so that he could later argue, after his inevitable cancellation on other grounds, that his mistreatment was a matter of free speech and not a matter of sexual misconduct? Perhaps. It is as a convincing a theory as any other, and none

289

are very convincing. I have heard both versions of the Katz affair defended with perfect confidence by people I respect. All their confidence is baseless. The incontrovertible fact is that we do not know the facts.

Our very conception of participation in the public discourse is predicated upon a gross distortion of the proper relationship between truth and opinion. We abhor silence, as if having nothing to say is somehow worse than saying much without substance. It is not shameful to recognize one's own incompetence for judgment, if judgment requires knowledge that one does not possess. Regarding subjects which we cannot adequately know, especially those which concern the private lives of other people, it is honorable not to have an opinion.

A dear friend of mine, I will call her Jane, was raped by a boy with whom she had attended middle school and high school, and with whom she had been close for most of her life. He was monstrously drunk at the time, so much so that he does not remember the act (at least he has never indicated to her that he does). She did not tell the police or any of their mutual friends, neither directly afterwards, when basic functioning was a task that she could hardly manage, or many months later, when the fog had begun to lift and she dreaded re-engulfment. For quite a long while after the trauma, she interpreted any remotely analogous incident primarily as a tale of rape. (Whenever a new cycle of ignorant gossip about a sexual-assault-related claim captivates the nation, and the same priorists who last time asked "why didn't the victim come forward earlier?" ask it again, Jane's nails puncture her palms.)

This event determined her disposition towards every allegation levied against a man regarding sexual misconduct — even cases like Katz's, though Katz was certainly not accused of rape, or of a less violent kind of sexual assault. Jane maintained that prior disposition until her brother was accused of sexual assault by a woman with whom he had gone to college. For years after the accusation was made, her brother receded into a depression that sapped him of the strength or the inclination to leave his bed, or to read, or to speak to most anyone other than Jane. During that bleak era, she would schedule her days around their phone calls, convinced that her voice was all that kept him from suicide. She believes, on the basis of her own cross-examination of her brother, in his innocence.

Discussing the Joshua Katz affair with Jane is psychologically and sociologically fascinating. Depending on the day, or the aspect under discussion, or the attitude of her interlocutors, she assumes either the priorism of a victim of rape or the priorism of her brother's sister. Whichever of these personas participates in a given conversation, it is evident that Jane is agitated by contradictory loyalties, which is why it is so difficult for her to conjure genuine concern about the facts of the case she is discussing. She doesn't know whether Katz is guilty or innocent; she knows that her brother is innocent, and she does not want to be the kind of person who would have assumed her brother's guilt, or would not have advocated for his rights to fair treatment and due process. She has no idea why Katz's female student did not participate in the primary investigation, but she knows why she has never gone to the police, and she does not want to be the kind of person who would doubt the veracity of the testimony of a woman such as herself.

It must be acknowledged that Jane's antithetical loyalties have a certain integrity, even though they inhibit her from

developing a dispassionate view of this case. While there are many priorists who have exploited the Katz affair for their side, not all priorists are operating in bad faith, in the sense that they are not all primarily motivated by a desire for community membership. Priorism is not always crass, though it always facilitates an intellectual incompetence. The views that Jane develops purely on the basis of her prior loyalties, which are outgrowths of her own dark experience, are not cheaply held. They are understandable, even admirable impulses — but they are not intellectually supportable ones. Loyalty is a precious human expression, and it can be enriching and beautifying. But it must be closely watched, tempered, and monitored to keep from becoming blind and devolving into tribalism.

Sooner or later, in the analysis of our scandals, owing to the complexity of the questions and the mixed availability of evidence and the laziness of our public discussion, one must consider seriously questions of epistemology — of what we can know and how we can know it. The "fake news" and "alternative facts" of the Trumpists brought this philosophical conundrum into the open, though it has always been a fundamental concern for conscientious citizens. And now it seems to be everywhere, as each gang cherry-picks their experts and sends them into battle on every subject from medicine to foreign policy. The Katz affair is another example of the ruined reputation of authority.

"It is wrong always, everywhere, and for anyone, to believe anything upon insufficient evidence." So wrote the English mathematician and philosopher W.C. Clifford in his essay "The Ethics of Belief," which appeared in 1877. In his essay Clifford advances a defense of evidentialism, an

epistemic doctrine which stipulates that a belief is only ever rightly and morally held if it is supported by conclusive evidence. Clifford insists that even if a belief is true but is held for any reason other than that it was empirically or logically proven, it is wrong to hold it. (Milton's wonderful phrase for this intellectual predicament was "a heretic in the truth.") And the word "belief" does not refer simply to the question of religious faith, which was the immediate though hidden subject of his essay, but extends also to every variety of knowledge: "No simplicity of mind, no obscurity of station, can escape the universal duty of questioning all that we believe." It is an exorbitant imperative, practically impossible to fulfill, and paralyzing even to attempt.

Nineteen years after this essay appeared, William James published his famous rebuttal to Clifford in "The Will to Believe." Therein James defined a hypothesis as "anything that may be proposed to our belief; and just as the electricians speak of live and dead wires, let us speak of any hypothesis as either live or dead. A live hypothesis is one which appeals as a real possibility to him to whom it is proposed." He goes on to defend the human "right to believe at our own risk any hypothesis that is live enough to tempt our will." This laxity about truth is necessary, James argues, in order for certain strains of higher belief to remain possible. He is salvaging an epistemology for religion. Clifford's rigor, he warns, prescribes an agnosticism which "would absolutely prevent [one] from acknowledging certain kinds of truth" and is therefore "irrational." (It was daring of James to invoke rationality in the service of his idea of faith.)

But surely James' prescription is as untenable as Clifford's — it is as intellectually lazy as Clifford's is intellectually severe. Clifford slams the door shut, James removes the hinges. Can

this great controversy about religion be applied to politics? It is surely impossible for a citizen to gain proficiency in all the subjects that would allow her to cast a thoroughly informed vote, for example. Insisting on Cliffordian certainty in public affairs is futile. As Clifford himself noted, we all rely upon authorities, and it is our responsibility to determine what counts as authority in various fields. But if evidentiary certainty is not possible, does this ignorance emancipate us from Cliffordian scruples and gain us a Jamesian freedom to believe whatever kindles to us?

Consider a concrete instance: the Katz affair. Given all that we do not know, does James' latitude apply in such a case? Do we have a "right to believe at our own risk any hypothesis" regarding Katz and his cancellation "that is live enough to tempt our will"? Is it cowardly to hold one's tongue and not contribute to the fight over first principles simply because one is not certain? If one is convinced that independent thought is under siege, isn't it fair to extrapolate from what one already knows about American society and infer that Katz was unfairly treated? And even if Katz was not unfairly treated — does it really matter? Shouldn't anyone who opposes the attack on independent thought defend Katz, as he has become a synecdoche for the larger problem?

Similarly, suppose one believes that there is a certain kind of professor who serially abuses his position and takes advantage of his students. And suppose that this same person is also convinced that there are charlatans who have made careers out of condemning cancel culture, and such people, the most powerful among them, have connived to dress Katz up as a wronged saint. Doesn't such a person have a duty to speak up regardless of whether or not she has evidence of Katz's specific guilt?

The answer, of course, is no. It is undignified to play the fool in the name of ideological loyalty. No citizen or ally is required to simply repeat what others on her team expect her to say, no matter the valorousness of that team's general code. None of us have the right, let alone the duty, to feign certainty. It is entirely honorable to have no opinion about the Katz affair, or about any controversy that will not admit of clarity. We have instead the onerous obligation to defend our values while putting pressure on platitudes and slogans. Put down your scripts. They refer to nothing beyond themselves.

295

LEON WIESELTIER

Problems and Struggles

"So Socrates!" he teased, "you are still saying the same things
I heard you say long ago." Socrates replied: "It is more terrifying
than that: not only am I always saying the same things, but
also about *the same things."*

<div align="right">

XENOPHON, MEMORABILIA, IV.4.6

(Translated by Jonathan Lear)

</div>

In the plenitude of discouragements that is contemporary history, the one that perhaps stings me the most is my increasing despair about the possibility of persuasion. Who changes their mind anymore? What is the difference between an open society that is intellectually petrified and a closed society? In a democratic society, which governs itself by exchanges and tabulations of opinion, surely the first requirement of meaningful citizenship is receptivity. Thoughtlessness is a betrayal of democracy. Mill said that democracy is "government by discussion." The purpose of discussion is to test the merit of opinions with the presumption that one

may convince others, or become convinced by others, of new views. One of the quintessential experiences of democratic life is to admit that one is wrong. In debates about large principles and large programs, everybody cannot be right, and sometimes not even a little right; and in a liberal order the adjudication of contradictions is accomplished not by guns but by arguments. Or so we like to tell ourselves. But the degrading spectacle of what passes for public debate in America has shaken my hoary faith in the dependability of argument. Is social media a discussion? Is a shriek an argument? Where is the reasoned deliberation that Milton and Madison and Mill regarded as the foundation of a decent polity? They intuited that the road from unreason to indecency is not long, and we are diabolically confirming their intuition. We have made "public reason" into an oxymoron. We are drowning in discursive garbage. Even the people who believe in persuasion seem to persuade only each other. They are just another American community of the elect — the mild and articulate sect of the arguers.

Many observers have noticed this intellectual crack-up. They suggest a host of solutions. We must keep our minds open. We must listen more carefully. We must respect each other. We must be reasonable, and even rational. We must identify our biases and correct for them. We must bring evidence. We must lower the temperature. We must enhance our capacity for empathy. We must connect with each other, and with the Other. We must practice epistemic humility. These homilies are everywhere, and all the preaching is true. We should indeed do all these noble and necessary things. These are the traits of a democratic individual. But is it not time to notice the futility of this wisdom in present-day America? Nobody seems to be hearing that we should listen. These exhortations leave almost no trace on our public life,

which gets insistently dumber and nastier. They have become a sad and lovely genre of their own, a journalistic counterpoint of urgent but soothing platitudes. They may be accomplishing nothing more than providing solace and companionship for those who utter them. I have uttered many of them myself, and I stand by them. They *are* the only answers. But I am beginning to feel a little foolish, and disconnected, and marginal; I do not feel sufficiently helpful.

To some extent, of course, it was ever thus. There never was a time when Madisonian graciousness ruled our politics. Philadelphia in 1787 and Illinois in 1858 were epiphanies, not norms. Indeed, the promiscuity of the nineteenth-century American press can make social media seem redundant, in its slanders and its outrages. The manipulability of public opinion has always been a primary assumption of American politics and its cunning practitioners. Was there ever a medium of communication that was inhospitable to zeal, or that turned its back on lies? Have fanatics and extremists ever been at a loss for instruments of influence? There is some consolation to be had, I suppose, from this long history of what ails us. We are not the first to have fallen short of our discursive ideals.

Moreover, it is good that people stick up for what they believe. Intellectual stubbornness is in its way a mark of intellectual maturity. The malleable are too often mistaken for the reasonable. It is good that people hold strong convictions, and that they confer upon beliefs a prominent role in their identities. Yet the strength of a conviction has no bearing on its merit. Beliefs are not like foods that taste better hot. Too many people hold their beliefs for bad reasons, or for no reasons at all — merely because other people like themselves hold them, in the "cascades" and the "contagions" that have exercised social scientists in their study of our era of confor-

298

mity. In the articulation of our beliefs, the most common substitute for reasons are passions. The idolatry of feelings that has characterized our culture for many decades has now been extended to our politics. But what does passion have to do with persuasion? Persuasion by passion is a nice definition of demagoguery.

This time we have fallen *very* short. The collapse is especially painful for someone such as myself, who has spent his years in the argument business. It was, and still is, an idealistic calling. It came with many scruples about the integrity of argument. We worked hard when we argued, and we tried never to make it personal. (Almost nobody has a perfect record about turning an argument into a quarrel. I certainly do not. Sometimes hostility follows naturally from having understood the dangerous nonsense that your interlocutor is peddling.) There was an atmosphere of exhilaration that surrounded the seriousness. Of course there were also degraded forms of the practice: the gladiatorial kind, for which debate is a kind of sport, an exhibition of dialectical virtuosity, a contest of cleverness; and the academic kind, in which debate consists in making "moves" and "turns" and combinations thereof, as in a professional game; and the festival-of-ideas kind, in which thinking is presented breezily with a "hard stop," for the entertainment of the paying customers and the rich. But there remained, there still remain, intellectuals with a sense of honor, for whom truth and method matter most, and who regard their activity, rightly, as a significant contribution to their society. One would think that such people are never more valuable than in a crisis — but they are learning, I fear, that it is precisely in a crisis that they may be least valuable, and most easily overridden. In 2016, for example, almost every thoughtful conservative columnist in the country valiantly

opposed Trump, and it was as if they never existed. Right now the argument for persuasion, an American argument if ever there was one, seems to be experiencing the same indifference.

Yet there is another way to consider this problem, and others, so as to elude despair and to find strength. It is to regard it not as a problem, but as a struggle.

The success with which we meet the difficulties that we face depends first on an accurate description of them. Nothing destroys hope so quickly as asking a question in a way that makes it impossible to answer. Such a question leaves us with the crippling impression that the world is finally intractable, that there is nothing that can be done. It is one of pessimism's finest tricks. There are predicaments, of course, in which nothing can be done — but they are rare, even in adversity, and they, too, must be accurately characterized, if we are to be sure that we are being thwarted by reality and not by ourselves.

There are problems and there are struggles. Problems have solutions; struggles have outcomes. Problems are technical; struggles are historical. Problems recur; struggles persist. Problems teach impatience; struggles teach patience. Problems are fixed; struggles are fought. Problems require skill; struggles require character. Problems demand knowledge; struggles demand wisdom. Problems may end; struggles may not end. A problem that does not end is a defeat or a failure; a struggle that does not end is a responsibility and a legacy.

We are not given to choose between a world of problems and a world of struggles, and so we must be dexterous. Different temperaments incline to, or feel especially beset by, the one or the other; and this may be the case with communi-

ties and societies, too. The American affinity for problems over struggles is well known: the great American epic of practicality and its rewards. We care so much about practicality that eventually it was raised into a philosophy, according to which the proven satisfactions of a hammer and a nail were powerful enough to rid us of nothing less than metaphysics. William James, who perversely regarded pragmatism as a spiritual dispensation, once defined reality as "a perfect jungle of concrete expediencies." Whether or not reality is like that, American reality is. The wildness of American religiosity may be understood as the response to such an environment of rampant utilities. (Silicon Valley is a hotbed of New Age rubbish.) Yet the American obsession with how things work has produced many admirable results, not least the technocracy that now inspires the wrath of the populists. Over many decades it has done more for the public good than any mob ever did, even if sometimes it has attempted to plant its standpoint where it does not belong and sought in its fanatical meliorism to reduce struggles to the scale of problems. But eventually struggles, too, have a place for policy, which is best not made by visionaries.

Thinkers from Augustine to Heidegger have belittled the uses of things. The "ready-to-hand," owing to its "serviceability," is ontologically shallow, according to the latter, and much too distant from Being. According to the former, the *uti*, the use of something for the sake of something else, is similarly secondary and extrinsic to the highest meanings, and he ponders whether "men should enjoy themselves, use, or do both." The American experience of enjoyment in use, of pleasure in function, is beyond his imagination. Such a hierarchy of value would be wrecked by a visit to an American hardware store. The anti-pragmatists are disquieted by a love

of the extrinsic just as the pragmatists are disquieted by a love of the intrinsic. The answer to Augustine's question, obviously, is that we must do both.

Moreover, there is glory, and not only necessity, in our practical achievements (just as, say, there is beauty, and not only necessity, in architecture). *Homo faber*, if he is to make things and build things, must include among his talents a sense of form and a concept of design, and an ability to work out the purposes of an object as well as its material properties. The gulf between instrumentality and art is not as wide as the aesthetes and the Platonists would have us believe. I learned this lesson in Kensington, Maryland, where there used to be a shop that sold antique tools — carpentry tools, construction tools, kitchen tools, fireplace tools — a paradise of practicality; and when I first walked into the shop I was struck not by the spectacle of utility but by the spectacle of imagination. The shapes and the metals were gorgeous. I still own the heavy late-nineteenth-century iron cooking pot, with its delicate handles and its handsomely pockmarked lid, that I acquired there. It is a welcome drag on my aspirations to loftiness.

Here is a passage from one of the many American books on (this is its subtitle) "how to perfect the fine art of problem-solving":

> Problem-solving is a critical survival skill because things go wrong for us all the time. Working through problems is crucial for productivity, profit, and peace. Our problem-solving skills, however, have been short-circuited by our complicated, technology-reliant world. Why learn how to fix something when Google can do it? Unfortunately, calamity doesn't always fit in a search

bar. And increasingly in our modern, perilous world, the issues that emerge are subtle, laced in subtext, or teeter on the tip of a slippery slope — all attributes that require a human touch to solve. As said humans, we must not only be able to address the problems that arise across all professions and walks of life, we must also be able to solve them. Before they drown, damn, or destroy us. Thankfully, problem-solving is a skill that can be learned.

I can almost hear *The Star-Spangled Banner* in the background. But every word is unimpeachable, except perhaps the reference to peace, which belongs more realistically to the realm of struggle. The undaunted confidence in human agency, the respect for the concrete, the commendation of the artisanal and the collaborative, the faith in education and the transmission of skills: these are elements of the mentality that built cities and created technological revolutions, and their dazzling social and economic benefits. The inventors, the tinkerers, the adjusters, the repairers, the tweakers: they are pillars of everyday existence, who defy our sense of helplessness and relieve us of many of the oppressions of our material setting. They make life more dignified, because there is dignity in safety and comfort and the conquest of anxiety.

The same mentality, alas, these same elements, are also the source of our Icarian perils. Sometimes our ability to make things exceeds our ability to comprehend what we are making, and we deploy our inventions before we adequately understand their purposes and their effects. "Problem-solving" is ethically contentless; it serves many causes and many codes. Evil, like goodness, seeks technical support, which is why "pragmatic," in ordinary usage, also has a pejorative connotation. (As does "fixer".) The question of how things work is

303

never the most fundamental question one can ask about human affairs. But fundamental questions are not the only questions that we are obliged to ask. We are, even the largest-souled among us, commonplace creatures who live fragilely in a world of cracks and fixes. We are fortified more by reforms than by revolutions. So blessed be the fixers, especially those who recognize the limits of the fix as a model for all human solutions.

Not all the difficulties that beset us can be described as problems that can be fixed. Some of them are deeper and thicker and more lasting, and therefore more immune to our practical brilliance and our utilitarian talents. They are conditions, inherited states-of-affairs, systems and structures, traditions and loyalties, inner dispositions in the individual and the community, cultural premises hallowed by the generations, abstract conceptions and reified ideals. They imbue everything we do, but we cannot take a hammer to them. (Except wantonly, of course: violence in a problem-fixing society is owed in part to the special frustration of problems that cannot be fixed. Frustration, and the inability to live with it, is one of the characteristic hazards of the can-do worldview.) Indeed, the ubiquity of their effects, their saturation of all the private and public realms, contributes to their durability. And yet they must be fought.

There is the difference: fixing is not exactly a fight, even when it is hard. No fight is necessary when satisfaction can be technically and efficiently achieved, and there are no first principles at stake. A solution to a problem may be wrong without being evil. Trial-and-error is a benign war

on error; a correction of mistakes, not of sins. The question of how best to fight inflation, or how best to curtail our dependence on fossil fuels, or how best to halt nuclear proliferation — such questions may provoke virulent debates, but the virulence is generally not philosophical. These are "how" questions, and not all "how" questions must become "why" questions. A debate about means when there is a consensus about ends is much more easily resolved than a debate about ends. Conversely, one time-honored way of wrecking a debate about means is to turn it into a debate about ends — to make every difficulty into a matter of first principles, to transform problems into struggles. The transformation of a problem into a struggle is a fine strategy for the enemies of a solution.

Perhaps the fundamental difference between a problem and a struggle is time. The temporal horizons of struggle are long —sometimes very long, even longer than a lifetime. Sometimes we bequeath a struggle to our children. The struggler, like the lover, is prepared to wait. A problem, by contrast, does not tolerate such duration. It needs to be solved soon, if we are to function; whereas struggles are not the condition of our functioning but of our just and proper functioning. One of the meanest facts of human life is that unjust societies can function. (Making a society function is one of the oldest excuses for injustice.) But there is some comfort, too, in that fact, since a just society has never existed. Our only alternatives may be imperfection or extinction.

Fiat justitia pereat mundus: the old Latin maxim captures the tense relation between perfection and reality. Let justice be done even if the world perish! That was the maxim's customary reading, not least by Kant, who described as "a sound principle of right...which should be seen as an obligation of those in

power not to deny or detract from the rights of anyone out of disfavor or sympathy to others." But what sort of justice is the destruction of the world? Where is the virtue in nothingness? (Kant dodged this ethically complicating objection with a strange paraphrase of the maxim's meaning: "let justice reign even if all the rogues in the world must perish.") We may read the maxim differently, then, and less as a mandate for zeal: we may read it as a warning that the insistence upon perfect justice may destroy everything, as a caution about absolutism in a just struggle. Be careful not to destroy the world when you seek justice! And I have seen a peculiarly American inflection of the adage. At the Supreme Court there hangs a portrait of John Marshall painted by Rembrandt Peale in 1834. The jurist is set heroically in a stonework oval with Roman ornamentation, and beneath him is a stone on which are carved the large words *FIAT JUSTITIA*. The rest of the maxim, the worry about the consequences of righteousness, has disappeared. Only a society consecrated to newness, a society that regarded itself as a beginning in what is right, could so blithely have banished the shadows from the ancient injunction.

A struggle does not allow for such innocence, if only because of its wealth of sobering experience. If you have struggled against an injustice, then you have known it, and witnessed it, and existed with it. You have learned too much about the world to believe that pragmatism is all the equipment that you will need to meet it. There are other inner resources that must be readied: steadfastness, patience, tenacity, resilience, courage. The less your life has need of those qualities, the happier (and the luckier) it is. A life of problems is not like a life of struggles. The trials of fixing are real, but they differ from the trials of struggling — the fixer's trials are more like exasperations. But an exasperation with history, particu-

larly with a history of suffering, is no mere exasperation: it is a sense of tragedy. It broaches the hardest question of all, which is the question of the warrant for hope.

A life in struggle is a life in hope, and hope gets stronger as its basis in reality gets weaker, until finally it floats free of experience and proclaims a pure assertion of the will to exist. The more empirical the hope, the less it is needed. But unempirical hope, or hope after catastrophe, is, for that reason, invincible; and it would be an offense against all the communities of struggle, all the shattered but intact peoples, to dismiss such hope as illusion, when it is the purest evidence of unbroken vitality. In a beautiful study of the spiritual perdurability of the Crow Nation, Jonathan Lear has called this "radical hope," by which he means an inner independence from history that permits one to entertain "the possibility of new possibilities." For this reason, anyone involved in a struggle will not count a bad day as the last word, because he lives in expectation of it, and he is accustomed to a different pace for progress, to the unsteadiness of forward motion, to delays and reversals and losses. The larger the goal, the rougher the road to it.

If we prefer to see ourselves as a nation of problem-solvers, it may be in part because we prefer to look away from the strugglers in our midst. Having completed their tasks, problem-solvers proceed to the most typical American activity of all: they move on. But the strugglers cannot move on. They are prisoners of circumstances, and of the power that with its prejudice arranged their circumstances. Their inner freedom is a measure of outer necessity. Our centuries of innovations and breakthroughs were also centuries of oppression and discrimination. Our country has harbored many communities of struggle: the Native Americans, for example. For a hundred

years or so the labor movement represented a community of struggle, and it may do so again. But no Americans have a more natural understanding of struggle than black Americans. Their emancipation, which we treat as a discrete historical event circa 1863, was (in the words of one historian) "the long emancipation."

The story of African American culture is a story of melancholy and its mastery. There is joy in the blues, which is not the case with many other traditions of sad song. The slave songs and the spirituals are intimate with the "trouble of the world," but I have never heard one of them recommend surrender. "O me no weary yet, o me no weary yet, I have a witness in my heart, o me no weary yet." The slaves sang, "Lord, make me more patient"; they sang, "Hold out to the end." And many decades later the poets expressed the same extreme commitment to endurance. Here is Sterling A. Hayden, addressing a Southern "nameless couple" who have suffered much hardship:

> Even you said
> That which we need
> Now in our time of fear, —
> Routed your own deep misery and dread,
> Muttering, beneath an unfriendly sky,
> *"Guess we'll give it one mo' try,*
> *Guess we'll give it one mo' try."*

And here is Countee Cullen's "The Dark Tower", whose title refers to a place on 136th Street in Harlem where poets used to meet, as if the poem, in its first person plural, might speak for them all.

We shall not always plant while others reap
The golden increment of bursting fruit,
Not always countenance, abject and mute,
That lesser men should hold their brothers cheap;
Not everlastingly while others sleep
Shall we beguile their limbs with mellow flute,
Not always bend to some more subtle brute;
We were not made eternally to weep.

The night whose sable breast relieves the stark,
White stars is no less lovely being dark,
And there are buds that cannot bloom at all
In light, but crumple, piteous, and fall;
So in the dark we hide the heart that bleeds,
And wait, and tend our agonizing seeds.

There is the temperament of struggle: waiting and tending
to one's agonizing seeds, which one day, owing precisely to the
pain of their cultivation, will grow.

Are Americans, particularly liberal Americans, still capable of
such a temperament? Have we, in the inward velocity of our
digital and consumerist present, forfeited the mental readi-
ness for the extended future, or squandered it on futurism?
I arrived at this broad and imprecise distinction between
problems and struggles in order to understand the despair
that I see around me. I attribute that despair to a confusion
between these orders of difficulty. It makes sense to despair
of solving a problem — some things, after all, cannot be fixed;
but it makes no sense to despair in a struggle, because disap-

Problems and Struggles

pointment is a regular feature of struggle, and perseverance comes before success. Injustice is much bigger than a problem. Anybody who combats injustice without the wisdom of struggle will fail in the effort to prevent it from becoming a fate. There are concrete instances of injustice, of course, which can be addressed with legal or political remedies. But there are no policies for the human heart. An earned income tax credit cannot heal psychic and cultural wounds. Discrimination can be ended by practical means, but not racism. Discrimination is a problem, but racism is a struggle. Racism, and all the other panics about difference, will never disappear. They are as old as civilization, and the greatest affront to it. All that can be done is to raise the legal and political and social costs of a particular expression of a prejudice, and then, having inflicted defeat upon it, await its resurgence, which must never surprise us even when it shocks us. The struggler is not a pessimist, but he is a disabused man. The appearance of anti-Semitism in America does not refute the revolutionary promise of America for Jews, because which student of Jewish history, which student of Christian history, which student of evil in human history, ever believed that once and for all anti-Semitism would end? Anti-Semitism was never illegitimate in the European political tradition, and in the Russian one, but it is illegitimate in America according to the terms of our founding. (Whereas white supremacy was inscribed in some of them.)

When friends tell me, as a consequence of Trump and the ascendancy of the radical American right, that America is over, or when they tell me, as a consequence of Netanyahu and the ascendancy of the Israeli right, that Israel is over, I castigate them for being disinclined to struggle. (I have three motherlands: America, Israel, and my library.) When they

tell me, as they spin the globe, that democracy is over, I reply that the rise of authoritarianism is not an event, but an era; and that it will take a long time, a generation or more, to push back the authoritarians and restore the prestige of the open society; and that we must not measure the crisis in election cycles, because it is more profound than politics; and that the inability of democracy to defend itself has always been its greatest historical failing; and that its rejection does not refute it — in sum, that we are in a historical struggle. The refusal to recognize it as such makes it more likely to fail. It is, moreover, a privilege to serve. The struggle for democracy, like the struggle for justice, makes life less trivial. Camus believed that Sisyphus was happy.

But do we, as they say in foreign policy, any longer have the staying power? The analogy with foreign policy is actually quite useful. One already hears and reads about "Ukraine fatigue" in America. *We* are fatigued by *their* fight for survival? The vanity! If the Ukrainian war is just, then it is just even when we get tired of it. The Biden administration has responded more or less splendidly to Putin's aggression, but more will be needed, because this is not a problem, it is a struggle. (The Ukrainians have established "resiliency centers" against the destruction of the country's infrastructure and the winter cold.) It was right about now that I expected the administration's determination to collide with the country's lack of determination. I mean, it's been a whole year. Pretty soon we will have another "forever war" on our hands.

There is no more damning evidence that the readiness for struggle is waning in America than our stupid retreat from Afghanistan. Twenty years is not even close to forever, except for people who do not understand historical time and have been damaged by the warp speed of American life. There were

sound moral and strategic reasons for our presence in Afghan-istan; and this is unwittingly conceded every time the same opinion pages that stridently called for an end to the "forever war" publish poignant pieces about the plight of Afghan women and Afghan schoolchildren in the kingdom of the Taliban. What did they think was going to happen? The whole world was taught that it could wait America out, that we have only a limited competence for commitment. Unlike us, our enemies know how to practice the art of waiting. They are not intimidated, or bored, by the *longue duree*. In their global rivalry with us, they are preparing for a struggle.

The psychology of struggle is a brake also against another danger that faces us. Owing to the magnitude and the multi-plicity of the crises that confront us, the apocalyptic spirit has been given new life. Hysteria is increasingly accepted as intel-ligent, as a condign response to a proper analysis of things. In our culture we are riveted by endings, especially by spectacu-lar ones. There is a new fashion in the-end-of-history, which is just as blind as the old one. Unlike the old one, this one is animated not by a sensation of triumph but by a sensation of weariness, by a loss of heart. History may now be numbered among the causes of depression. The prophecies of decline and destruction are overwhelming. In politics, the belief that time is running out, that it is too late to change course, that all that awaits us is cataclysm, has two antithetical consequences: apathy and apocalypse.

An apocalyptic is someone who decides to treat a struggle as a problem, and to get it over with. He wants a quick eschato-logical fix; his understanding is distorted by his desperation.

Despondency has sapped him of his will and his energy, or rather, it has left of his will and his energy only enough for the less exacting way of radicalism, which (as we know from the radical past) will either blow things up or exhaust itself. Struggle, in other words, even struggle unto the generations, is the quintessential anti-apocalyptic path. It will not be waited out, or permanently hobbled by gloom. In its decision to outwit despair, in its solemn promise that its resolution will be invulnerable to fortune, the spirit of struggle arms us not only against the injustice that we fight but also against our own frailties. We may reflect, and be calm, and hold together, in the storm, because we are wiser than the storm. Like Durer's knight we can advance, but unlike Durer's knight we are not alone.

CONTRIBUTORS

MICHAEL IGNATIEFF's most recent book is *On Consolation: Finding Solace in Dark Times.*

MARY GAITSKILL is the author, among other books, of *Bad Behavior* and *This is Pleasure.*

SERGEI LEBEDEV is a Russian novelist and the author of *Oblivion* and *Untraceable.* This essay was translated by Antonina W. Bouis.

KAREN SOLIE is a Canadian poet whose most recent book is *The Caiplie Caves.*

MICHAEL WALZER is professor emeritus at the Institute for Advanced Study in Princeton. His new book *The Struggle for a Decent Politics: On "Liberal" as an Adjective* was recently published.

DAVID A. BELL is the Sidney and Ruth Lapidus Professor in the Era of North Atlantic Revolutions and Director of the Shelby Cullom Davis Center at Princeton University.

JUSTIN E. H. SMITH is a professor of history and philosophy of science at the University of Paris.

MICHAEL C. KIMMAGE is a professor of history at the Catholic University of America and the author most recently of *The Abandonment of the West: The History of an Idea in American Foreign Policy.*

ADAM ZAGAJEWSKI, who died in 2021, was an acclaimed Polish poet. The poems in this issue were translated by Clare A. Cavanagh.

ANDREW SCULL is a professor of sociology at the University of California at San Diego, and the author of *Desperate Remedies: Psychiatry's Turbulent Quest to Cure Mental Illness.*

ROBERT ALTER is professor emeritus of Hebrew and Comparative Literature at University of California at Berkeley.

STEVEN B. SMITH is a professor of political science at Yale University and the author most recently of *Modernity and its Discontents: Making and Unmaking the Bourgeois from Machiavelli to Bellow.*

BENJAMIN MOSER is a writer and translator, and the author most recently of *Sontag: Her Life and Work.*

HELEN VENDLER is the A. Kingsley Porter University Professor emerita at Harvard University.

JOHN HODGEN is the Writer in Residence at Assumption College in Worcester, Massachusetts and the author of *The Lord of Everywhere.*

CELESTE MARCUS is the managing editor of *Liberties.*

LEON WIESELTIER is the editor of *Liberties.*

As a matter of principle, *Liberties Journal* does not accept advertising or other funding sources that might influence our independence.

We look to our readers and those individuals and institutions that believe in our mission for contributions — large and small — to support this not-for-profit publication.

If you are interested in making a donation to *Liberties*, please contact Bill Reichblum, publisher, by email at bill@libertiesjournal.com or by phone: 202-891-7159.

Liberties — A Journal of Culture and Politics is distributed to booksellers in the United States by Publishers Group West; in Canada by Publishers Group Canada; and, internationally by Ingram Publisher Services International.

LIBERTIES, LIBERTIES: A JOURNAL OF CULTURE . AND POLITICS, is published quarterly in Fall, Winter, Spring, and Summer by Liberties Journal Foundation.

ISBN 978-1-7357187-9-8
ISSN 2692-3904

Printed in Canada.

The insignia that appears throughout *Liberties* is derived from details in Botticelli's drawings for Dante's *Divine Comedy*, which were executed between 1480 and 1495.